the coshop book

Scott Kelby

THE PHOTOSHOP BOOK FOR DIGITAL PHOTOGRAPHERS

THE PHOTOSHOP BOOK FOR DIGITAL PHOTOGRAPHERS TEAM

CREATIVE DIRECTOR

Felix Nelson

TECHNICAL EDITOR

Chris Main

FDITOR

Richard Theriault

PROOFREADER

Barbara Thompson

PRODUCTION DIRECTOR

Kim Gabriel

PRODUCTION LAYOUT

Dave Damstra Paul Royka

PRODUCTION ART

Ted LoCascio Margie Rosenstein

Dave Cross

COVER DESIGNED BY

Felix Nelson

COVER PHOTOS BY

Kevin Ames, Ames Photographic

Illustration, Atlanta, GA

(www.amesphoto.com)

THE NEW RIDERS TEAM

PUBLISHER

David Dwyer

ASSOCIATE PUBLISHER

Stephanie Wall

EXECUTIVE EDITOR

Steve Weiss

PRODUCTION MANAGER

Gina Kanouse

EDITOR

Sarah Kearns

PRODUCTION

Wil Cruz

PROOFREADER

Michael Thurston

Published by

New Riders Publishing

Copyright © 2003 by Scott Kelby

FIRST EDITION: March 2003

All rights reserved. No part of this book may be reproduced or transmitted in any form or by any means, electronic or mechanical, including photocopying, recording, or by any information storage and retrieval system, without written permission from the publisher, except for the inclusion of brief quotations in a review.

Photoshop is a registered trademark of Adobe Systems, Inc.

International Standard Book Number: 0-7357-1236-0

Library of Congress Catalog Card Number: 2001096932

07 06 05 04 03 7 6 5 4 3

Interpretation of the printing code: the rightmost double-digit number is the year of the book's printing; the rightmost single-digit number is the number of the book's printing. For example, the printing code 03-1 shows that the first printing of the book occurred in 2003.

Composed in Cronos and Helvetica by New Riders Publishing.

Trademarks

All terms mentioned in this book that are known to be trademarks or service marks have appropriately capitalized. New Riders Publishing cannot attest to the accuracy of this information. Use of a term in this book should not be regarded as affecting the validity of any trademark or service mark.

Warning and Disclaimer

This book is designed to provide information about Photoshop for digital photographers. Every effort has been made to make this book as complete and as accurate as possible, but no warranty of fitness is implied.

The information is provided on an as-is basis. The author and New Riders Publishing shall have neither the liability nor responsibility to any person or entity with respect to any loss or damages arising from the information contained in this book or from the use of the programs that may accompany it.

www.scottkelbybooks.com

For my wonderful wife Kalebra, and my precious little boy Jordan. It's amazing just how much joy and love these two people bring into my life. irst, I want to thank my amazing wife Kalebra. As I'm writing this, she's lying on the couch across from me reading a book (not one of mine, sadly), but I have to say that just looking at her makes my heart skip a beat, and again reminds me how much I adore her, how genuinely beautiful she is, and how I couldn't live without her. She's the type of woman love songs are written for, and I am, without a doubt, the luckiest man alive to have her as my wife.

Secondly, I want to thank my 6-year-old son Jordan, who spent many afternoons with his adorable little head resting on my lap as I wrote this book. God has blessed our family with so many wonderful gifts, and I can see them all reflected in his eyes. I'm so proud of him, so thrilled to be his dad, and I dearly love watching him grow to be such a wonderful little guy, with such a tender and loving heart. (You're the greatest, little buddy.)

I have to thank my wonderful, crazy, hilarious, and loving dad Jerry for filling me with childhood memories of nothing but fun, laughter, and love. His warmth, compassion, understanding, ethics, and sincerity have guided me my entire life, and I could never repay him for all that he's done for me. I love you, Dad.

I also want to thank my big brother Jeffrey for being such a positive influence in my life, for always taking the high road, for always knowing the right thing to say and just the right time to say it, and for having so much of our dad in you. I'm honored to have you as my brother and my friend.

My heartfelt thanks go to the entire team at KW Media Group, who every day redefine what teamwork and dedication are all about. They are truly a special group of people, who come together to do some really amazing things (on really scary deadlines) and they do it with class, poise, and a can-do attitude that is truly inspiring. I'm so proud to be working with you all.

Special thanks to my layout and production crew. In particular, I want to thank my friend and Creative Director Felix Nelson for his limitless talent, creativity, input, cover design, overall layout, and just for his flat-out great ideas. To Chris Main for putting every technique through rigorous testing, and catching the little things that other tech editors might've missed. To Kim Gabriel for keeping us all on track and organized, so we could face those really scary deadlines. To Margie Rosenstein for adding her special touch to the look of the book, and to Dave Damstra, Ted LoCascio, and Paul Royka for giving the book such a tight, clean layout. To Barbara Thompson for stepping in at the last minute to help proof the book. Also, thanks to the newest member of our team, Dave Cross, who jumped right into the production fray, and whose suggestions made it a better book than it would've been.

Thanks to my compadre Dave Moser, whose tireless dedication to creating a quality product makes every project we do better than the last. Thanks to Jim Workman, Jean A. Kendra, and Pete Kratzenberg for their support, and for keeping a lot of plates in the

air while I'm writing these books. A special thanks to my Executive Assistant Kathy Siler for keeping me on track and focused, and for doing such a wonderful job, all the while keeping such an amazingly upbeat attitude, even though her Redskins didn't make the playoffs, while my Bucs went on to win the Super Bowl. (I'm going to pay for that one.)

I want to thank my longtime friend and first-class Editor Richard Theriault. This is the eighth book Dick has worked on with us, and we're totally hooked—we couldn't do it without him, and we wouldn't want to if we could.

I owe a special debt of gratitude to my friends Kevin Ames and Jim DiVitale for taking the time to share their ideas, techniques, concepts, and vision for a Photoshop book for digital photographers that would really make a difference. Extra special thanks to Kevin for spending hours with me sharing his retouching techniques, and for providing the cover shots for the book as well.

I want to thank all the photographers, retouchers, and Photoshop experts who've taught me so much over the years, including Jack Davis, Deke McClelland, Ben Willmore, Julieanne Kost, David Cuerdon, Robert Dennis, Helene DeLillo, Jim Patterson, Doug Gornick, Manual Obordo, Dan Margulis, Peter Bauer, Joe Glyda, and Russell Preston Brown.

Thanks to the brilliant and gifted digital photographers who graciously lent their talents to this book, including Carol Freeman, Richard LoPinto, Vincent Versace, Jim Patterson, Jack Davis, Kevin Ames, and Jim DiVitale.

Also thanks to my friends at Adobe Systems, Barbara Rice, Terry White, Gwyn Weisberg, Kevin Connor, Tanguy Leborgne, Karren Gauthier, Julieanne, and Russell. Thanks to our friend Jill Nakashima for all her support, kindness, and enthusiasm over the years—we all miss her, and wish her the very best.

Thanks to my Editor Steve Weiss (who totally "gets it"), to Dave Dwyer (who's always trying to raise the bar), and the rest of the wonderful family at New Riders—they're really great people who continually strive to produce really great books.

And most importantly, my deepest thanks to the Lord Jesus Christ for always hearing my prayers, for always being there when I need Him, and for blessing me with a wonderful life I truly love and such a warm loving family to share it with.

ABOUT THE AUTHOR

Scott Kelby

Scott is Editor-in-Chief and co-founder of *Photoshop User* magazine, Editor-in-Chief of Nikon's *Capture User* magazine, and Editor-in-Chief of *Mac Design Magazine*. He is President of the National Association of Photoshop Professionals (NAPP), the trade association for Adobe® Photoshop® users, and he's President of KW Media Group, Inc., a Florida-based software education and publishing firm.

Scott is author of the best-selling books *Photoshop 7 Down & Dirty Tricks* and *Photoshop Photo-Retouching Secrets*, and co-author of *Photoshop 7 Killer Tips*, all from New Riders Publishing. He's a contributing author to the books *Photoshop Effects Magic*, also from New Riders; *Maclopedia*, the *Ultimate Reference on Everything Macintosh* from Hayden Books; and *Adobe Web Design and Publishing Unleashed* from Sams.net Publishing. Scott has authored two best-selling Macintosh books: *Mac OS X Jaguar Killer Tips*, and the awardwinning *Macintosh: The Naked Truth*, both also from New Riders.

Scott is Training Director for the Adobe Photoshop Seminar Tour and Conference Technical Chair for PhotoshopWorld (the twice-yearly convention for Adobe Photoshop users), and he is a speaker at graphics trade shows and events around the world. He is also featured in a series of Adobe Photoshop training videos and CD-ROMs and has been training Photoshop professionals since 1993.

For more background info on Scott, visit www.scottkelby.com.

www.scottkelbybooks.com Vii

CHAPTER 1
Start Me Up
Mastering the File Browser
Saving Your Digital Negatives6
Creating a Contact Sheet for Your CD8
Browser Basics14
Browser Essentials
Organizing Your Images Using the File Browser24
Batch Renaming Your Files
Editing in the Browser33
Not Getting "Burned" by the Browser35
CHAPTER 2
Cream of the Crop
Cropping and Resizing
Custom Sizes for Photographers
Cropping Photos44
Cropping to a Specific Size47
Creating Your Own Custom Crop Tools49
Cropping Without the Crop Tool52
Automated Close Cropping54
Using the Crop Tool to Add More Canvas Area56
Straightening Crooked Photos58
Using a Visible Grid for Straightening Photos60
Resizing Digital Camera Photos
Resizing and How to Reach Those Hidden
Free Transform Handles67
The Cool Trick for Turning Small Photos into
Poster-Sized Prints
CHAPTER 3
The Big Fixx
Digital Camera Image Problems
Compensating for "Too Much Flash"
Dealing with Digital Noise
Removing Color Aliasing
Fixing Photos Where You Wish You Hadn't Used Flash
Fixing Underexposed Photos

TABLE OF CONTENTS www.scottkelbybooks.com

When You Forget to Use Fill Flash
CHAPTER 4
Before You Color Correct Anything, Do This First! 104 Color Correcting Digital Camera Images 106 Drag-and-Drop Instant Color Correction 115 Correcting Flesh Tones for Photos Going on Press 118 Adjusting RGB Flesh Tones 127 Getting Better Automated Color Correction 123 Color Correcting One Problem Area Fast! 127 Studio Portrait Correction Made Simple 131 The Magic of Editing in 16-Bit 133 Dodging and Burning 16-Bit Photos 137 Working with Photoshop's Camera Raw Plug-In 146 Using the JPEG 2000 Plug-In 146 CHAPTER 5 149 The Mask Masking Techniques
Extracting People from Their Background .150 Precise Selections Using the Pen Tool .154 Saving Your Intricate Selections .161 Loading the Highlights as a Selection .162 Making Selections in 16-Bit Images .164 CHAPTER 6 .169 Head Games Retouching Portraits
Removing Blemishes

Removing the Signs of Aging
Pro Wrinkle Removal184
Dodging and Burning Done Right186
Colorizing Hair190
Whitening the Eyes Quick Trick192
Whitening Eyes
Enhancing and Brightening Eyes
Enhancing Eyebrows and Eyelashes
Whitening Teeth202
Removing Hot Spots
Glamour Skin Softening
Advanced Skin Softening208
Transforming a Frown into a Smile213
Digital Nose Job215
De-Emphasizing Nostrils
CHAPTER 7221
Invasion of the Body Snatchers
Body Sculpting
Slimming and Trimming
Removing Love Handles
Slimming Thighs and Buttocks
Fixing Grannies
Borrowing Body Parts (Cheating)232
CHAPTER 8
38 Special
Photographic Special Effects
Blurred Lighting Vignette
Using Color for Emphasis
Adding Motion Where You Want It242
Focus Vignette Effect
Adjusting the Color of Individual Objects246
Replacing the Sky
Replicating Photography Filters250
Layer Masking for Collaging
Adding Depth of Field
Stitching Panoramas Together260

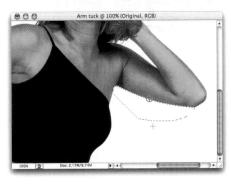

TABLE OF CONTENTS www.scottkelbybooks.com

CHAPTER 9
Back in Black
From Color to Grayscale
•
Using the Lightness Channel27
Custom Grayscale Using Channel Mixer27
Calculations Method
Creating Duotones
CHAPTER 1029
Sharp-Dressed Man
Professional Sharpening Techniques
, ,
Basic Sharpening29
Lab Color Sharpening
Luminosity Sharpening30
Edge-Sharpening Technique30
Extreme Edge Sharpening
Sharpening with Layers to Avoid Color Shifts
and Noise
Sharpening Close-Up Portraits of Women
Advanced Sharpening for Portraits of Women
CHAPTER 1132
The Show Must Go On
Showing It to Your Clients
Watermarking and Adding Copyright Info32
Embedding Digimarc Digital Copyright Info328
Showing a Client Your Work on Your Computer
Letting Your Clients Proof on the Web
Customizing Photoshop's Web Gallery
Getting One 5"x7", Two 2.5" x 3.5", and Four
Wallet Size on One Print344
How to Email Photos
Contributing Photographers350
Index352

I had no intentions of writing this book

So here it was, about four weeks before I would be flying up to New York City to teach a one-day seminar to more than 1,200 professional Photoshop junkies. (Okay, it was more like 1,160 pros, 42 people who just wanted a paid day off from work, and one total freak who kept asking me if I'd ever been in prison. I told him unequivocally, "Not as far as you know.")

Anyway, the seminar was just four weeks away, and there was one session that I still didn't have an outline for. It was called "Correcting Photos from Digital Cameras" (which is dramatically better than my original working title for the class, "Die, Traditional Camera User, Die!").

I knew what I needed to cover in the session because for the past ten years I've trained thousands of traditional photographers on how to use Photoshop. Most of them either have now gone digital or are in the process of going digital, and all these digital photographers generally seem to have the same type of Photoshop questions, which I'm actually thankful for, because now I can give them the answers. If they constantly asked different questions, I'd get stumped from time to time, and then I'd have to resort to "Plan B" (providing answers that sound good, but are in reality just wild-ass guesses).

So I knew what I had to cover, but I wanted to do some research first, to see if other people in the industry were addressing these questions in the same way I was, or did they have a different take on them, different techniques or ideas? So I went out and bought every single book I could find about digital photography and Photoshop. I spent nearly \$1.2 million. Okay, it wasn't quite that much, but let's just say for the next few months I would have to cut out some luxuries such as running water, trash collection, heat, etc.

I started reading through all these books, and the first thing I thought I'd look up was how they dealt with digital noise (High ISO noise, Blue channel noise, color aliasing, etc.), but as I went through them, I was amazed to find out that not one single book addressed it. Not a one. Honestly, I was shocked. I get asked this question many times at every single seminar, yet not one of these books even mentioned it. So then I started looking for how they work with 16-bit photos. Nothing. Well, one book mentioned it, but they basically said "it's not for you—it's for high-end pros with \$15,000 cameras." I just couldn't believe it—I was stunned. So I kept up my search for more topics I'd been asked about again and again, with the same results.

Well, I went ahead with my New York session as planned, and by all accounts it was a big hit. I had photographer after photographer coming up to tell me, "Thank you so much—those are exactly the things I was hoping to learn." That's when I realized that there's a book missing—a book for people who already know how to shoot, they even know what they want to do in Photoshop; they just need somebody to show them how to do it. Somebody to show them how to deal with the special challenges (and amazing opportunities) of using digital photos with Photoshop. I was so excited, because I knew in my heart I could write that book.

So now I had intentions

The day after the seminar I flew home and immediately called my Editor at New Riders (we'll call him "Steve" because, well...that's his name), and I said, "I know what I want my next book to be—a Photoshop book for digital photographers." There was a long uncomfortable pause. Steve's a great guy, and he really knows this industry, but I could tell he was choking a bit on this one. He politely said, "Really, a digital photography book, huh?" It was clear he wasn't nearly as excited about this concept as I was (and that's being kind). He finally said, "Ya know, there are already plenty of digital photography books out there," and I agreed with him, because I just about went broke buying them all. So now I had to convince my Editor that not only was this a good idea, but that it was such a good idea that he should put our other book projects on hold so I could write this book, of which there are (as he put it) "already plenty of digital photography books out there."

INTRODUCTION (continued)

Here's what I told my Editor about what would be different about my digital photography book:

- (1) It's not a digital photography book; it's a Photoshop book. One that's aimed at professional and high-end prosumer photographers who either have gone digital, or are just moving to digital. There'd be no discussion of film (gasp!), f-stops, lenses, or how to frame a photo. If they don't already know how to shoot, this book just won't be for them. (Note: Editors hate it when you start listing the people the book won't be appropriate for. They want to hear, "It's perfect for everybody! From grandma right up to White House press photographers," but sadly, this book just isn't.)
- (2) I would skip the "Here's What a Digital Camera Is" section and the "Here's Which Printer to Buy" section, because they were in all those other books that I bought. Instead, I'd start the book at the moment the photo comes into Photoshop from the camera.
- (3) It would work the way digital photographers really work—in the order they work—starting with sorting and categorizing photos from the shoot, dealing with common digital photography problems, color correcting the photos, selecting and masking parts of the photo, retouching critical areas, adding photographic special effects, sharpening their photos, and then showing the final work to the client for approval.
- (4) It wouldn't be another Photoshop book that focuses on explaining every aspect of every dialog box. No sirree—instead, this book would do something different—it would show them how to do it! This is what makes it different. It would show photographers step-by-step how to do all those things they keep asking at my seminars, sending me emails about, and posting questions about in our forums—it would "show them how to do it!"

For example, I told Steve that about every Photoshop book out there includes info on the Unsharp Mask filter. They all talk about what the Amount, Radius, and Threshold sliders do, and how those settings affect the pixels. They all do that. But you know what they generally don't do? They don't give you any actual settings to use! Usually, not even a starting point. Some provide "numerical ranges to work within," but basically they explain how the filter works, and then leave it up to you to develop your own settings. I told him I wouldn't do that. I would flat-out give them some great Unsharp Mask filter settings—the same settings used by many professionals, even though I know some highfalutin Photoshop expert might take issue with them. I would come out and say, "Hey, use this setting when sharpening people. Use this setting to correct slightly out-of-focus photos. Use this setting on landscapes, etc." I give students in my live seminars these settings, so why shouldn't I share them in my book? He agreed. I also told him that sharpening is much more than just using the Unsharp Mask filter, and it's much more important to photographers than the three or four pages every other book dedicates to it. I wanted to do an entire chapter showing all the different sharpening techniques, step-by-step, giving different solutions for different sharpening challenges.

I told him about the File Browser, and how there's so much to it, it's just about a separate program unto itself, yet nobody's really covering the things photographers are telling me they need to know—like automatically renaming their digital camera photos with names that make sense. Other books mention that you can do that in the File Browser—I want to be the guy that "shows them how to do it!" I want a whole chapter just on the File Browser.

Steve was starting to come on board with the idea. What he didn't want was the same thing I didn't want—another digital photography book that rehashes what every other digital photography and Photoshop book has already done. Well,

xiv

Steve went with the idea, and thanks to him, you're holding the book that I am so genuinely excited to be able to bring you. But the way the book was developed beyond that took it further than Steve or I had planned.

How the book was developed

When Steve gave me the final approval (it was more like, "Okay, but this better be good or we'll both be greeting people by saying, 'Would you like to try one of our Extra Value Meals today?'"), I sat down with two of the industry's top digital photographers—commercial product photographer Jim DiVitale and fashion photographer Kevin Ames—to get their input on the book. These two guys are amazing—they both split their time between shooting for some of the world's largest corporations, and teaching other professional digital photographers how to pull off Photoshop miracles at events such as PhotoshopWorld and PPA/PEI's Digital Conference, and a host of other events around the world.

We spent hours hammering out which techniques would have to be included in the book, and I can't tell you how helpful and insightful their input was. This wasn't an easy task, because I wanted to include a range of techniques wide enough that it would be accessible to "prosumers" (the industry term to describe serious high-end amateurs who use serious cameras and take serious shots, yet don't do photography for a living), but at the same time, I wanted high-end professionals to feel right at home with techniques that are clearly just for them, at their stage of the game.

Does this make the book too advanced?

Absolutely not. That's because my goal is to present all these techniques in such a simple, easy-to-understand format that no matter where you are in your Photoshop skills, you'll read the technique and rather than thinking, "Oh, I could never pull that off," you'll think, "Hey, I can do that."

Although it's true that this book includes many advanced techniques, just because a technique is advanced, doesn't mean it has to be complicated or "hard to pull off." It just means that you'll be further along in the learning process before you'd even know you need that technique.

For example, in the retouching chapter, I show how to use the Healing Brush to completely remove wrinkles, and that's what many photographers will do—completely remove all visible wrinkles. But an advanced Photoshop user might retouch the photo differently, because they know that a 79-year-old man's face shouldn't be as wrinkle-free as Ben Affleck's. When they do a similar retouch, they're not going to remove every wrinkle—instead, they'll be looking for a way to just lower the intensity of the wrinkles, so the portrait looks more natural (and the photo appears unretouched). To do that, they'll need something beyond the basic Healing Brush technique—they'll need a more advanced technique that may require a few more steps along the way, but produces far better results.

So, how hard is it to do the advanced "healing" technique we just talked about? It's simple—duplicate the Background layer, remove all the wrinkles using the Healing Brush, and then lower that layer's Opacity a bit to bring back some of the original wrinkles from the layer underneath (see page 184). It works like a charm, but really—how complicated is that? Heck, anyone that's used Photoshop for a week can duplicate a layer and lower the Opacity, right? Right. Yet few photographers know this simple, advanced technique. That's what this book is all about.

If you understand that line of thinking, you'll really get a lot out of this book. You'll be able to perform every single technique. You'll be putting to use the same advanced correction and retouching techniques employed by some of today's leading digital photographers; yet you'll make it all look easy, because it really is easy, and it's a lot of fun—once somebody shows you how to do it.

Continued

INTRODUCTION (continued)

So what's not in this book?

There are some things I intentionally didn't put in this book. Like punctuation marks (kidding). No, seriously, I tried not to put things in this book that are already in every other Photoshop book out there. For example, I don't have a chapter on the Layers palette, or a chapter on the painting tools, or a chapter showing how each of Photoshop's 102 filters looks when it's applied to the same photograph. I also didn't include a chapter on printing to your color inkjet because (a) every Photoshop book does that, and (b) every printer uses different printer driver software; if I showed an Epson color inkjet workflow, you can bet you'd have an HP or a Canon printer (or vice versa) and then you'd just get mad at me. I also didn't include a chapter on color management because every Photoshop book has one (go look on your shelf and you'll see), but beyond that, a chapter on color management just doesn't cover it—that topic needs its own book (and if you want the best one on the subject, check out *Real World Color Management* by Bruce Fraser, Fred Bunting, and Chris Murphy, from Peachpit Press; ISBN: 0201773406).

What does this "For Pros Only" logo mean?

It means "Go away—this isn't for you!" (Kidding.) Actually, it's a "heads-up" to people who are farther along in their skills, and are looking for more advanced techniques. What it isn't is a "this is hard" warning. It just means that as you get better in Photoshop, these are the techniques you're going to want to

consider next, because although they usually include more steps and take a little longer, they provide more professional results (even though the difference may be subtle).

Is this book for you?

I can't tell you that for sure, so let's take a simple yet amazingly accurate test that will determine without a doubt if this book is for you. Please answer the following questions:

- (1) Are you a photographer?
- (2) Do you now, or will you soon have a digital camera?
- (3) Do you now, or will you soon have Adobe Photoshop?
- (4) Do you now, or will you soon have \$39.99 (the retail price of this book)?

Scoring: If you answered "Yes" to question #4, then yes, this book is for you. If you answered "Yes" to questions 1, 2, or 3, that certainly is a good indicator, too.

Is this book for Windows users, Mac users, or both?

Because Photoshop is identical on Windows and on the Mac, the book is designed for both platforms. However, the keyboard on a PC is slightly different from the keyboard on a Mac, so any time I give a keyboard shortcut in the book, I give both the PC and Mac keyboard shortcuts. See, I care.

How should you use this book?

You can treat this as a "jump-in-anywhere" book because I didn't write it as a "build on what you learned in Chapter 1" type of book. For example, if you just bought this book and you want to learn how to whiten someone's teeth for a portrait you're retouching, you can just turn to page 202, and you'll be able to follow along and do it immediately. That's because I spell everything out. Don't let that throw you if you're a longtime Photoshop user; I had to do it because although some of the people that will buy this book are gifted, talented, and amazing traditional photographers, since they're just now "going digital," they may not know anything about Photoshop. I didn't want to leave them out or make it hard for them, so I really spell things out like "Go under the Image menu, under Adjustments, and choose Curves" rather than just writing "Open Curves." However, I did put the chapters in an order that follows a typical correction, editing, and retouching process, so you might find it useful to start with Chapter 1 and move your way through the book in sequence.

The important thing is that wherever you start, have fun with it, and even more importantly, tell your friends about it so I can recoup the \$1.2 million I spent on all those digital photography books.

Wait, one more thing! You can download the photos used in the book.

Most of the photos used in this book are available for you to download from the book's companion Web site at www.scottkelbybooks.com/new/DigitalPhoto.html. Of course, the whole idea is that you'd use these techniques on your own photos, but if you want to practice on these, I won't tell anybody. Okay, now turn the page and get to work!

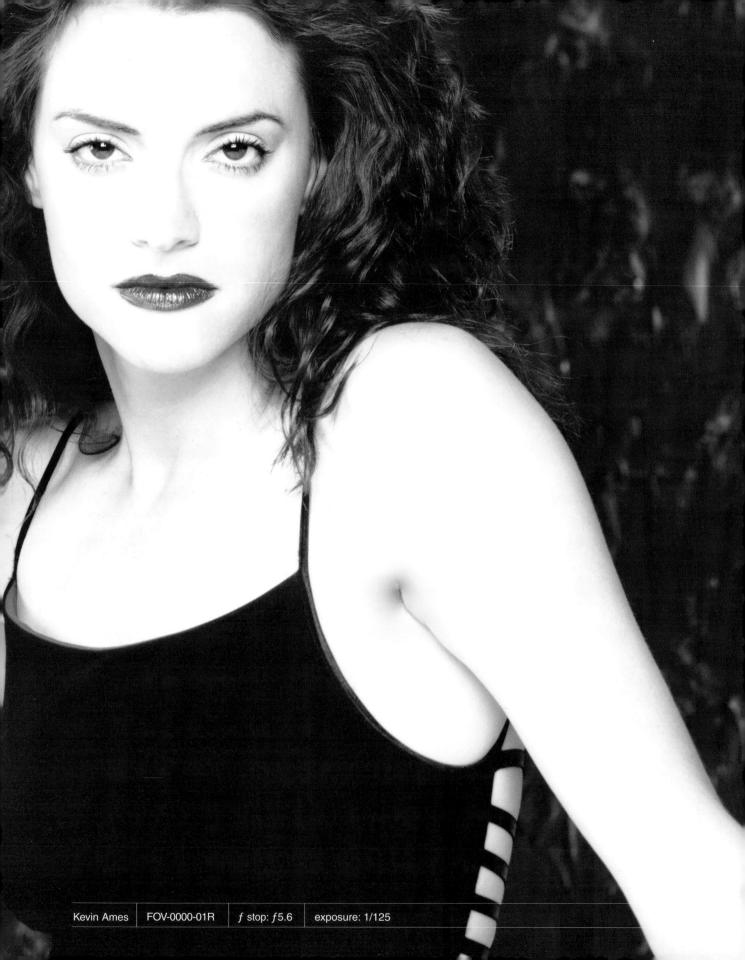

At first, you might not think that Photoshop's File Browser deserves its own chapter, but when you look at all the things it's done for the community (including taking meals to other software applications that

Start Me Up mastering the file browser

are less fortunate), you realize it probably does deserve it after all. Especially when you take into consideration the fact that the File Browser all by itself is probably more powerful than many standalone products, like the Whopper (that computer in the movie War Games with Matthew Broderick) or Microsoft Office 2000. Sure, the Whopper could simulate a Soviet First Strike, but frankly, it was pretty lame at sorting and categorizing your photos (as is Microsoft Office). In fact, I'm not sure the Whopper could sort or categorize photos at all, which is probably why no Photoshop book to date has a chapter on the Whopper. You'd think that with all the cool things the File Browser does, surely at least one Photoshop book out there would dedicate a chapter to it, right? Well, not as far as I've found. So I set out to do just that—really dig into the meat of the Browser, uncover its hidden power, and see if once and for all it was really written by a man named Professor Faulken (this is precisely why they shouldn't let me write these chapter intros after 1:00 a.m.).

Saving Your Digital Negatives

Okay, I know this is the File Browser chapter, but there are just a couple of critically important things we have to do before we actually open Photoshop.

Step One:

Plug your card reader (CompactFlash card, Smartcard, etc.) into your computer and the images on the card will appear on your hard drive (as shown). Before you do anything else, before you even open Photoshop, you need to burn these photos to a CD. Don't open the photos, adjust them, choose your favorites, and *then* burn them to a CD—burn them now—right off the bat.

The reason this is so important is that these are your negatives—your digital negatives, which are no different than the negatives you'd get from a film lab after they process your film. By burning a CD now, before you enter Photoshop, you're creating a set of digital negatives that can never be accidentally erased or discarded—you'll always have these "digital negatives."

Now, what if you don't have a CD burner? That's easy—buy one. It's that critical, and such a key part of your digital setup. Luckily, burning CDs has become so fast, inexpensive (you can buy blank, writable CD discs for around 10¢ each), and easy-to-do that you can't afford to skip this step, especially if you're a professional photographer.

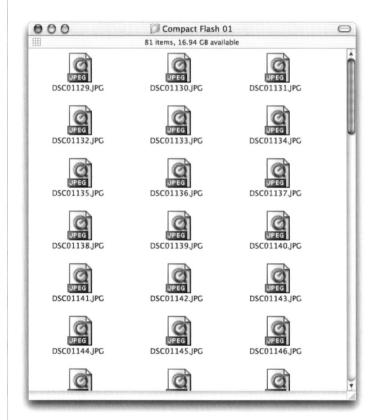

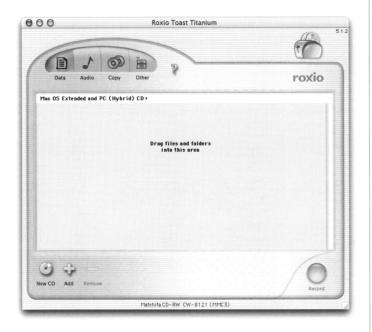

Step Two:

My personal favorite CD-burning software is Roxio Toast Titanium (its interface is shown at left). It's become very popular, partially because its easy-to-use drag-and-drop interface is a real timesaver. Here's how it works: Select all the images from your card reader, then click-and-drag the whole bunch into the Toast data window.

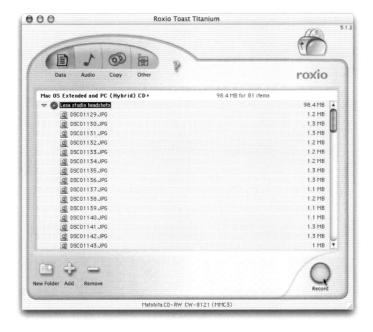

Step Three:

After your images appear in the Toast data window, double-click on the tiny CD icon in the window and give your disc a name (you can see the name highlighted in the example at left). Then simply click the Record button and Toast does the rest, leaving you with a reliable, protected set of digital negatives. If you're the extra careful type (read as "paranoid"), you can burn yourself another copy to keep as a second backup. There's no loss of quality, so burn as many copies as you need to feel secure (remember, just because you're paranoid, doesn't mean they're not out to get you).

Creating a Contact Sheet for Your CD

All right, your CD of "digital negatives" is burned, but before you go any further, you can save yourself a lot of time and frustration down the road if you create a CD jewel-box-sized contact sheet now. That way, when you pick up the CD, you'll see exactly what's on the disc before you even insert it into your computer. Luckily, the process of creating this contact sheet is automated, and after you make a few decisions on how you want your contact sheet to look, Photoshop takes it from there.

Step One:

Go under the File menu, under
Automate, and choose Contact Sheet II.

(Note: People frequently ask me why it's called "Contact Sheet II," rather than just Contact Sheet. It's because it's the second version of Contact Sheet. When Adobe first introduced this feature back in Photoshop 5.5, it was, well...pretty lame [and that's being kind]. So when they updated and improved it in the Photoshop 6 release, my guess is that Adobe was afraid people who had tried the previous Contact Sheet wouldn't try it again, so they added "II" to the name to let people know this was kind of like a version 2.0.)

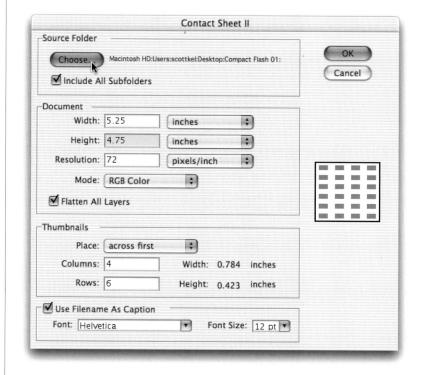

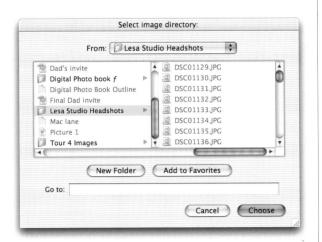

Contact Sheet II Source Folder OK Macintosh HD:Users:scottkel:Desktop:Compact Flash 01 Choose... Cancel Include All Subfolders -Document Width: 4.75 inches . Height: 4.75 inches * Resolution: 72 pixels/inch ---Mode: RGB Color Flatten All Layers -Thumbnails . Place: across first Columns: 6 Width: 0.784 inches Rows: 6 Height: 0.423 inches ✓ Use Filename As Caption Font Size: 12 pt Font: Helvetica

Step Two:

When the Contact Sheet II dialog appears (opposite page), under the Source Folder section, click the Choose button and the standard Open dialog will appear (shown at left). Navigate to your newly burned CD and click the Choose button in your Select dialog. This tells Photoshop to make your contact sheet from the images on your CD.

Step Three:

The rest of the dialog is for you to pick how you want your contact sheet to look. Under the Document section of the dialog, enter the Width and Height of your jewel box cover (the standard size is 4.75" x 4.75") and the Resolution for your images. (I usually choose a low resolution of 72 ppi because the thumbnails wind up being so small, they don't need to be a high resolution, and Contact Sheet runs faster with low-res images.)

I also leave the Mode as RGB (the default), and I choose to Flatten All Layers; that way I don't end up with a large multi-layered Photoshop document. I just want a document that I can print once and then delete.

The Thumbnails section is perhaps the most important part of this dialog, because this is where you choose the layout for your contact sheet's thumbnails (Columns and Rows). Luckily, Adobe put a preview box on the far-right side of the

Continued

dialog, using little gray boxes to represent how your thumbnails will look. Change the number of Rows or Columns, and this live preview will give you an idea of how your layout will look.

Finally, at the bottom of the dialog, you can decide if you want to have Photoshop print the file's name below each thumbnail on your contact sheet. I strongly recommend leaving this feature turned on. Here's why:

One day you may have to go back to this CD looking for a photo. The thumbnail will let you see if the photo you're looking for is on this CD (so you've narrowed your search a bit), but if there's no name below the image, you'll have to launch Photoshop and use the Browser to search through every photo to locate the exact one you saw on the cover.

However, if you spot the photo on the cover *and* see its name, then you just open Photoshop, and then open that file. Believe me, it's one of those things that will keep you from ripping your hair out by the roots, one by one.

There's also a pop-up menu for choosing from a handful of fonts and font sizes for your thumbnail captions. The font choices are somewhat lame, but believe me, they're better than what was offered in the original Contact Sheet, so count your blessings.

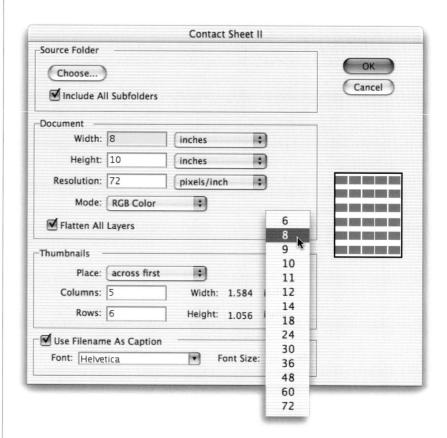

When you put a lot of thumbnails on your contact sheet, you'll need to make the font size smaller, or you'll see only the first few characters.

Here's the same contact sheet with a much smaller font size. Not only can you now read the full name, but the thumbnails are larger too.

TIP: When you're choosing a font size for your thumbnail captions, make sure you decrease the default size of 12 to something significantly lower. This is because of the long file names assigned to the images from your digital camera. In this example, I had to lower the font size to 6 to actually be able to read the entire file name under each thumbnail. If I left the font size at the default of 12, you'd get the result shown at left, where you see only the first few letters of the file name, making the whole naming thing pretty much useless. So how small should you make your type? The more thumbnails you're fitting on your contact sheet, the smaller you'll need to make the font size. Also note that in the contact sheet to the left, the thumbnails themselves are actually smaller than the thumbnails below left because they need to make room for the larger 12-point type.

Step Four:

Now all you have to do is click OK, sit back, and let Photoshop do its thing. (It may take up to two and half hours to create a single contact sheet. Kidding! Had you going there, didn't !?) It only takes a minute or so, and when you're done, you're left with a contact sheet like the one shown at right, with rows of thumbnails and each photo's file name appearing as captions below its thumbnail.

Step Five:

This is more like a tip than a step, but a number of photographers add a second contact sheet to make it even easier to track down the exact image they're looking for. It's based on the premise that in every roll (digital or otherwise), there's usually one or two key shots—two really good "keepers" that will normally be the ones you'll go searching for on this disc (after all, it's pretty rare to shoot 30 or 40 shots and each one of them is just fantastic. Usually, there's a couple of great ones, 15 or so that are "okay," and the rest shall never see the light of day, so to speak). So what they do is make an additional contact sheet that either becomes the front cover of the jewel case (with the regular contact sheet on the inside cover of the case), or vice versa (the regular contact sheet is visible

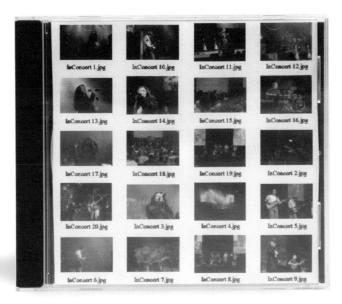

on the outside of the jewel case, and this additional contact sheet is on the inside). They create this additional contact sheet manually and only include the one or two key photos from that roll, along with a description of the shots, to make finding the right image even easier. The capture shown on the previous page (bottom) shows a two-photo contact sheet for the cover of the CD jewel case.

Step Six:

Here's the final result, after the contact sheet has been printed and fitted to your CD jewel case.

Browser Basics

Okay, we've burned our CD and we've created our contact sheet to keep track of all our images, so now we're going to open the images right from the CD using the File Browser (which is what we use to sort and categorize our digital camera images).

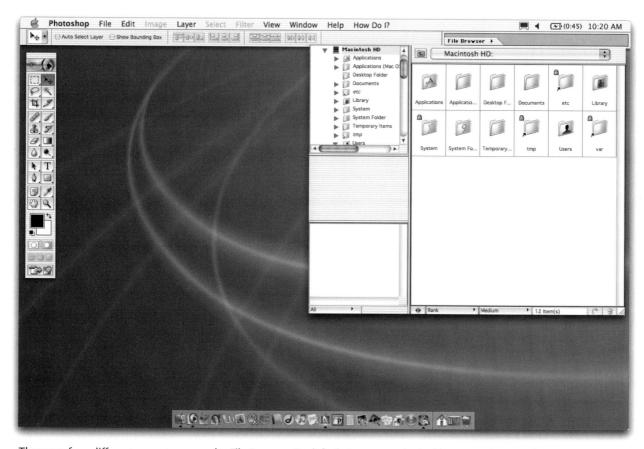

There are four different ways to access the File Browser. By default, it appears docked in your Palette Well near the top of your screen in the far right of the Options Bar (unless you're working at a resolution of 800x600; in that case, the Palette Well is not visible). To access the File Browser from the Palette Well, just click once on its tab (click directly on the word "File Browser"), and it pops down (as shown above). To tuck it away, just click on the tab again. It's pretty handy to just pop it down when you need it, and then quickly tuck it away in the Palette Well when you don't.

Other ways to access the Browser:

Personally, I prefer to have the Browser floating onscreen, like a palette in its own separate window. To access the File Browser as its own separate palette, go under the File menu and choose Browse. An even quicker way is to use the keyboard shortcut Shift-Command-O (PC: Shift-Control-O), or you can even open it from the Window menu by choosing File Browser.

Undocking/re-docking the File Browser:

Here's one that gets a lot of people stuck—you've opened the Browser as its own separate palette, and now you want to put it back in the Palette Well. Here's the problem—where's the tab? Can you drag it back up there if you can't find the tab? Ahhhhh. (Gotcha!) Actually, it's pretty easy (if you know where to look). Just choose Dock to Palette Well from the Browser's pop-down menu (found by clicking on the right-facing triangle at the top right of the File Browser palette).

Thumbnail generation extraordinaire:

One of the main features that I love about the File Browser is that it does something wonderful to digital camera images—it automatically creates full-color thumbnails of any images you open within it. For example, when you open a folder or CD of images, for just a moment you'll see the generic icons (as shown at right), just as you would if you opened the memory card from your computer. As you can see, when it comes to finding an image, these generic icons are basically worthless.

However, in just a second or two, Photoshop automatically generates gorgeous thumbnails in their place (below right). Photoshop is pretty quick about it too, but obviously the more images you have, the longer it will take (it could take up to three or four seconds), but believe me—it's worth the wait. Also, it builds thumbnails from the top down, so even though you see thumbnails in your main window, if you scroll down, the thumbnails further down could still be drawing-just be patient and they'll appear (coming soon to a Browser window near you!).

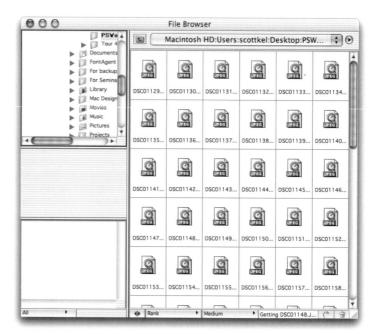

The File Browser takes the lame default icons and transforms them into...

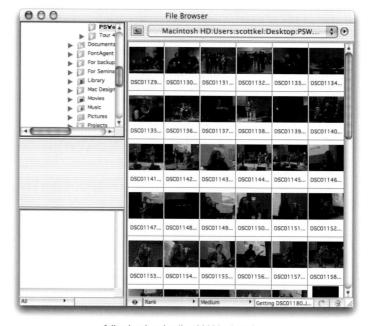

...full-color thumbnails. Ahhhhh, that's better!

If you look at either picture on the left-hand page, you can see that the Browser is divided into four different "panels," and each panel has its own set of features and functions. Here's a quick look at the four panels, and the essential techniques you'll need to get the most out of the Browser.

Browser Essentials

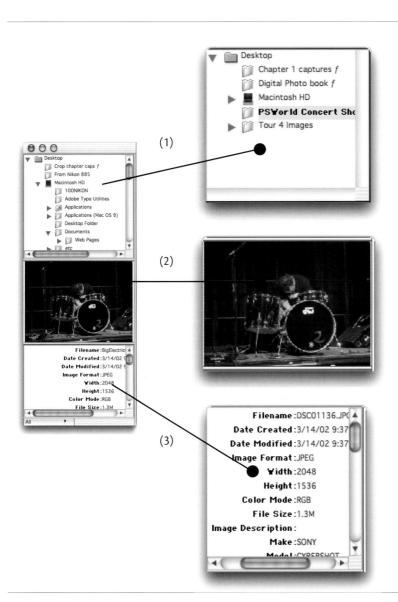

(1) NAVIGATION: The top-left panel is designed to let you navigate to your digital camera's memory card, to your hard drive, a CD of images (hint, hint), a network drive—you name it. The idea behind this is simple: It gives you access to your digital camera images without having to leave Photoshop. You can sort images by dragging thumbnails directly into folders that appear in this panel.

TIP: If you hold Option (PC: Alt) as you drag, you'll send a copy there, rather than the original.

- (2) PREVIEW: The area directly below the navigation pane shows you a larger preview of your currently selected thumbnail. I've got a cool tip for using this preview, so check it out in the left column of page 20.
- (3) DATA WINDOW: The bottom-left panel displays the EXIF data (Exchangeable Image File data) that's automatically embedded into your photo by your digital camera. This data gives background details on your image, including size, resolution, and camera settings. Plus, Photoshop adds some info to this panel as well (called meta data), so you're getting the EXIF data and

Continued

Photoshop's embedded meta data, as well. What Photoshop adds is pretty minor: the file's name, the date the Photoshop file was created, when it was last modified, the size (in pixels), which file format it's saved in, etc. This is followed by the EXIF data, whose first entry is the make of the camera that shot the image.

If you prefer to see just the EXIF data and not the other info that Photoshop throws in, you can ask that only the EXIF data be displayed by changing the popup menu just below the data window from "All" to "EXIF."

TIP: If you're not working in the File Browser but you want to view the EXIF data for the currently open image, you can—just go under the File menu and choose File Info. When the dialog appears, choose EXIF from the Section pop-up menu at the top (as shown at right).

EXIF's brain dump:

So how much information does the EXIF data really have about your image? Probably more than you'd care to know. It knows the make and model of the camera that took the shot, the exposure setting, F-stop, whether or not your flash fired, your ISO speed, whether you've bought any dotcom IPOs, seen any UFOs, or have a 401(k). Shown here is the ALL setting: Photoshop's info and the EXIf data.

TIP: Before we leave the "left-column" panels, I wanted to give you one more quick tip: When you click on any thumbnail image (in the main window, which we'll cover next), a larger preview of that thumbnail appears in the center of the left column. The problem is that this preview, while larger than the thumbnails, just doesn't seem large enough. But the cool thing is, you can increase its size. If you look at the captures at right, you'll see a divider bar between each of the four panels. These bars are moveable, and if you drag them upward, downward, or to the right of the preview area, the preview itself will grow to fill in the space, giving you a much larger and more useful preview.

The default preview is pretty small (left column, center).

But it doesn't have to stay like that! Slide the divider bars above and below the preview, and the preview grows to fill the space. Drag the divider to the right of the Preview panel, and it grows to fill that space as well.

* 81 Item(s) (* 🔐

(4) THUMBNAIL VIEW PANEL (sometimes called Desktop View Window): The fourth panel (and the one you'll work with most) is the thumbnail window (it's the entire right side of the Browser), which displays thumbnail views of your photos.

If you click on a thumbnail within this panel, a black line appears around the thumbnail (as shown at left), letting you know it's selected, and its preview is displayed in the Preview panel in the left column of the Browser. If you want to open the full-size image in Photoshop, just double-click on it.

You can select multiple photos to open at the same time by clicking on the first photo you want to open, holding the Command key (PC: Control key), and then clicking on any other photos. You can select entire rows by clicking on the first thumbnail in a row, holding the Shift key, and clicking on the last photo in that row.

You can navigate from thumbnail to thumbnail by using the Arrow keys on your keyboard.

Thumbnail View options:

There's a display View By pop-up menu at the bottom of this panel that lets you decide how large you want your thumbnails to be displayed. In the captures we've shown thus far, I've had the view set to Medium. In the capture shown at left, I switched the thumbnail view to Large, and you can see what a big difference that makes.

Continued

Viewing things your way:

The default setup for your Browser isn't the only option for how your Browser looks and displays its data. One of the most popular views hides the Navigation pane, the Preview pane, and the EXIF data pane, leaving just the thumbnails in view. This is particularly effective if you've set your thumbnail view size to Large, because at this larger size, the Preview pane becomes much less important. To view just the thumbnails, either:

(a) choose Expanded View from the popdown menu to "uncheck" (turn off) this feature (it's on by default), or

(b) click the two-headed arrow at the bottom of the thumbnails, to the immediate left of the Sort By pop-up menu (as shown below).

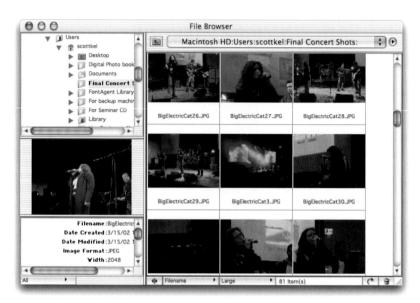

Here's the standard default layout (notice that only three thumbnails across are visible in this default layout).

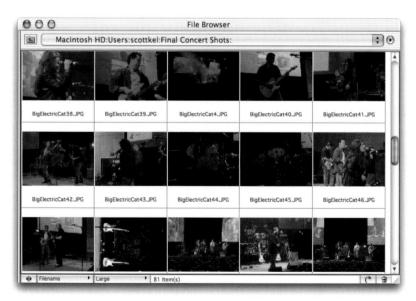

By turning off "Expanded View," you now get five rows across in the exact same amount of space.

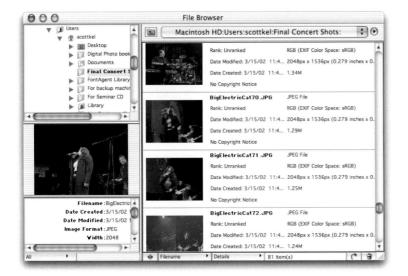

Getting the details:

There's another layout view for your Browser window, and this particular view is very popular with professional photographers because not only does it display the thumbnail at a large size, but to the right of the thumbnail, it also displays pertinent information about the photo.

To switch to the Details view, simply choose Details from the Browser's pop-down menu (as shown above).

Organizing Your Images Using the File Browser

Besides having the luxury of actually seeing your images before you open them in Photoshop, perhaps the most useful function of the File Browser is to help you sort and categorize your photos from right within Photoshop.

Think of it this way: When you open a group of photos, you're probably going to get a mixed bag—some great shots, some decent shots, and some you know are destined for the trash (out of focus, boring, bad lighting, etc. In short, they were "born to die"). By "ranking" your photos, you can have the best photos appear at the top of the Browser, followed by the second best, third best, and so on.

Step One:

At the bottom of the File Browser, change the View By pop-up to "Large with Rank" (as shown at right). This way, when you rank your photos, you'll be able to see its rank displayed below each thumbnail.

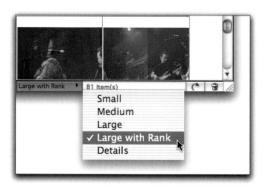

Step Two:

To the immediate left of the View By pop-up menu is a menu that lets you decide how your thumbnails are sorted. By default, it sorts them alphabetically by file name. Click on this pop-up menu and choose Rank to have your photos sorted by rank (putting the "A" images at the top of the Browser, followed by the Bs, Cs, etc.).

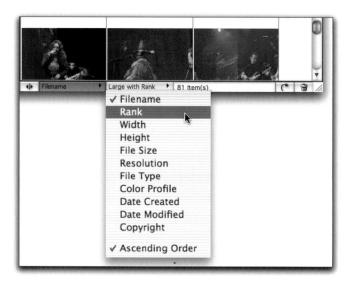

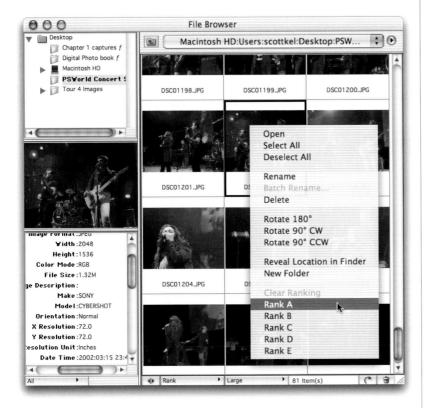

To rank a photo, just Control-click (PC: Right-click) on the thumbnail in the Browser, and a pop-up menu of rankings will appear. Just make your choice from the menu and release the mouse. You'll see your ranking appear right along with the thumbnail.

TIP: You'd expect that if you rank a file as "A," it would jump to the top of the list, right? Nope. That would be way too easy. Once you've ranked your images, they stay right in the same order they were (which gives you the impression that ranking is just about useless) until you do something Adobe calls "Refreshing the Desktop View." You can do that by either:

- (a) Choosing Refresh Desktop View from the File Browser's popdown menu, or
- (b) Pressing F5 on your keyboard (the hidden shortcut for "Refresh the Desktop View"). You can also refresh by choosing Rank again from the Sort By pop-up menu.

Step Four:

What do you do if an image is so bad that not only do you not want to rank it, you want it out of your Browser and fast? Just click on the file, press Option-Delete (PC: Delete), and the Browser immediately sends that file outside of Photoshop and straight to the Trash (PC: Recycling Bin), where it will helplessly remain until you end its sad little life by emptying the Trash (Recycling Bin).

Continued

TIP: Other ways to rank

If you don't like the A, B, C ranking system supplied by Adobe, you can click to the right of the word "Rank" below the thumbnail and that field will become highlighted. Now you can type in any word or number, and then refresh the Browser. The photos will then be ranked alphabetically. For example, you could type in "Keepers" for the good images and "Garbage" for the bad ones; but there's a catch—the letter "g" comes before the letter "k," so your File Browser will rank your "Garbage" shots at the top and your "Keepers" at the bottom.

Want a quick fix? When you choose Rank from the Sort By pop-up menu, also uncheck "Ascending Order" from the bottom of that menu (as shown at right). Now ranking is in reverse alphabetical order, so "Keepers" would appear before "Garbage."

Canceling your rankings:

If you have your photos ranked and decide, for whatever reason, that you want to clear the decks and start over—enter all new rankings from scratch—you can very easily. Just select the photos whose rankings you want to clear, then choose Clear Ranking from the Browser's pop-down menu (as shown at right). You'll get the obligatory, "Are you sure you want to do this?" warning dialog, and if you do indeed want to clear the ranks of the selected photos, just click Yes. You can also choose Clear Ranking by Control-clicking (PC: Right-clicking) within a thumbnail, and then choosing it from the resulting pop-up menu.

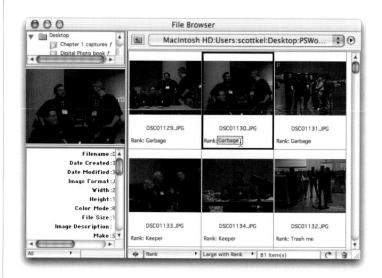

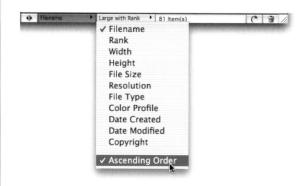

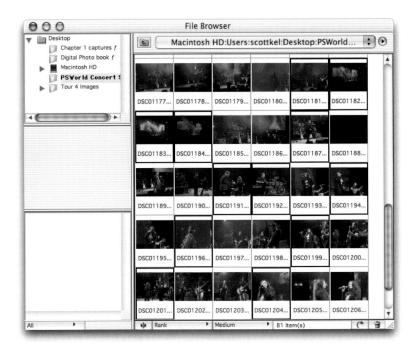

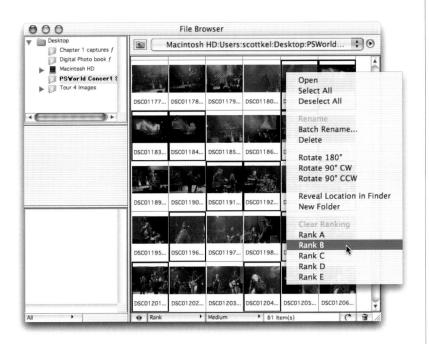

Okay, now that you've learned how to rank a file, what happens if you need to rank 30 or 40 images the same? Well, my friend, you're about to enter a world of earthly delights that dare not speak its name, because you are about to learn the closely guarded, super-secret, hidden-deep-within-CIA-files technique of Batch Ranking. Things will never be the same.

Batch Ranking:

With Batch Ranking, you're able to select multiple images that you want to share the same rank and assign that rank to all of them at once. Here's a step-by-step:

Step One:

Hold the Command key (PC: Control key) and click on all the photos you want to share the same rank (they will appear highlighted, as shown above left).

Step Two:

Control-click (PC: Right-click) on any selected image, and from the pop-up menu that appears, choose your desired ranking (I ranked them "B" in this example).

Continued

Press F5 on your keyboard (the shortcut for Refresh Desktop View), and all the selected images will now be reordered according to their new ranking (as shown right).

All right, are you ready to take this thing to a whole new level? I thought so; but, the next thing I'm going to show you is so mind-blowing that it's been known to cause momentary hysterical blindness in laboratory test rats (at least ones that use Photoshop).

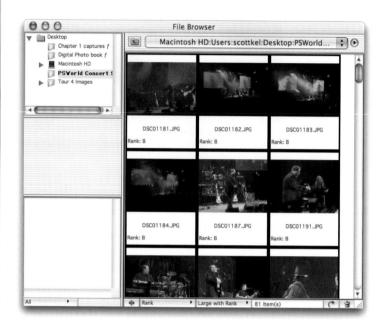

The File Browser will actually let you change the name of an entire folder (or disc) full of images, so your digital camera photo names are no longer the cryptic "DSC01181.JPG," "DSC01182.JPG," and "DSC01183.JPG" variety, but names you choose that will be more recognizable, such as "Concert Shot 1," "Concert Shot 2," "Concert Shot 3," etc.—and best of all, the whole process is automated. (Incidentally, this is particularly helpful when you're working off your CD, because you can have it create a duplicate folder of these photos on your hard drive with the new names.) Here's a step-by-step:

Batch Renaming Your Files

Step One:

You can hold the Command key (PC: Control key) and click on only the photos you want to rename, but a more likely scenario is that you'll want to rename all the photos open in your Browser, so go under the Browser's pop-down menu and choose Select All (as shown at left).

Step Two:

After you have selected all the photos that you want to rename, go under the Browser's pop-down menu again, but this time choose Batch Rename.

When the Batch Rename dialog appears, you first need to choose a destination for these renamed photos. Your choices are limited to either renaming the photos in the same folder where they reside (if you're working off a CD of saved originals, this really isn't a choice), or what you'll probably choose for the Destination Folder is "Move to new folder." If you choose "Move to new folder," you'll need to click the Choose button (as shown at right), and in the resulting dialog, navigate to the folder you want your photos moved into after they're renamed.

One limitation of Batch Renaming is that it either renames your originals or moves them to a new folder. I wish there was an option where Photoshop would make copies (leaving the originals untouched) and rename only the copies; but at this point, there's not.

Step Four:

Under the File Naming section of the dialog, the first field on the top left is where you type in the name you've chosen (in the example shown here, I'm renaming the files "BigElectricCat," which is the name of the band shown in the photos). Just click your cursor in this field, and type in the name.

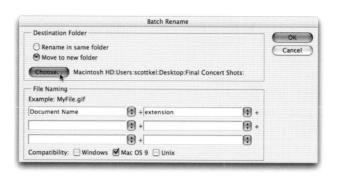

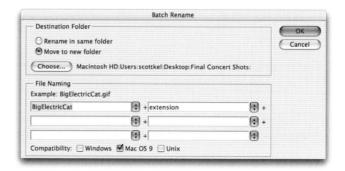

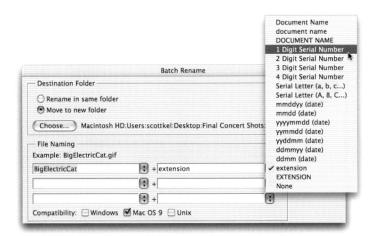

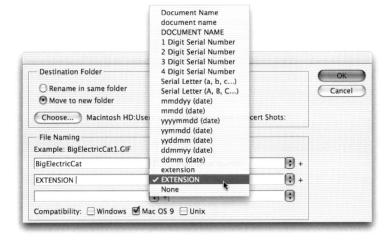

Step Five:

The next field to the right is where you tell Photoshop the numbering scheme you'd like to use following the name you assigned (after all, you can't have more than one file in the same folder named "BigElectricCat." Instead, you'd need them to be named "BigElectricCat1," "BigElectricCat2," etc.). To use Photoshop's built-in auto-numbering, click-and-hold on the pop-up menu to the immediate right of the field, and the pop-up menu shown at left will appear. Here you can choose to number your photos with a 1- to 4-digit serial number, letters, or by date. In our example, we'll choose "1 Digit Serial Number" to have Photoshop automatically add a sequential number after the name, starting with "1."

Step Six:

You can choose to add a file extension (either in caps by choosing "EXTENSION" from the pop-up menu, or in all lowercase by choosing "extension"). If your files are JPEG files, Photoshop will automatically add the .jpg extension to every saved file. There are three other naming fields, just in case you're really anal about naming your files.

NOTE: If you're concerned about making a mistake when you rename your files, don't be, because directly below the File Naming section header is a live example of what your file name will look like.

FREAK-OUT WARNING: Don't let it freak you out that it always shows .gif as the file extension, even though your file is a JPEG—it's just using .gif to let you know that you chose an extension to be added. The real extension it adds will be based on the file format of the files you chose to rename. So if your files are in JPEG format, Photoshop will add the .jpg extension, not .gif as the live example shows. This FOW (Freak-Out Warning) is based on actual realworld testing and evaluation (meaning the first time it happened to me, I freaked out).

Step Seven:

When you click OK, Photoshop does its thing, and in just a few seconds, your photos will appear in the new folder sporting their brand-new names.

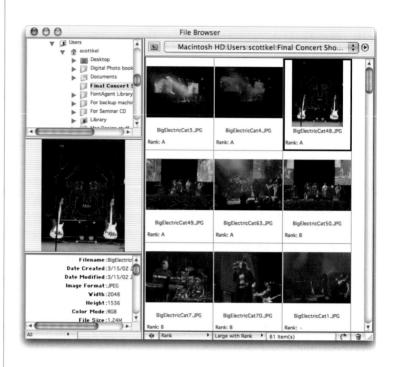

Right within the File Browser you can make a number of edits to your images that can save you time later when you actually open the images in Photoshop. Here are some of the edits you can perform:

Editing in the Browser

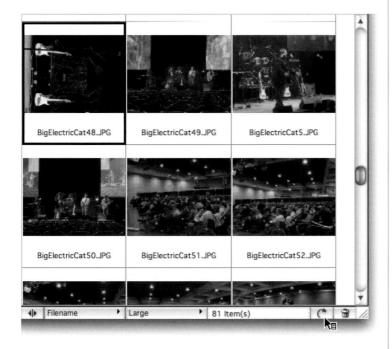

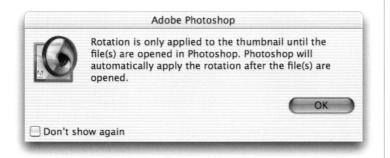

Rotation:

Near the bottom-right corner of the Browser next to the Trash icon is a button with a little circular arrow on it. Clicking it rotates the currently selected photo in the Browser 90° clockwise. This is incredibly handy if you turned the camera vertically for a tall (portrait) shot rather than a wide (landscape) shot. When these tall photos originally appear within the browser, you'll see them lying on their side, and they'll need to be rotated until they're right side up (which, incidentally, may take three clicks of the rotation button. depending on which way the photo is facing).

When you rotate an image in the Browser, Photoshop gives you a warning dialog (shown at left) telling you that it's just rotating the preview thumbnail, and not actually rotating the file itself. So the rotation of this photo won't really take place until you actually double-click on the file to open it in Photoshop; then it rotates the way you want it.

Continued

TIP: You can save yourself some clicks when rotating your image with this little shortcut: Hold the Option key (PC: Alt key), and then click on the rotation button. This will rotate the image counterclockwise (rather than the default rotation of clockwise), letting you correct that "sideways" picture in just one click. If you forget the shortcut, you can always choose Rotate 90° CCW from the pop-down menu (shown at right).

Deleting photos:

If you burned a CD when you first inserted your memory card (and I know you did, because now you know how important it is to keep your negatives safely stored), then delete any image you don't want by clicking on the thumbnail within the Browser and dragging it to the Trash icon at the bottom-right corner of the window.

You can also use the keyboard shortcut I shared earlier: Click on the file to be deleted and press Option-Delete (PC: Delete key only), and that file will be moved to your Trash (PC: Recycling Bin) until you choose to "Empty the Trash."

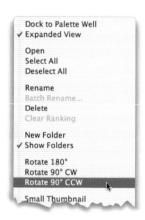

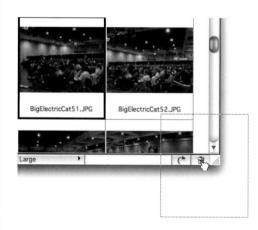

Here's where I reveal the bad news: the secret "dark side" of the Browser that winds up burning a lot of users who don't really understand what the Browser is doing. First the secret, and then we'll look at how to deal with it.

Not Getting "Burned" by the Browser

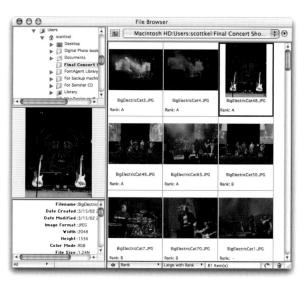

Here are the sorted images, with their rankings, rotations, etc.

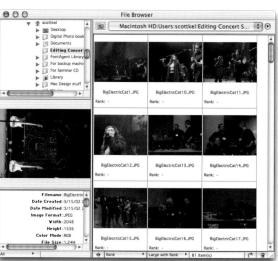

You burn the file to CD and open the exact same images, and all the ranking, rotations, deletions, and other edits are completely gone. This stinks! It's rude, it's uneconomical, yet entirely avoidable—just read the text on the right.

The scenario I'm about to describe has happened to untold thousands of nice people like yourself: You go into the Browser, you rotate certain images, you click on names of certain images and change them, you delete others, and get everything just the way you want it, and then you burn your newly edited images to a CD. A couple of weeks go by and you pop that CD in, open it in your Browser, and all your changes (names, rotation, deleted files, etc.) are GONE! It's as if you just pulled the images in from your camera—you lost all your changes! Has this already happened to you? Perhaps to someone you know, a loved one or other disinterested party? It doesn't have to be this way. You can avoid all the heartache and personal trauma. How? Don't use the Browser anymore (kidding—totally a joke). Here's the deal: The changes you make in the Browser window itself are actually stored within a memory cache, kind of an invisible text file that tells Photoshop "this file is rotated, that one has been deleted, this one is now named 'Frank's party,' etc." As long as your images stay in the same folder they were created in, Photoshop will be able to read that cache file, and when you open that file months later, it remembers all the changes you made. However, if you burn those images to

Continued

CD, or put them on a different hard drive, on a network, a Zip disk, or even rename the folder—that breaks the link to the cache, and you lose all the changes.

Luckily, there's a way around this. Before you move these images (into a new folder, onto a CD, to a different hard drive, etc.), go to the Browser's pop-down menu and choose Export Cache. Photoshop acknowledges that the Cache has been exported with a message dialog. Exporting the Cache creates two visible files within the folder that contain all the edits you made in the Browser.

Because these two files are now visible (as shown below right), you can copy them right along with all your photos, onto another drive, another folder, a CD etc., and by doing that, you're sending along your list of edits made in Photoshop's Browser. That way, when you (or your Italian confidential secretary) open those images in Photoshop's Browser at a later date, all the changes you made will be intact.

IMPORTANT NOTE:

If you export your cache, and then update these images in your Browser, you have to Export your Cache again—it doesn't update automatically.

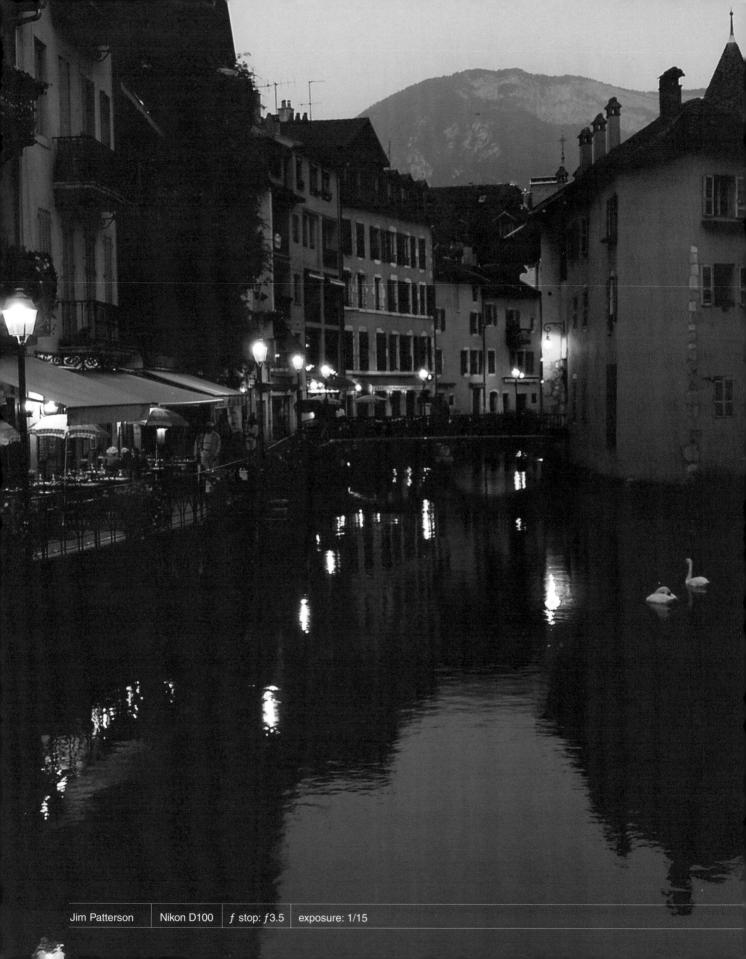

If a chapter on cropping and resizing doesn't sound exciting, really, what does? It's sad, but a good portion of our lives is spent doing just that—cropping and resizing. Why is that? It's because nothing, and

Cream of the Crop cropping and resizing

I mean nothing, is ever the right size. Think about it. If everything were already the right size, there'd be no opportunity to "Super Size it." You'd go to McDonald's, order a Value Meal, and instead of hearing, "Would you care to Super Size your order?" there would just be a long, uncomfortable pause. And frankly, I'm uncomfortable enough at the McDonald's drive-thru, what with all the cropping and resizing I'm constantly doing. Anyway, although having a chapter on cropping and resizing isn't the kind of thing that sells books (though I hear books on crop circles do fairly well), both are important and necessary, especially if you ever plan on cropping or resizing things in Photoshop. Actually, you'll be happy to learn that there's more than just cropping and resizing in this chapter. That's right—I super-sized the chapter with other cool techniques that honestly are probably a bit too cool to wind up in a chapter called "Cropping and Resizing," but it's the only place they'd fit. But don't let the extra techniques throw you; if this chapter seems too long to you, flip to the end of the chapter and rip out a few pages, and you have effectively cropped the chapter down to size. (And by ripping the pages out yourself, you have transformed what was originally a mere book into an "interactive experience," which thereby enhances the value of the book, making you feel like a pretty darn smart shopper.) See, it almost makes you want to read it now, doesn't it?

Photoshop's dialog for creating new documents has a pop-up menu with a list of Preset Sizes. You're probably thinking, "Hey, there's a 4x6, 5x7, and 8x10—I'm set." The problem is there's no way to switch the orientation of these presets (so a 4x6 will always be a 4" tall by 6" wide portrait-oriented document). That's why creating your own custom new document sizes is so important. Here's how:

Step One:

Go under the File menu and choose New. When the New dialog box appears, click on the Preset Sizes pop-up menu to reveal the list of preset sizes.

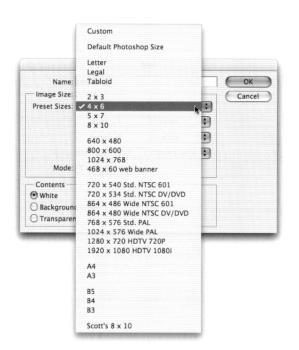

Step Two:

Go ahead and hit Cancel in the New dialog (now that you've seen the preset list where you'll be adding your own custom settings) instead of actually creating a document. Now, find the Photoshop folder on your hard drive. Inside that folder, you'll find a folder called Presets, and in that folder you'll find a text document named New Doc Sizes.txt.

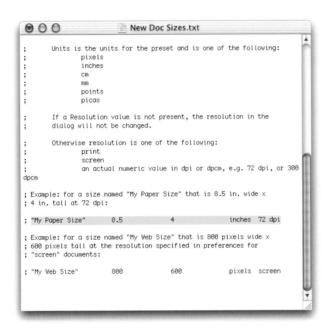

```
000
                         New Doc Sizes.txt
       Units is the units for the preset and is one of the following:
               pixels
               inches
               cm
               points
               nicas
       If a Resolution value is not present, the resolution in the
       dialog will not be changed.
       Otherwise resolution is one of the following:
               an actual numeric value in dpi or dpcm, e.g. 72 dpi, or 300
: Example: for a size named "My Paper Size" that is 8.5 in. wide x
; 4 in. tall at 72 dpi:
; "My Paper Size"
                                                      inches 72 dpi
; Example: for a size named "My Web Size" that is 800 pixels wide x
; 600 pixels tall at the resolution specified in preferences for
; "screen" documents:
; "My Web Size"
                                      600
                                                      pixels screen
"My Paper Size" 8.5
                                     inches 72 dpi
```

Double-click on that text document to open it in your word processor or other text editor. Scroll to the bottom of the document and vou'll see some examples of how to create your own presets. Rather than trying to decipher the instructions in this document, just highlight the line of text that starts out "My Paper Size." Don't get the semicolon (;) at the beginning of the line; start with the opening quote and highlight down to the last letter of "dpi." Now press Command-C (PC: Control-C) to copy that selected text. Note: If you accidentally select the semicolon, it won't work. Also, if you miss the opening quote, it won't work, so make sure you've selected that text exactly as shown at left.

Step Four:

Now go to the very last line in the document, the one that begins "My Web Size," and click your cursor once right after the letter "n" in the word "screen" at the end of the line. Press Return (PC: Enter) twice to move down two lines, and then press Command-V (PC: Control-V) to paste the line you copied earlier into this space (as shown at left).

Step Five:

The hard part's over—now all you have to do is highlight the name "My Paper Size" (just the words, not the quotes around them), and then type in the name that you want for your custom preset (for example, we'll call this one "Scott's 6"x4""), as shown at right. (Needless to say, don't start your preset name with "Scott's" unless your name happens to be Scott. If that's the case, then I applaud you for having such an unusually cool name.)

Step Six:

Next, highlight the 8.5 and type in your desired width (in this case, 6). Then highlight the 4 and type in...well, it's already a 4, but you won't always get that lucky (unless, of course, you're really into 4" height for everything). Note: Don't add a quote for inches after you enter your width or height settings because that will mess with the script and it won't work, so just enter the number with no inch marks.

```
New Doc Sizes.txt
        Units is the units for the preset and is one of the following:
                pixels
                inches
                cm
                points
                picas
       If a Resolution value is not present, the resolution in the
       dialog will not be changed.
       Otherwise resolution is one of the following:
               print
               screen
               an actual numeric value in dpi or dpcm, e.g. 72 dpi, or 300
dpcm
; Example: for a size named "My Paper Size" that is 8.5 in. wide \times
: 4 in. tall at 72 dpi:
; "My Paper Size"
; Example: for a size named "My Web Size" that is 800 pixels wide x
; 600 pixels tall at the resolution specified in preferences for
; "screen" documents:
; "My Web Size"
                       800
                                                       pixels screen
"Scott's 6"x4"" 8.5
                                               inches 72 doi
```

```
000
                          New Doc Sizes.txt
       Units is the units for the preset and is one of the following:
               pixels
               inches
               CM
               mm
               points
               picas
;
       If a Resolution value is not present, the resolution in the
       dialog will not be changed.
;
       Otherwise resolution is one of the following:
               print
               screen
               an actual numeric value in dpi or dpcm, e.g. 72 dpi, or 300
; Example: for a size named "My Paper Size" that is 8.5 in. wide \times
; 4 in. tall at 72 dpi:
; "My Paper Size"
                                                       inches 72 dpi
; Example: for a size named "My Web Size" that is 800 pixels wide x
; 600 pixels tall at the resolution specified in preferences for
; "screen" documents:
; "My Web Size"
                       800
                                       600
                                                       pixels screen
"Scott's 6"x4""
                                                       inches 72 dpi
```

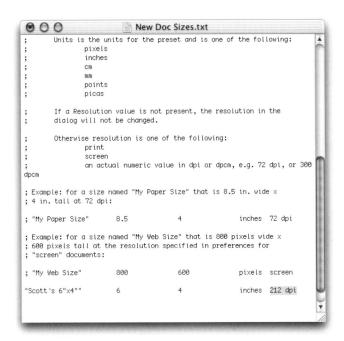

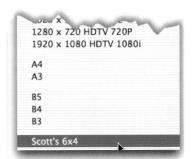

Step Seven:

In this case, because we're creating a new document that's measured in inches, we don't have to change the next word—it's already inches, but if you did want to change it to pixels, just highlight the word "inches" and replace it with the word "pixels." Of course, you can type in any unit of measurement, if you're so inclined, such as picas, millimeters, centimeters, kilometers, miles, acres, and so on. (Okay, you can't really enter kilometers, miles, or acres. I just wanted to see if you were paying attention.)

Next, you need to choose a resolution, so highlight the number that appears before "dpi." Here, we've changed it to "212" for print. For low-res or the Web you can leave it at "72."

Now, save this file and close it. In OS X, be sure to save as plain Text. That's it, nothing fancy—just save and close.

Step Eight:

This last step is critically important. You must quit Photoshop and restart for your custom presets to appear. This one catches a lot of people, so don't forget to do it or you won't see your preset.

After you restart Photoshop, go under the File menu and choose New, and when you click the Preset Sizes pop-up menu, scroll all the way to the bottom and there your new custom preset will appear. (I know what you're thinking: Shouldn't my custom settings appear at the top of the list, rather than all the way at the bottom? Yup. That'd be nice. Sadly, that's just not the way it works.)

Cropping Photos

After you've sorted your images in the Browser, one of the first editing tasks you'll probably undertake is cropping a photo. There are a number of different ways to crop a photo in Photoshop. We'll start with the basic garden variety, and then we'll look at some ways to make the task faster and easier.

MothCaterplr @ 12.5% (CMYK)

Step One:

Press the letter "c" to get the Crop tool (you could always select it directly from the Toolbox, but I only recommend doing so if you're charging by the hour).

Step Two:

Click within your photo and drag out a cropping border (as shown at right). The area to be cropped away will appear dimmed (shaded). You don't have to worry about getting your crop border right when you first drag it out, because you can edit the border by dragging the points that appear in each corner and at the center of all four sides.

TIP: If you don't like seeing your photo with the cropped away areas appearing shaded (as in the previous step), you can toggle this shading feature off/on by pressing the Forward Slash key on your keyboard. When you press the Forward Slash key, the border remains in place but the shading is turned off (as shown at left).

Step Three:

While you have the crop border in place, you can rotate the entire border by moving your cursor outside the border (note the cursor's position in the lower-right corner of the image shown here at left), and when you do, the cursor changes into a double-headed arrow. Just click-and-drag and the cropping border will rotate in the direction that you drag (this is a great way to save time if you have a crooked image, because it lets you crop and rotate at the same time).

Step Four:

After you have the cropping border where you want it, just press the Return key (PC: Enter key) to crop (the final cropped photo is shown at right).

TIP: Changing your mind

If you've dragged out a cropping border and then decide you don't want to crop the image, there are three ways to cancel your crop:

- (1) Press the Escape (esc) key on your keyboard and the crop will be canceled and the photo will remain untouched.
- (2) Look up in the Options Bar and you'll see the International symbol for "No way" (as shown at right). Click the circle with the diagonal line through it to cancel your crop, or...
- (3) In the Toolbox, click on another tool. This will bring up a warning dialog asking if you want to crop the image. To cancel, don't press Cancel; press Don't Crop.

If you're outputting photos for clients, chances are they're going to want them in standard sizes so they can easily find frames to fit their photos. If that's the case, you'll find this technique handy, because it lets you crop any image to a predetermined size (like 5x7, 8x10, and so on).

Cropping to a Specific Size

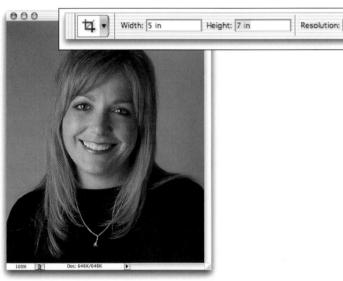

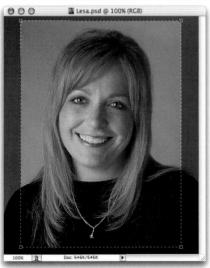

Step One:

The portrait shown here measures 5.917"x7.194" and we want to crop it to be a perfect 5"x7". First, get the Crop tool, and up in the Options Bar on the left you'll see fields for Width and Height. Enter the size you want for Width, followed by the unit of measurement you want to use (for example, use "in" for inches, "px" for pixels, "cm" for centimeters, "mm" for millimeters, etc.). Next, press the Tab key to jump over to the Height field and enter your desired height, again followed by the unit of measurement (as shown in the inset at left).

Step Two:

After you've entered these figures in the Options Bar, click within your photo with the Crop tool and drag out a cropping border. You'll notice that as you drag, the border is constrained to a vertical shape and no side points are visible—only corner points. Whatever size you make your border, the area within that border will become a 5"x7" photo. In the example shown at left, I dragged the border so it almost touched the top and bottom, to get as much of the subject as possible.

Continued

After your cropping border is onscreen, you can reposition it by moving your cursor inside the border, and your cursor will change to a Move arrow. You can now drag the border into place, or use the Arrow keys on your keyboard for more precise control. When it looks right to you, press Return (PC: Enter) to finalize your crop, and the area inside your cropping border becomes 5"x7". (I made the rulers visible so you could see that the image measures exactly 5"x7".)

TIP: After you've entered a Width and Height in the Options Bar, those dimensions will remain there. To clear the fields, just choose the Crop tool, and up in the Options Bar, click on the Clear button (shown upper right). This will clear the Width and Height fields (as shown lower right), and now you can use the Crop tool for freeform cropping (you can drag it in any direction—it's no longer constrained to a vertical 5x7).

COOLER TIP: If you already have one photo that is the exact size and resolution you'd like, you can use it to enter the crop dimensions for you. First, open the photo you'd like to resize, and then open your "ideal-size-and-resolution" photo. Get the Crop tool, and then go up in the Options Bar and click on the Front Image button (as shown lower right). Photoshop will automatically input that photo's Width, Height, and Resolution in the Crop tool's fields. All you have to do is crop, and the other image will now share the exact same specs.

I know, we just learned how to use the Crop tool and now we're jumping into an advanced technique: creating your own custom tools. The reason is, it fits with what we're already doing. Although it's more of an advanced technique, it's not complicated. In fact, once you set it up, it will save you time and money. What we're going to do is create what are called Tool Presets. These Tool Presets are a series of tools (in this case, Crop tools) with all our option settings already in place. So we'll create a 5x7, an 8x10, a 6x4, or whatever Crop tool we want. Then, when we want to crop to 5x7, all we have to do is grab the 5x7 Crop tool. Here's how:

Creating Your Own Custom Crop Tools

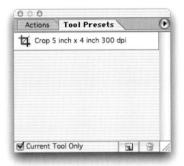

Width: 8 in Height: 10 in Resolution: pixels/inch

Step One:

Press the letter "c" to switch to the Crop tool, and then go under the Window menu and choose Tool Presets to bring up the Tool Presets palette (shown at left). By default, there's one Tool Preset already there, and unless you need a Crop tool that is 5 inches by 4 inches at 300 dpi, I'd drag this Tool Preset onto the Trash icon at the bottom of the palette, 'cause it just gets in the way. (Also, make sure that Current Tool Only is checked at the bottom of the palette, as shown. That way you'll only see Crop tools that we create, not the Presets for every tool that was put there by Adobe.)

Step Two:

Go up to the Options Bar and enter the dimensions for the first tool you want to create (in this example, we'll create a Crop tool that crops to an 8"x10" area). In the Width field, type 8. Press the Tab key to jump to the Height field and type 10 (as shown at left). Note: If you have your Rulers set to inches under the Units sections in Photoshop's Units & Rulers Preferences, then when you press the Tab key, Photoshop will automatically insert "in" after your numbers, indicating inches.

Continued

Go to the floating Tool Presets palette (the one you opened in Step One) and click the New Tool Preset button at the bottom of the palette (it looks like the New Layer button in the Layers palette). This brings up the New Tool Preset dialog where you can name your new preset. Name it "Crop to 8x10" and click OK.

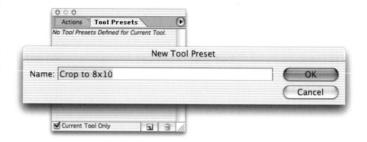

Step Four:

This new tool is added to the Tool Presets dialog (as shown at right).

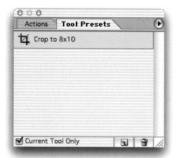

Step Five:

Continue this process of typing in new cropping dimensions in the Crop tool's Options Bar until you've created a set of custom Crop tools using the crop sizes you personally use the most. Make sure you make the names descriptive (add Portrait or Landscape, for example, where necessary).

TIP: If you need to change the name of a preset after you've created it, just double-click directly on the name to highlight it, and then type in the new name.

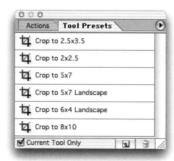

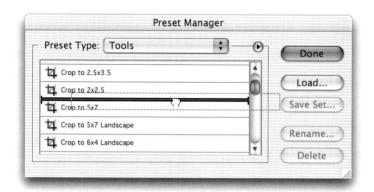

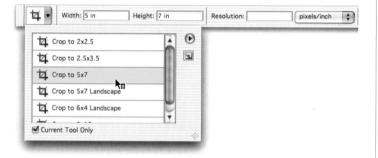

Step Six:

After you've created Tool Presets for all the custom Crop tools you'll need, chances are they won't be in the order you want them (it just works out that way). To reorder the tools the way you'd like them to appear, go under the Edit menu and choose Preset Manager. When it appears, choose Tools from the Preset Type pop-up menu, and scroll until you see the Crop tools you created. To reorder your tools, just click-and-drag them to where you want.

Step Seven:

After your tools are in your preferred order, you can close the Tool Presets palette because you don't actually need it to choose your tools. That's because there's an easier way: When you choose the Crop tool in the Toolbox, you can access your custom Crop tool presets from the Options Bar. Just click on the first icon from the left (as shown at left). A pop-down library of tools will appear and you can choose the one you want from there. As soon as you click on one, you'll see the Options Bar change to reflect the proper measurements, and now you can drag out the cropping marquee and it will be fixed to the exact dimensions you chose for that tool. Imagine how much time and effort this is going to save (really, close your eyes and imagine. Mmmmmm, Tool Presets. Yummy).

Cropping Without the Crop Tool

Sometimes it's quicker to crop your photo using some of Photoshop's other tools and features than it is to reach for the Crop tool every time you need a simple crop.

Step One:

This is the method I probably use the most for cropping images of all kinds (primarily, when I'm not trying to make a perfect 5x7, 8x10, and so on. I'm basically just "eyeing" it). Start by pressing "m" to get the Rectangular Marquee tool. (I use this tool so much that I usually don't have to switch to it—maybe that's why I use this method all the time.) Drag out a selection around the area you want to keep (leaving all the other areas to be cropped away outside the selection), as shown.

Step Two:

Go under the Image menu and choose Crop (as shown at right).

When you choose Crop, the image is immediately cropped (as shown). There are no crop handles and no dialogs—bang. It just gets cropped, down and dirty, and that's why I like it.

TIP: One instance of where you'll use the Crop command from the Image menu is when you're creating collages. When you drag photos from other documents onto your main document and position them within your collage, the parts of the image that extend beyond the document borders are actually still there. So to keep our file size manageable, we choose All from the Select menu (as shown) or press Command-A (PC: Control-A), and then we choose Crop from the Image menu. This deletes all the excess layer data that extends beyond the image border and brings our file size back in line.

Automated Close Cropping

Here's another handy method of cropping that doesn't use the Crop tool, and best of all, Photoshop does most of the work. It's used for situations where you want blank areas surrounding your image to be cropped away—perfect for product shots, tight cropping of Web graphics, or whenever you want your photo cropped as tightly as possible.

Step One:

Open the image you want to be "close cropped." In the example shown here, we have a product shot surrounded by white space.

Step Two:

Go under the Image menu and choose Trim.

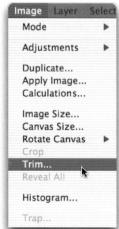

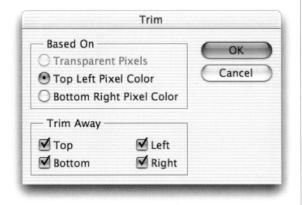

When the Trim dialog box appears, you can choose where you want the trimming (cropping) to occur (from the Top, Bottom, Left, or Right). By default, it will trim away blank areas from all sides. This is also where you tell Photoshop which color to trim away. In this case, the area to be trimmed away is white, so using the default "Top Left Pixel Color" will work just fine. In fact, 99% of the time, I don't change a single setting.

Step Four:

When you click OK, the photo will be close cropped (trimmed) down to the smallest possible size without deleting any non-white pixels (as shown at left).

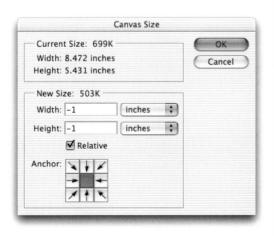

TIP: Clipping off unwanted areas

If you'd like to take 1" (or more) off your entire image, the easiest way might be to shrink the photo's canvas size. To do this, go under the Image menu and choose Canvas Size. When the Canvas Size dialog appears, click the Relative checkbox, and then enter -1 in both the Width and Height fields (as shown at left). When you click OK, you'll get a dialog warning you that this new canvas size will clip off part of your image, but that's okay; that's what we want. Click Proceed, and your image will be cropped in by 1" on all sides.

Using the Crop Tool to Add More Canvas Area

I know the heading at left doesn't make much sense—using the Crop tool to *add* more canvas area? How can the Crop tool (which is designed to crop photos to a smaller size) actually make the canvas area (white space) around your photo larger? That's what I'm going to show you.

Step One:

Open the image that you want to give additional blank canvas area. Press the letter "d" to set your Background color to its default color of white.

Step Two:

Press Command-minus (PC: Controlminus) to zoom out a bit (so your image doesn't take up your whole screen), and then press the letter "f." This lets you see the gray desktop area that surrounds your image (as shown at right).

Press the letter "c" to switch to the Crop tool, and drag a cropping marquee border out to any random size, as shown here (it doesn't matter how big or little the marquee is at this point).

Step Four:

Now, grab any one of the side or corner points and drag outside the image area, out into the gray desktop area that surrounds your image (as shown at left). The area that your cropping border extends outside the image is the area that will be added as white canvas space, so position it where you want to add the blank canvas space.

Step Five:

Now, just press the Return key (PC: Enter key) to finalize your crop, and when you do, the area outside your image will become white canvas area.

Straightening Crooked Photos

If you handhold the camera for most of your shots rather than using a tripod, you can be sure that some of your photos are going to come out a bit crooked. Here's a quick way to straighten them accurately in just a few short steps.

Step One:

Open the photo that needs straightening. Choose the Measure tool from Photoshop's Toolbox (it looks like a little ruler, and it's hidden behind the Eyedropper tool, so just click-and-hold for a moment on the Eyedropper tool until the Measure tool appears in the flyout menu).

Step Two:

Try to find something in your photo that you think is supposed to be straight (the window ledge in this example). Drag the Measure tool horizontally along this straight edge in your photo (as shown), starting from the left and extending right. As soon as you drag the tool, you can see the angle of the line displayed both in the Info palette (which will appear automatically) and up in the Options Bar, but you can ignore them both because Photoshop is already taking note of the angle and placing that info where you'll need it in the next step.

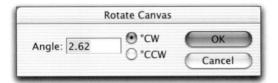

Go under the Image menu, under Rotate Canvas, and choose Arbitrary, and the Rotate Canvas dialog will appear. Photoshop has already put the proper angle of rotation you'll need to straighten the image (based on your measurement), and it even sets the button for whether the image should be rotated clockwise or counterclockwise.

Step Four:

All you have to do now is click OK, and your photo will be perfectly straightened. After the image is straight, you might have to re-crop it to keep any white space from showing around the corners of your photo.

TIP: When you use the Measure tool, the line it lays down stays put right over your photo until you rotate the image. If you want to clear the last measurement and remove the line it drew in your image, press the Clear button that appears up in the Options Bar.

Using a Visible Grid for Straightening Photos

Here's another popular technique for straightening photos that works particularly well when you're having trouble finding a straight edge within your image.

Step One:

Open a photo that needs straightening. (At right is a photo taken with a handheld Nikon digital camera, and as you can see, the image is tilted a bit to the right.)

Step Two:

Go under the View menu and make sure Extras is turned on, and then under Show in the View menu (it's just below Extras), choose Grid. The keyboard shortcut is Command-" (PC: Control-").

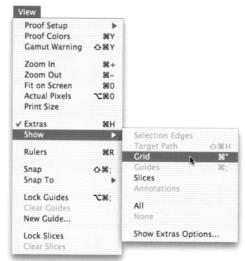

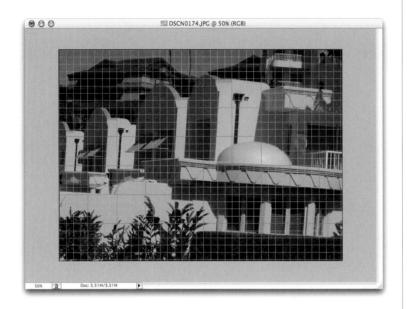

When you choose Show>Grid, Photoshop puts a non-printing grid of squares over your entire photo (as shown at left). Now, grab the bottomright corner of your image window and drag outward to reveal the gray canvas area around your photo.

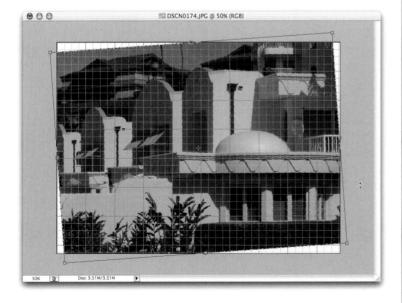

Step Four:

Press Command-A (PC: Control-A) to select the entire photo, and then press Command-T (PC: Control-T) to bring up the Free Transform bounding box around your photo. Move your cursor outside the bounding box and click-and-drag upward or downward to rotate your image (using the grid as a straight edge to align your image). If one of the horizontal grid lines isn't close enough to a part of your image that's supposed to be straight, just move your cursor inside the bounding box, and then use the Up/Down Arrow keys on your keyboard to temporarily nudge your photo up/down until it reaches a grid line.

Continued

TIP: If you want more control of your rotation (and this is particularly helpful when you're trying to align to a grid, rather than just "eyeing it"), try this: While you have Free Transform in place, go up to the Options Bar and click once inside the Rotation field (as shown at right). Then use the Up/Down arrow on your keyboard to rotate your photo in 1/10" increments, giving you maximum control.

Step Five:

Go back under the View menu, under Show, and choose Grid to remove the grid. After you remove the grid, you'll notice that there are white canvas areas visible in the corners of your image, so you'll have to crop the image to hide these from view.

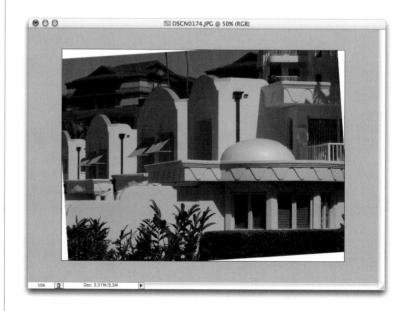

Step Six:

Press the letter "c" to switch to the Crop tool, and then drag out a cropping border that will crop your image so none of the white corners are showing. When your border is in place, press Return (PC: Enter). The final cropped image is shown at left.

TIP: When you're using the Grid, you can toggle it on and off by pressing Command-H (PC: Control-H), which is the shortcut for hiding Extras.

Resizing Digital Camera Photos

If you're used to resizing scans, you'll find that resizing images from digital cameras is a bit different, primarily because scanners create high-resolution scans (usually 300 ppi or more), but the default setting for digital cameras usually produces an image that is large in physical dimensions, but lower in ppi (usually 72 ppi). The trick is to decrease the size of your digital camera image (and increase its resolution) without losing any quality in your photo. Here's the trick:

Step One:

Open the digital camera image that you want to resize. Press Command-R (PC: Control-R) to make Photoshop's rulers visible. As you can see from the rulers, the photo is just a little more than 21" wide by nearly 28.5" high.

Step Two:

Go under the Image menu and choose Image Size to bring up the Image Size dialog box shown at right. Under the Document Size section, the Resolution setting is 72 pixels/inch (ppi). A resolution of 72 ppi is considered "low resolution" and is ideal for photos that will only be viewed onscreen (such as Web graphics, slideshows, and so on), but is too low to get high-quality results from a color inkjet printer, color laser printer, or for use on a printing press.

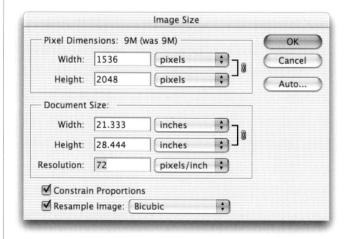

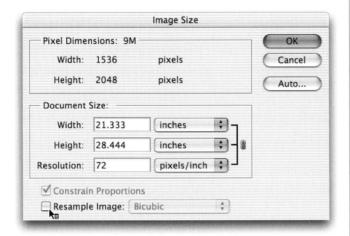

If we plan to output this photo to any printing device, it's pretty clear that we'll need to increase the resolution to get good results. I wish we could just type in the resolution we'd like it to be in the Resolution field (such as 200 or 300 ppi), but unfortunately, this "resampling" makes our low-resolution photo appear soft (blurry) and pixelated. That's why we need to turn the Resample Image checkbox off (it's on by default). That way, when we type in a resolution setting that we need, Photoshop automatically adjusts the Width and Height of the image down in the exact same proportion. As your Width and Height come down (with Resample Image turned off), your resolution goes up. Best of all, there's absolutely no loss of quality. Pretty cool!

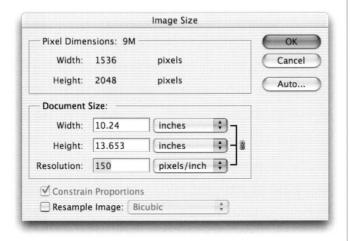

Step Four:

Here I've turned off Resample Image and I typed 150 in the Resolution field (for output to a color inkjet printer. I know, you probably think you need a lot more resolution, but you usually don't). At a resolution of only 150 ppi, I can actually print a photo that is 10.25" wide by almost 14" high.

Step Five:

Here's the Image Size dialog for our source photo, and this time I've increased the Resolution setting to 212 ppi (for output to a printing press. Again, you don't need nearly as much resolution as you'd think). As you can see, the Width of my image is no longer 21.333"—it's now just 7.245". The Height is no longer 28.444"—now it's 9.66".

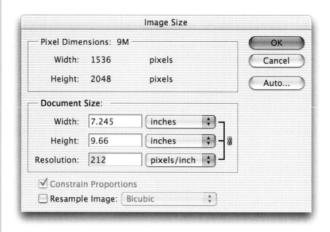

Step Six:

When you click OK, you won't see the image window change at all—it will appear at the exact same size on screen. But now look at the rulers. You can see that it's now just over 7" wide by 9.5" high.

Resizing using this technique does *three* big things: (1) It gets your physical dimensions down to size (the photo now fits on an 8x10 sheet); (2) it increases the resolution enough so you can output this image on a printing press; and (3) you haven't softened, blurred, or pixelated the image in any way—the quality remains the same—all because you turned off Resample Image.

NOTE: Do not turn off Resample Image for images that you scan on a scanner—they start as high-resolution images in the first place. Turning Resample Image off is only for photos taken with a digital camera.

What happens if you drag a large photo onto a smaller photo in Photoshop (this happens all the time, especially if you're collaging or combining two or more photos)? You have to resize the photo using Free Transform, right? Right. But here's the catch: When you bring up Free Transform, at least two, or more likely all four, of the handles you need to resize the image are out of reach. You see the center point (as shown in the photo below), but not the handles you need to reach to resize. Here's how to get around that hurdle quickly and easily.

Resizing and How to Reach Those Hidden Free Transform Handles

Step One:

In the example shown at left, we opened two photos and used the Move tool to drag one on top of the other (the photo that you drag appears on its own layer automatically). To resize a photo on a layer, press Command-T (PC: Control-T) to bring up the Free Transform function. Next, holding the Shift key (to constrain your proportions), grab one of the Free Transform corner points and (a) drag inward to shrink the photo, or (b) drag outward to increase its size (not more than 20%, to keep from making the photo look soft and pixelated). But the problem is, you can't even see the Free Transform handles in this image.

Step Two:

To instantly have full access to all of Free Transform's handles, just press Command-0 (PC: Control-0 [that's zero, not "O"]) and Photoshop will instantly zoom out your document window and surround your photo with gray canvas desktop, making every handle well within reach. Try it once, and you'll use this trick again and again. Note: You must choose Free Transform first for this trick to work.

Generally speaking, shrinking the physical dimensions of a photo does not create a quality problem—you can make an 8x10 into a 4x5 with little visible loss of quality. Increasing the size of an image is where you run into problems (the photo often gets visibly blurry, softer, and even pixelated). However, digital photography guru (and *Photoshop User* columnist) Jim DiVitale showed me a trick he swears by that lets you increase your digital camera images up to full poster size with hardly any visible loss of quality to the naked eye, and I tell ya, it'll make a believer out of you.

Step One:

Open the digital camera image you want to increase to poster size. The image shown here was taken with a 3-megapixel Nikon digital camera. It's physically 5.12" wide by 6.827" high, at 300 ppi.

Step Two:

Go under the Image menu and choose Image Size. When the Image Size dialog box appears, make sure Resample Image is turned on. Switch the unit of measurement pop-up menus in the dialog from Inches to Percent (as shown) and type in 110, which will increase your image by 10%. Believe it or not, when you increase in 10% increments, for some reason it doesn't seem to soften or blur the image. It's freaky, I know, but to believe it you just have to try it yourself.

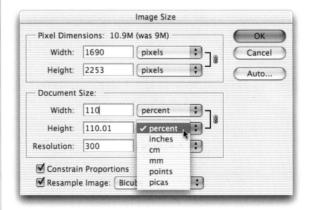

To get this image up to poster size, it's going to take quite a few passes with this "increase-by-10%" technique, so I recommend creating your own custom Action to do it for you at the press of one key. Here's how: Go under the Window menu and choose Actions. When the palette appears, click the Create New Action button at the bottom of the palette. When the New Action dialog appears, name your action "Upsize 110%," and then choose a Function Key (F-key) that you want to assign this Action to (I chose F11). Then, click the Record button and repeat Step Two. After you've increased 110%, click the square Stop button at the bottom of the Actions palette to complete your recording process. Now, every time you press the F11 Function Key (or the F-key you actually assign) on your keyboard, your current image will be increased by 10%.

Step Four:

Here's the final image, increased from approximately 5"x7" to approximately 18"x24," and even onscreen, the loss of quality is almost negligible, yet the image is the size of a standard, full-sized poster. I had to run the Action 12 times to get up to that size, but because I wrote an Action, it took only a fraction of the time (and trouble). Thanks to Jimmy D for sharing this amazing, yet deceptively simple technique with us. Jim rocks!

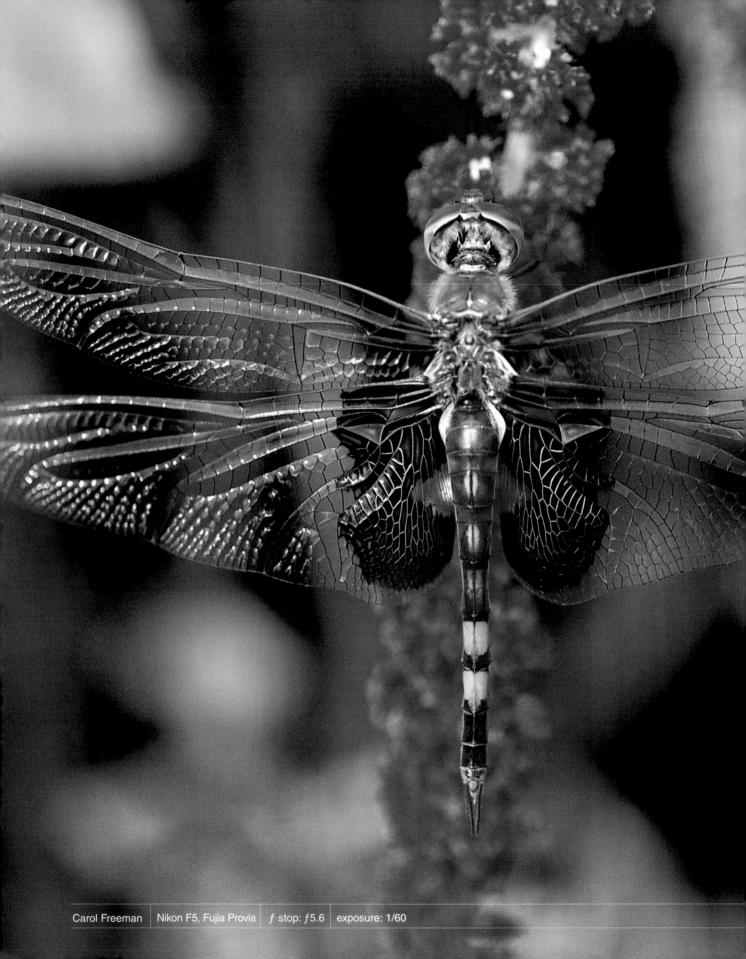

Okay, did you catch that reference to the band The Fixx in the title? You did? Great. That means that you're at least in your mid-thirties to early forties. (I myself am only in my mid- to early twenties, but I listen to oldies

The Big Fixx digital camera image problems

stations just to keep in touch with baby boomers and other people who at one time or another tried to break-dance.) Well, the Fixx had a big hit in the early '80s (around the time I was born) called "One Thing Leads to Another," and that's a totally appropriate title for this chapter because one thing (using a digital camera) leads to another (having to deal with things like digital noise, color aliasing, and other nasties that pop up when you've finally kicked the film habit and gone totally digital). Admittedly, some of the problems we bring upon ourselves (like leaving the lens cap on; or forgetting to bring our camera to the shoot, where the shoot is, who hired us, or what day it is; or we immersed our flash into a tub of Jell-O®, you know—the standard stuff). And other things are problems caused by the hardware itself (the slave won't fire when it's submerged in Jell-O[®], you got some Camembert on the lens, etc.). Whatever the problem, and regardless of whose fault it is, problems are going to happen, and you're going to need to fix them in Photoshop. Some of the fixes are easy, like running the "Remove Camembert" filter, and then changing the Blend Mode to Fromage. Others will have you jumping through some major Photoshop hoops, but fear not, the problems you'll most likely run into are all covered here in a step-by-step format that will have you wiping cold congealed water off your flash unit faster than you can say, "How can Scott possibly be in his mid-twenties?".

Compensating for "Too Much Flash"

Don't ya hate it when you open a photo and realize that either (a) the flash fired when it shouldn't have; (b) you were too close to the subject to use the flash and they're totally "blown out"; or (c) you're simply not qualified to use a flash at all, and your flash unit should be forcibly taken from you, even if that means ripping it from the camera body? Here's a quick fix to get your photo back from the "flash graveyard" while keeping your reputation, and camera parts, intact.

Step One:

Open the photo that is suffering from "flashaphobia." In the example shown here, the flash, mounted on the camera body, washed out the entire subject.

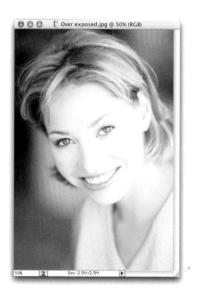

Step Two:

Make a copy of the photo by pressing Command-J (PC: Control-J). This will create a layer titled "Layer 1."

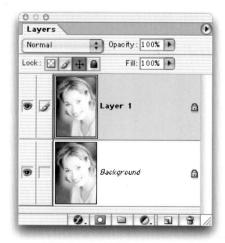

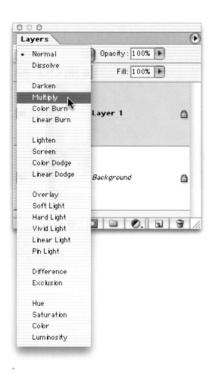

Next, change the Blend Mode of Layer 1 from Normal to Multiply from the popup menu at the top of the Layers palette. This Blend Mode has a "multiplier" effect, and brings back a lot of the original detail the flash "blew out."

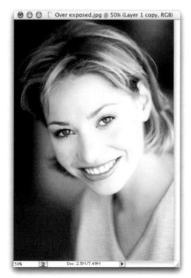

Step Four:

If the photo still looks washed out, you may need to make a duplicate of Layer 1. Just press Command-J (PC: Control-J), and this layer will be duplicated; this duplicate will already be in Multiply mode. Incidentally, because of the immutable laws of life, chances are that creating one layer with its Blend Mode set to Multiply won't be enough, but adding another layer (in Multiply mode) will be "too much." If that's the case, just go to the Layers palette and lower the Opacity setting of the top layer to 50% or less-this way, you can "dial in" just the right amount, and get the amount of flash looking right.

Dealing with Digital Noise

If you shoot in low-light situations, you're bound to encounter digital noise. Is there anything worse than these large red, green, and blue dots that appear all over your photo? Okay, besides that "crazy music" those teenagers play, like Limp Bizkit or...well...Limp Bizkit, is there anything worse? This digital noise (often called "Blue channel noise," "high ISO noise," "color aliasing," or just "those annoying red, green, and blue dots") can be reduced. Here's how:

Step One:

Open a photo that contains visible digital noise (in this case, it's a shot taken in low light, and those "red, green, and blue" dots appear throughout the photo).

Step Two:

Go under the Image menu, under Mode, and choose Lab Color. Switching to Lab Color is a non-destructive mode change, and won't damage your RGB photo in any way—you can switch back and forth between RGB and Lab Color any time. You won't see any visible difference in your image onscreen, but if you look up in the title bar for your document, you'll see "Lab" in parentheses, to let you know you're in Lab Color mode.

Step Three:

When you're in RGB mode, your image is made up of three channels: a Red, a Green, and a Blue channel. When these three are combined, they create a full-color photo. When you convert to Lab Color, Photoshop composes your photo differently—although it looks the same, it's now made up of a Lightness channel (the luminosity of the photo, where the detail is held) and two color channels, named "a" and "b." Go to the Channels palette and you'll see these channels. Click on the "a" channel (as shown).

Step Four:

Now that you're affecting only the "a" channel (which consists of color data), go under the Filter menu, under Blur, and choose Gaussian Blur. When the Gaussian Blur dialog appears (shown at left), increase the Radius (amount of blur) until you see the dots pretty much disappear, and then click OK. In this case, I increased the Radius to 2 pixels.

Step Five:

Now, in the Channels palette, click on the "b" channel (as shown at left). Press Command-F (PC: Control-F) to apply the Gaussian Blur filter to this "b" channel with the exact same setting we used on the "a" channel. Because you're using the re-apply shortcut, you won't see the Gaussian Blur dialog box—it will just automatically apply the filter for you.

Step Six:

Go back under the Image menu, under Mode, and choose RGB to return to RGB mode. You'll notice that the spots are much less pronounced because they no longer appear in red, green, and blue. You blurred the color channels, and by doing so, you eliminated those colors that are distracting to the eye. The effect appears much more muted, and in some cases (depending on the photo) will nearly disappear.

Removing Color **Aliasing**

Here's another quick trick Jim DiVitale and Kevin Ames use for reducing the color aliasing (digital noise) that often appears in digital photos shot in lowlighting situations.

Step One:

Open the photo that has visible color aliasing. Go under the Filter menu, under Blur, and choose Gaussian Blur. Drag the Radius slider all the way to the left, then start dragging to the right until the color aliasing is blurred enough that you can't see it. Click OK to apply the blur.

Step Two:

Go under the Edit menu and choose Fade Gaussian Blur. When the Fade dialog appears, change the Fade Mode to Color (as shown) and the color aliasing will disappear. It's quick, it's easy, and it works. It's also an ideal candidate for becoming an action, so you can remove color aliasing with just one click.

There's a natural tendency for some photographers to react to their immediate surroundings, rather than what they see through the lens. For example, if you're shooting an indoor concert, there are often hundreds of lights illuminating the stage. However, some photographers think it's one light short—their flash, because where they're sitting, it's dark. When you look at your photos later, you see that your flash lit everyone in front of you (which wasn't the way it really looked—the crowd is usually in the dark), which ruins an otherwise great shot. Here's a quick fix to make it look as if your flash never fired at all.

Fixing Photos Where You Wish You Hadn't **Used Flash**

Step One:

Open a photo where shooting with the flash has ruined part of the image (like the image shown here taken during a seminar presentation, where the back ten rows are lit by the flash, when they should be dark. Just the stage lit by the stage lighting should appear out of the darkness).

Step Two:

Press the letter "L" to get the Lasso tool, and draw a loose selection over the area where the flash affected the shot. In the image shown here, the lasso encompasses a number of rows in the back of the theater.

Continued

In the next step, we're going to adjust the tonal range of this selected area, but we don't want that adjustment to appear obvious. We'll need to soften the edges of our selection quite a bit so our adjustment blends in smoothly with the rest of the photo. To do this, go under the Select menu and choose Feather. When the Feather Selection dialog box appears, enter 25 pixels to soften the selection edge. (By the way, 25 pixels is just my guess for how much this particular selection might need. The rule of thumb is the higher the resolution of the image, the more feathering you'll need, so don't be afraid to use more than 25 if your edge is visible when you finish.)

Step Four:

It will help you make a better adjustment if you hide the selection border (we call it "the marching ants") from view. Note: We don't want to Deselect—we want our selection to remain intact but we don't want to see the annoying border, so press Command-H (PC: Control-H) to hide the selection border. Now, press Command-L (PC: Control-L) to bring up the Levels dialog. At the bottom of the dialog, drag the right Output Levels slider to the left to darken your selected area. Because you've hidden the selection border, it should be very easy to match the surroundings of your photo by just dragging this slider to your left.

Step Five:

When the photo looks about right, click OK to apply your Levels adjustment. Then, press Command-H (PC: Control-H) to make your selection visible again (this trips up a lot of people who, since they don't see the selection anymore, forget it's there, and then nothing reacts as it should from that point on).

Step Six:

Last, press Command-D (PC: Control-D) to Deselect and view your repaired "flash-free" photo.

Fixing Underexposed Photos

This is a tonal correction for people who don't like making tonal corrections (over 60 million Americans suffer from the paralyzing fear of MTC [Making Tonal Corrections]). Since this technique requires no knowledge of Levels or Curves, it's very popular, and even though it's incredibly simple to perform, it does a pretty incredible job of fixing underexposed photos.

Step One:

Open an underexposed photo. The photo shown here, shot indoors without a flash, could've used either a fill flash or a better exposure setting.

Step Two:

Press Command-J (PC: Control-J) to duplicate your Background layer (this duplicate will be named Layer 1 by default). On this new layer, change the Blend Mode in the Layers palette from Normal to Screen to lighten the entire photo.

If the photo still isn't properly exposed, just press Command-J (PC: Control-J) and duplicate this Screen layer until the exposure looks about right (this may take a few layers, but don't be shy about it—keep copying layers until it looks right).

Step Four:

There's a good chance that at some point your photo will still look a bit underexposed, so you'll duplicate the layer again, but now it looks overexposed. What you need is "half a layer." Half as much lightening. Here's what to do: Lower the Opacity of your top layer to "dial in" the perfect amount of light, giving you something between the full intensity of the layer (at 100%) and no layer at all (at 0%). For half the intensity, try 50% (did I really even have to say that last line? Didn't think so). Once the photo looks properly exposed, choose Flatten Image from the Layers palette's popdown menu.

When You Forget to Use Fill Flash

Wouldn't it be great if Photoshop had a "fill flash" brush, so when you forgot to use your fill flash, you could just paint it in? Well, although it's not technically called the fill flash brush, you can create your own brush and get the same effect. Here's how:

Step One:

Open a photo where the subject or focus of the image appears in shadows. Go under the Image menu, under Adjustments, and choose Levels.

Step Two:

Drag the middle Input Levels slider (the gray one) to the left until your subject looks properly exposed. (Note: Don't worry about how the background looks—it will probably become completely "blown out," but you'll fix that later; for now, just focus on making your subject look right.) If the midtone slider doesn't bring out the subject enough, you may have to increase the highlights as well, so drag the far-right Input Levels slider to the left to increase the highlights. When your subject looks properly exposed, click OK.

Go under the Window menu and choose History to bring up the History palette. This palette keeps a running "history" of the last 20 adjustments you've made to your photo. In this instance, there should be only two entries (called "History States"). Open should be the first State, followed by Levels, showing that you opened the photo and then made a Levels adjustment.

Step Four:

In the History palette, click on the State named "Open." This will return your photo to how it looked when you originally opened the image (in other words, it will look the way it did before you adjusted the Levels).

Step Five:

In the History palette, click in the first column next to the grayed-out State named "Levels." An icon that looks like Photoshop's History Brush will appear in the column, showing that you're going to be painting from what your image looked like after you used Levels.

Step Six:

Choose the History Brush tool from the Toolbox (as shown at right), and choose a soft-edged brush from the Brush Picker in the Options Bar.

Step Seven:

Begin painting with the History Brush over your subject, avoiding the background area entirely. (Here, I'm painting over the left side of the subject's face.) As you paint, you'll notice that you're actually painting in the lightened version of the subject you adjusted earlier with Levels.

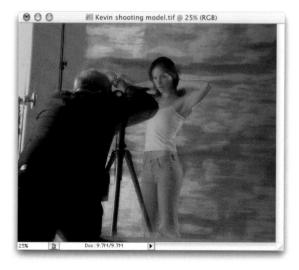

Step Eight:

Continue painting with the History Brush until your subject looks as if you used a fill flash. When you're painting, if it appears too intense, just lower the Opacity of the History Brush up in the Options Bar. That way, when you paint, the effect will appear less intense. You can see the final repair here at left, with the background unchanged, but the subject in shadows is "brought out."

Instant Red Eye Removal

When I see a digital camera with the flash mounted directly above the lens, I think, "Hey, there's an automated red-eye machine." If you're a pro, you probably don't have to deal with this as much, because your flash probably isn't mounted directly above your lens—you're using bounce flash, holding the flash separately, you've got studio lights, or one of a dozen other techniques. But even when the pros pick up a "point-and-shoot," red eye can find them. Here's the quick "I-just-want-it-gone" technique for getting rid of red eye fast.

Step One:

Open a photo where the subject has red eye. Zoom in on the eyes by dragging a rectangle around them with the Zoom tool (the Magnifying Glass tool).

Step Two:

Switch to the Brush tool, and choose a soft-edged brush that's nearly the same size as the part of the eye you want to correct. Press the letter "d" to set your Foreground color to black. Then, in the Options Bar, change the Blend Mode of the Brush tool from Normal to Color, as shown at right.

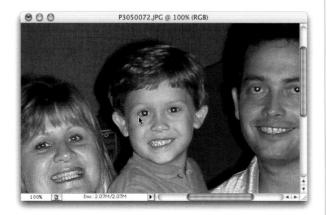

Use the Brush tool and paint directly over the red eye (you can even dab if you'd like). As you paint, the red disappears because with the Brush tool's Blend Mode set to Color, it desaturates (removing the color from) anywhere you paint.

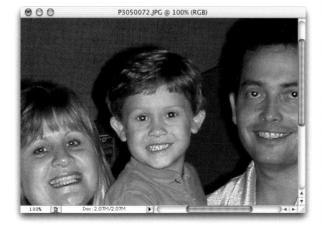

Step Four:

Paint over all the other eyes in the photo, and you're done—and best of all, the entire process takes just seconds.

Removing Red Eye and Recoloring the Eye

This technique is a little more complicated (not hard; it just has a few more steps), but the result is more professional because you're not just going to remove the red eye (like in the previous "instant red-eye removal" trick) and replace it with the more pleasing "gray eye." Instead, we're going to restore the eye to its original color.

Step One:

Open a photo where the subject has red eye.

Step Two:

Zoom in close on one of the eyes using the Zoom tool (the Magnifying Glass tool). Note: You might not want to do this late at night if you're home alone, because seeing a huge scary eye on your screen can really give you the willies.

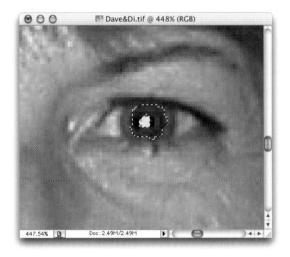

Press the "w" key to switch to the Magic Wand tool, and click within the red area of one of the eyes. One click may select all the red in the eye, but if it doesn't, hold the Shift key and click the Magic Wand again in an area of red that wasn't selected (holding the Shift key lets you add to your current selection). If the Magic Wand selects too much, go up to the Options Bar, lower the Threshold number, and try again. After one eye's red area is selected, scroll over to the other eye, hold the Shift key, and select it the same way so that both red-eye areas are selected.

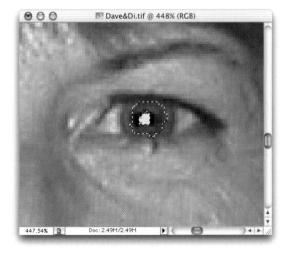

Step Four:

Now, press Shift-Command-U (PC: Shift-Control-U) to desaturate all the color from these selected red areas, leaving the eyes looking pretty gray. It's better than red, but you might want to touch it up a bit, and make it a bit darker, which we'll do in the next step.

Step Five:

Press the "d" key to set your Foreground color to black. Get the Brush tool and choose a small, soft-edged brush; then, up in the Options Bar, lower the Opacity setting to 20%.

Step Six:

Zoom out a bit by pressing Command— (the minus sign) (PC: Control—) until you can see both eyes onscreen. Paint just a couple of quick strokes over the selected areas of the eye to darken them, but stop before they turn completely black—you just want a good dark gray. You don't have to worry about painting into other areas of the eye, because your selection should still be in place while you're painting.

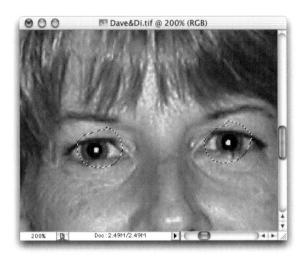

Step Seven:

Once the eyes look dark gray, you can Deselect by pressing Command-D (PC: Control-D). Press the "L" key to switch to the Lasso tool, and draw a loose selection around the entire iris of the left eye (as shown). The keyword here is loose—stay well outside the iris itself, and don't try to make a precise selection. Selecting the eyelids, eyelashes, etc. will not create a problem. Hold the Shift key and select the right eye in the same fashion.

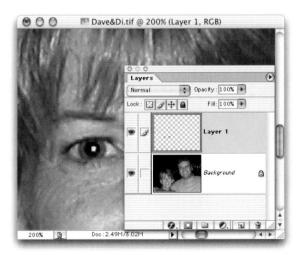

Step Eight:

After you have a loose selection around both irises, press Command-J (PC: Control-J) to put a copy of the eyes up on their own layer above the Background, as Layer 1.

Step Nine:

While you're on this "eyes" layer, go under the Image menu, under Adjustments, and choose Hue/Saturation. In the dialog, click on the Colorize checkbox (in the bottom-right corner). Now you can choose the color you'd like for the eye by moving the Hue slider. The area you removed earlier will remain the dark gray color, and only the iris will be affected by your colorization. In this case, we're going to colorize the iris blue. Don't worry about the color being too intense at this point—we can totally control that later—so if you want blue eyes, choose a deep blue and we'll dial in the exact blue later. Click OK to apply the blue to the irises and the area around them as well. (Don't let this freak you out that other areas right around the iris appear blue. We'll fix that in the next step.)

Step Ten:

Press the "e" key to switch to the Eraser tool, make sure that in the Options Bar the Mode is set to Brush, choose a hard-edged brush, and then erase the extra areas around the iris from your loose selection. This sounds much harder than it is—it's actually very easy—just erase everything but the blue iris. Don't forget to erase over the whites of the person's eyes. Remember, the eyes are on their own layer, so you can't accidentally damage any other parts of the photo.

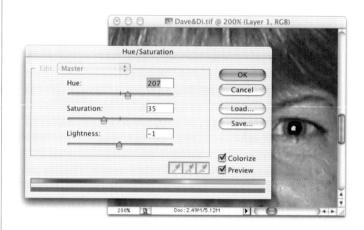

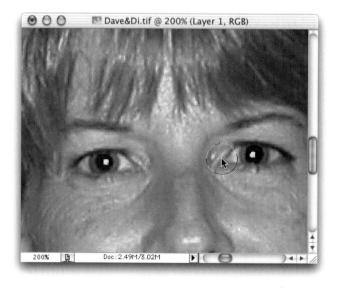

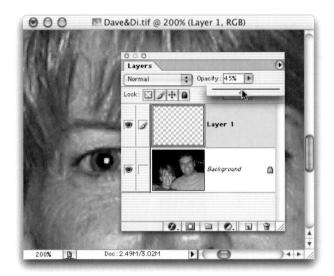

Step Eleven:

If the eye color seems too intense (and chances are, it does), we can lower the intensity in the Layers palette by simply lowering the Opacity slider until the eyes look natural.

Step Twelve:

To finish the red-eye correction and recolor, press Command-E (PC: Control-E) to merge the colored eye layer with the Background layer, completing the repair.

Keystoning is often found in photos with buildings or tall objects, where the buildings look as if they're falling away from the viewer (giving the impression that the tops of these buildings are narrower than their bases). The Crop tool has a Perspective function that can be used to fix these distortions, but actually I'm going to recommend that you don't use it, because it doesn't offer a preview of any kind—you're just guessing, so use this technique instead.

Step One:

Open an image that has a lens distortion problem (such as the photo shown at right, where the building seems to be leaning away from the viewer).

Step Two:

Grab the bottom-right corner of your image window and drag outward to reveal the gray canvas background. Press Command-A (PC: Control-A) to Select All and then press Command-T (PC: Control-T) to bring up the Free Transform function. Grab the center point of the bounding box and drag it straight downward until it touches the bottom-center Free Transform point (as shown at right at the cursor location near the bottom of the photo).

Press Command-R (PC: Control-R) to make Photoshop's rulers visible. Click-and-drag a guide out from the left ruler into your photo (we'll use this straight guide to help us line up our building). In the example shown at left, I placed the guide where I thought the top corner of the building should be aligned.

Step Four:

Once your guide is in place, hold the Command key (PC: Control key) and adjust the top left and right corner points of the bounding box until the corner of the building aligns with your guide. Making this correction can sometimes make your building look a bit "smushed" and "squatty" (my official technical terms), so you can release the Command/Control key, grab the top-center point, and drag upward to stretch the photo back out and fix the "squattyness" (again, technically speaking).

Step Five:

When the photo looks right, press Return (PC: Enter) to lock in your transformation. (Note: By repairing this problem with Free Transform, you got to see an onscreen preview of what you were doing, which the Crop tool's Perspective feature doesn't offer.) Now you can drag your guide back to the rulers, and hide the rulers again by pressing Command-R (PC: Control-R). There's still one more thing you'll probably have to do to complete this repair job.

Step Six:

If, after making this adjustment, the building looks "round" and "bloated," you can repair that problem by going under the Filter menu, under Distort, and choosing Pinch. Drag the Amount slider to 0%, and then slowly drag it to the right (increasing the amount of Pinch), while looking at the preview in the filter dialog, until you see the roundness and bloating go away. (In the example shown here, I used 5% for my Amount setting.)

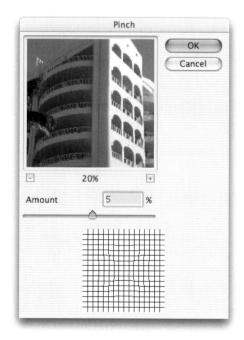

In the original photo, the building appears to be "falling away."

The same photo after repairing the distortion and bloating.

Step Seven:

When it looks right, click OK to complete your keystoning repair.
A before and after are shown here.

Removing Moiré Patterns from Coats, Shirts, Etc.

There are certain fabrics or garments, usually hideously ugly ones (kidding), that create a visible pattern when photographed with a digital camera. Perhaps the most common of these patterns, called moiré pattern, is one that shows up in garments and appears as a rainbow of colors. It's very hard to repair—that is, unless you know this great trick. (Thanks to Robert Dennis who showed it to me.)

Step One:

Open a photo with a visible moiré pattern (like the one shown here).

Step Two:

Press the letter "L" to switch to the Lasso tool, and draw a selection around the areas of the image that have a visible moiré pattern (as shown at right).

To hide our "tracks" a bit, we'll soften the edges of our selection. This will help the correction we're about to apply blend in better with the rest of the image. Go under the Select menu and choose Feather. When the Feather Selection dialog appears, enter 1 or 2 pixels and click OK to soften the edge of your selection.

Step Four:

Press Command-J (PC: Control-J) to copy the selected area onto its own layer above the Background layer.

Step Five:

Go under the Filter menu, under Blur, and choose Gaussian Blur. When the Gaussian Blur dialog appears, drag the Radius slider all the way to the left and then slowly drag it to the right until you see the moiré pattern disappear (you're basically "blurring" it away). Click OK. The photo will still look pretty bad because there's one more step we have to perform before it all comes together.

Step Six:

Go to the Layers palette and change the Blend Mode of this layer from Normal to Color. When you do this, the moiré pattern will be hidden by the blur and the object will look normal again, yet you didn't destroy any of its detail. How cool is that?

Before

After

The subtitle for this chapter is "Color Correction for Photographers," which invites the question "How is color correction for photographers different from color correction for anybody else?" Actually, it's quite

Color Me Badd color correction for photographers

a bit different, because photographers generally work in RGB or black-and-white. And in reality, digital photographers mostly work in RGB because, although we can manage to build reusable spacecrafts and have GPS satellites orbiting in space so golfers here on earth know how far it is from their golf cart to the green, for some reason creating a color inkjet printer that prints a decent black-and-white print is still apparently beyond our grasp. Don't get me started. Anyway, this chapter isn't about black-and-white, and now that I think about it, I'm sorry I brought it up in the first place. So forget I ever mentioned it, and let's talk about color correction. Why do we even need color correction? Honestly, it's a technology thing. Even with traditional film cameras, every photo needs some sort of color tweaking (either during processing or afterward in Photoshop) because if it didn't need some correction, we'd have about 30-something pages in this book that would be blank, and that would make my publisher pretty hopping mad (and if you haven't seen him hop, let me tell you, it's not pretty). So, for the sake of sheer page count, let's all be glad that we don't live in a perfect world where every photo comes out perfect and 6-megapixel cameras are only 200 bucks and come with free 1GB memory cards.

Before You Color Correct Anything, Do This First!

Before we correct even a single photo, there are two quick little preferences we need to change in Photoshop to give us better, more accurate corrections. Although it's just two simple changes, don't underestimate their impact—this is critically important stuff.

Step One:

The first thing you'll want to change is the RGB color space. Photoshop's default color space (sRGB IEC61966-2.1) is arguably the worst possible color space for professional photographers. This color space is designed for use by Web designers, and it mimics an "el cheapo" PC monitor from four or five years ago. Honestly, I wouldn't even recommend this space for Web designers today, and it's fairly ghastly for photographers, especially if their photos will wind up in print (brochures, ads, flyers, catalogs, etc.).

Step Two:

Press Shift-Command-K (PC: Shift-Control-K) to bring up the Color Settings dialog (shown in Step One, with sRGB IEC61966-2.1 as the default RGB Working Space). In the Working Spaces section, from the RGB pop-up menu, choose Adobe RGB (1998) as shown at right. This is probably the most popular RGB setting for photographers because it reproduces such a wide gamut of colors, and it's ideal if your photos will wind up in print. Click OK and this is your new default color work space. Yippee!

Now we're moving to a completely different area. In the Toolbox, click on the Eyedropper tool. You'll be using the Eyedropper to read color values from your photo. The default Sample Size setting for this tool (Point Sample) is fine for using the Eyedropper to steal a color from within a photo and making it your Foreground color. However, Point Sample doesn't work well when you're trying to read values in a particular area (like flesh tones), because it gives you the reading from just one individual pixel, rather than a reading of the area under your cursor.

Step Four:

For example, flesh tone is actually composed of dozens of different colored pixels (just zoom way in and you'll see what I mean). If you're color correcting, you want a reading that is representative of the area under your Eyedropper, not just one of the pixels within that area, which could hurt your correction decision making. That's why you'll go up in the Options Bar, under Sample Size, and choose 3-by-3 Average from the pop-up menu. This changes the Eyedropper to give you a 3-by-3 pixel average of the area you're reading. Once you've completed the changes on these two pages, it's safe to go ahead with the rest of the chapter and start correcting your photos.

Color Correcting Digital Camera Images

As far as digital technology has come, there's still one thing that digital cameras won't do: give you perfect color every time. In fact, if they gave us perfect color 50% of the time, that would be incredible, but unfortunately, every digital camera (and every scanner that captures traditional photos) sneaks in some kind of color cast in your image. Generally, it's a red cast, but depending on the camera, it could be blue. Either way, you can be pretty sure—there's a cast. (Figure it this way: If there wasn't, the term "color correction" wouldn't be used.) Here's how to get your color in line.

Step One:

Open the digital camera photo you want to color correct. (The photo shown here doesn't look too bad, but as we go through the correction process, you'll see that, like most photos, it really needed a correction.)

Step Two:

Go under the Image menu, under Adjustments, and choose Curves. Curves is the hands-down choice of professionals for correcting color because it gives you a greater level of control than other tools, such as Levels (which we use for correcting black-and-white photos). The dialog box may look intimidating at first, but the technique you're going to learn here requires no previous knowledge of Curves, and it's so easy, you'll be correcting photos using Curves immediately.

First, we need to set some preferences in the Curves dialog so we'll get the results we're after when we start correcting. We'll start by setting a target color for our shadow areas. To set this preference, in the Curves dialog, double-click on the black Eyedropper tool (it's on the lower right-hand side of the dialog, the first Eyedropper from the left). A Color Picker will appear asking you to "Select Target Shadow Color." This is where we'll enter values that, when applied, will help remove any color casts your camera introduced in the shadow areas of your photo.

Step Four:

We're going to enter values in the R, G, and B (red, green, and blue) fields of this dialog (the blue field is highlighted at left).

For "R," enter 20 For "G," enter 20 For "B," enter 20

Then click OK. Because these figures are evenly balanced (neutral), they help ensure that your shadow area won't have too much of one color (which is exactly what causes a color cast—too much of one color). Additionally, using the numbers we're giving you in this chapter will help your photos maintain enough shadow and highlight detail if you decide to output them on a printing press (for a brochure, magazine cover, print ad, etc.).

Step Five:

Now we'll set a preference to make our highlight areas neutral. Doubleclick on the highlight Eyedropper (the third of the three Eyedroppers in the Curves dialog). The Color Picker will appear asking you to "Select Target Highlight Color." Click in the "R" field, and then enter these values:

TIP: To move from field to field, just press the Tab key.

For "R," enter 240 For "G," enter 240 For "B," enter 240

Then click OK to set those values as your highlight target.

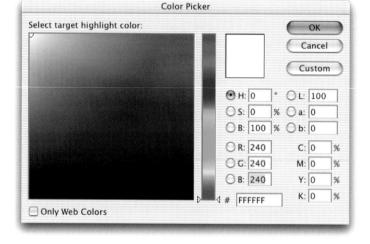

Step Six:

Now, set your midtone preference. You know the drill: Double-click on the midtone Eyedropper (the middle of the three Eyedroppers) so you can "Select Target Midtone Color." Enter these values in the RGB fields:

For "R," enter 128 For "G," enter 128 For "B," enter 128

Then click OK to set those values as your midtone target.

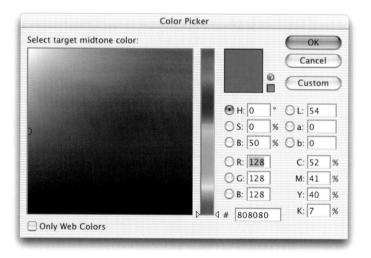

Step Seven:

Okay, you've entered your preferences (target colors) in the Curves dialog. After you make your adjustments and finally click OK in the Curves dialog (don't do this yet), you'll get an alert dialog asking you if you want to "Save the new target colors as defaults." Click Yes, and from that point on, you won't have to enter these values each time you correct a photo, because they'll already be entered for you—they're now the default settings.

Step Eight:

Now that we've entered all these values, you're going to use these Eyedropper tools that reside in the Curves dialog to do most of your correction work. Your job is to determine where the shadow, midtone, and highlight areas are, and click the right Eyedropper in the right place (you'll learn how to do that in just a moment). So remember, your job: Find the shadow, midtone, and highlight areas, and click the right Eyedropper in the right spot. Sounds easy, right? It is.

You start by setting the shadows first, so you'll need to find an area in your photo that's supposed to be black. If you can't find something that's supposed to be the color black, then it gets a bit trickier—in the absence of something black, you have to determine which area in the image is the darkest. If you're not sure where the darkest part of the photo is, you can use the following trick to have Photoshop tell you exactly where it is.

Step Nine:

If you still have the Curves dialog open, click OK to exit it for now. Go to the palette and click on the half white/half black circle icon to bring up the Adjustment Layer pop-up menu (it's the fourth icon from the left at the bottom of the palette). When the menu appears, choose Threshold (this brings up a dialog with a histogram and a slider under it).

Step Ten:

When the Threshold dialog appears, drag the Threshold Level slider under the histogram all the way to the left. Your photo will turn completely white. Slowly drag the Threshold slider back to the right, and as you do, you'll start to see some of your photo reappear. The first area that appears is the darkest part of your image. That's it—that's Photoshop telling you exactly where the darkest part of the image is. Click OK to close the Threshold dialog. This adds a special layer to your Layers palette with a square icon for the thumbnail (as shown at right).

Step Eleven:

Now that you know where your shadow area is, mark it by clicking and holding on the Eyedropper tool in the Toolbox, and from the flyout menu that appears, choose the Color Sampler tool. Click the Color Sampler once on the area that is darkest and a target cursor will appear on that spot. (This is your visual cue to where the shadows are. You'll need this marker later.) When you do this, the Info palette will automatically

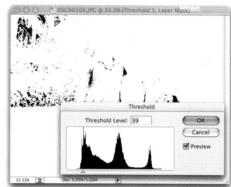

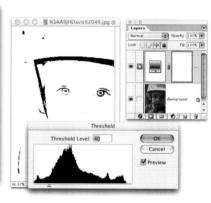

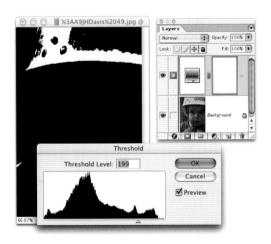

appear onscreen. You don't need this palette right now, so you can click to close it, or just drag it to one side so it's out of the way.

Now to find a white area in your image.

Step Twelve:

If you can't find an area in your image that you know is supposed to be white, you can use the same technique to find the highlight areas that you just used to find the shadow areas. Go to the Layers palette and double-click on the Threshold Adjustment Layer icon to bring up the Threshold dialog, but this time drag the slider all the way to the right. Your photo will turn black. Slowly drag the Threshold slider back toward the left, and as you do, you'll start to see some of your photo reappear (as shown top left). The first area that appears is the lightest part of your image. Click OK in the Threshold dialog, and then take the Color Sampler tool and click once on the brightest point to mark it as your highlight point.

Step Thirteen:

You're now done with your Threshold Adjustment layer, so you can go to the Layers palette and drag that layer onto the Trash icon to delete it. When you do this, your photo will look normal again, but now there are two target markers visible on your photo (as shown at left).

Step Fourteen:

Press Command-M (PC: Control-M) to bring up the Curves dialog. First, select the shadow Eyedropper (the one half filled with black) from the bottom right of the

Curves dialog. Move your cursor outside the Curves dialog box into your photo and click once directly on the center of the #1 target. When you click on the #1 target, you'll see the correct shadow areas. (Basically, you just reassigned the shadow areas to your new neutral shadow colorthe one you entered earlier as a preference in Step Four.) If you click on the #1 target and your photo now looks horrible, you either clicked in the wrong spot or what you thought was the shadow point actually wasn't. Undo the setting of your shadow point by pressing Command-Z (PC: Control-Z) and try again. If that doesn't work, don't sweat it; just keep clicking in areas that look like the darkest part of your photo until it looks right.

Step Fifteen:

While still in the Curves dialog, switch to the highlight Eyedropper (the one filled with white). Move your cursor over your photo and click once directly on the center of the #2 target to assign that as your highlight. You'll see the correct highlight colors.

Step Sixteen:

Now that the shadows and highlights are set, you'll need to set the midtones in the photo. It might not look as if you need to set them because the photo might look properly corrected, but chances are there's a cast in the midtone areas. You might not recognize the cast until you've corrected it and it's gone, so it's worth giving it a shot to see the effect (which will often be surprisingly dramatic). Unfortunately, there's no Threshold Adjustment Layer trick that works well for finding the midtone areas, but if you're totally stumped (you just

After

can't find a gray area that's not a highlight and not a shadow), you can try this:

Open the Info palette. By default, the top-left reading shows the RGB color values. Click and hold on the little Eyedropper icon on the top left and a pop-up list of measurement options will appear. Choose Total Ink, as shown at bottom of opposite page. Now, move the Eyedropper tool over areas in your photo that you think might be midtones, but watch the reading in the Info palette. See if you can find an area whose Total Ink reading is 128 and use that area for your midtone. Click the midtone Eyedropper (the middle of the three, half filled with gray) to correct the midtones, and watch the change within your photo. It can make all the difference.

Step Seventeen:

You can now remove the two Color Sampler targets on your photo by going up to the Options Bar and clicking on the Clear button.

Step Eighteen:

There's one more important adjustment to make before you click OK in the Curves dialog and apply your correction. In the Curves grid, click on the center of the curve and drag it upward a bit to brighten the midtones of the image (as shown at left). This is a visual adjustment, so it's up to you to determine how much to adjust, but it should be subtle—just enough to brighten the midtones a bit and bring out the midtone detail. When it looks right to you, click OK to apply your correction to the highlights, midtones, and shadows, removing any color casts and brightening the overall contrast.

Step Nineteen:

The values I gave you at the beginning of this correction technique were for photos that would be reproduced in RGB mode (i.e., your final output would be to a photo-quality color inkjet printer, a color laser printer, a dye-sub printer, etc.). However, if you're color correcting your photos for final output to a printing press (for a brochure, catalog, print ad, magazine, etc.), you need to use an entirely different set of values for your highlights, midtones, and shadows. Also, these numbers are entered into the CMYK fields, rather than the RGB fields. At right are a set of values that are very common for prepress correction, because they enable significant details to be reproduced on press.

CMYK SHADOWS

For "C," enter 75 For "M," enter 63 For "Y," enter 62 For "K," enter 90

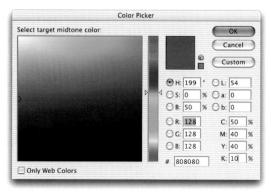

CMYK MIDTONES

For "C," enter 50 For "M," enter 40 For "Y," enter 40 For "K," enter 10

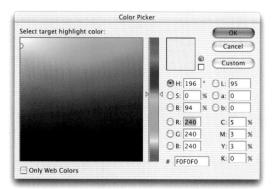

CMYK HIGHLIGHTS

For "C," enter 5 For "M," enter 3 For "Y," enter 3 For "K," enter 0

This is a wonderful timesaving trick for quickly correcting an entire group of photos that have similar lighting. It's ideal for studio shots, where the lighting conditions are controlled, but works equally well for outdoor shots, or really any situation where the lighting for your group of shots is fairly consistent. Once you try this, you'll use it again and again and again.

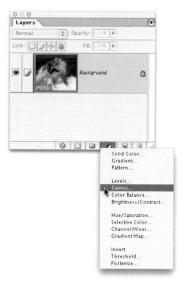

Step One:

First, here's a tip within a tip: If you're opening a group of photos, you don't have to open them one by one. Just go under the File menu and choose Open. In the Open dialog, click on the first photo you want to open, and then hold the Command key (PC: Control key) and click on any other photos you want to open. Then, when you click the Open button, Photoshop will open all the selected photos. (If all your photos are consecutive, hold the Shift key and click on the first and last photo in the list to select them all.) So now that you know that tip, go ahead and open at least four or five images, just to get you started.

Step Two:

At the bottom of the Layers palette, there's a pop-up menu for adding Adjustment Layers. Click on it and choose Curves. Note: An Adjustment Layer is a special layer that contains the tonal adjustment of your choice (such as Levels, Curves, Color Balance, etc.). There are a number of advantages of having this correction applied as a layer, as you'll soon see, but the main advantage is that you can edit or delete

this tonal adjustment at any time while you're working, plus you can save this adjustment with your file as a layer.

Step Three:

When you choose this Adjustment Layer, you'll notice that the regular Curves dialog appears, just like always. Go ahead and make your corrections, just as you did in the previous tutorial (setting highlights, midtones, shadows, etc.), and when your correction looks good, click OK.

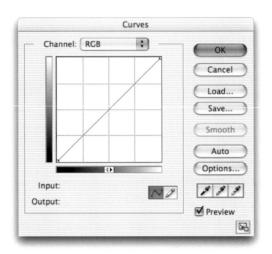

Step Four:

In the Layers palette, you'll see that a new Adjustment Layer was created, and if you expand the width of your Layers palette (click and drag on the very bottom-right corner of the palette), you can actually read the word "Curves," as shown at right.

Step Five:

Because you applied this correction as an Adjustment Layer, you can treat this adjustment just like a regular layer, right? Right! Now, Photoshop lets you drag layers between open documents, right? So, go to the Layers palette and simply drag this layer right onto one of your other open photos, and that photo will instantly have the same correction applied to it. This technique works because you're correcting photos that share similar lighting conditions. Need to correct 12 photos, just drag and drop it 12 times (making it the fastest correction in town!). In the example shown at left, the original corrected image is on the far left, and I've dragged and dropped that Curves Adjustment Layer onto one of the other open photos.

Step Six:

Okay, what if one of the "dragged corrections" doesn't look right? That's the beauty of these Adjustment Layers. Just double-click directly on the Adjustment Layer icon for that photo and the Curves dialog will reappear with the last settings you applied still in place. You can then adjust this individual photo separately from the rest. Try this "dragging-and-dropping-Adjustment-Layers" trick once and you'll use it again and again to save time when correcting a digital roll with similar lighting conditions.

If the photos you're correcting are destined for a printing press, rather than just a color printer (i.e., they'll appear in a brochure, print ad, catalog, flyer, etc.), you have to compensate for how the inks react with one another on a printing press. Without compensating, you can almost guarantee that all the people in your photos will look slightly sunburned. Here's a technique that lets you correct flesh tone "by the numbers" to get perfect skin tones every time.

Step One:

When it comes to getting proper flesh tones on press, you're going to be concerned mainly with the relationship between the magenta and the yellow in the flesh tone areas. Your goal will be to have at least 3% to 5% more yellow in your flesh tone area than magenta. The amount of yellow and magenta can be displayed in the Info palette, so start by going under the Window menu and choosing Info to bring up the Info palette (shown at right). Then convert your image to CMYK mode by going under the Image menu, under Mode, and choosing CMYK Color.

Step Two:

First, you need to see what the current balance of yellow to magenta is, so press Command-M (PC: Control-M) to open Curves. Next, move your cursor outside the Curves dialog and into your photo over an area that contains flesh tones (we'll call this our sample area). While your cursor is there, look in your Info palette at the relationship of the magenta and the yellow.

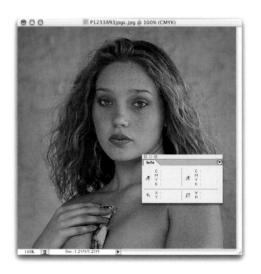

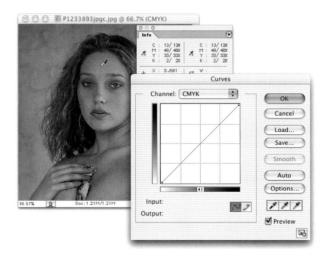

In the Info palette, look at the CMYK readout (on the right side of the palette). If the magenta reading is higher than the yellow reading (as shown at left), you'll have to adjust the balance of the magenta and the yellow. In the example shown here, the magenta reads 54% and the yellow is only 42%, so there's 12% more magenta, and that means instant sunburn; so you'll have to adjust this balance to get perfect flesh tones.

Step Four:

You might be tempted to just lower the amount of magenta, but to keep our adjustment from appearing too drastic, we'll do a balanced adjustment: Lower the magenta some, and then increase the yellow enough until we hit our goal of 3% to 5% more yellow. First, start by lowering the amount of magenta. In the Curves dialog, choose Magenta from the Channel pop-up menu (as shown at left). To find out exactly where the magenta in your flesh tone area resides on the Curve, hold Shift-Command (PC: Shift-Control) and click once in the sample flesh tone area. This adds a point to the magenta channel Curve right where the magenta in the flesh tone is located. (And because you added the Shift key, it also added a point to your yellow Curve, which you'll see in a moment.)

Step Five:

In the Output field at the bottom of the Curves dialog, type in an amount that's 6% or 7% lower than the value shown. (Remember, the magenta reading was 12% more than the yellow, so you're going to reduce the difference by half.)

Step Six:

After you've lowered the magenta, switch to the Yellow channel by choosing it from the Channel pop-up menu at the top of the Curves dialog. You should already see a point on the Curve. This is where the yellow resides in the sample flesh tone area that you clicked on in Step Four. In the Output field at the bottom of the Curves dialog, type in a figure that's at least 3% higher than the number that you typed in the Output field for the magenta Curve in Step Five. (The Info palette provides a before/after reading, with the before on the left, and the reading after your adjustment on the right, so you can check your numbers in your sample area after you adjust the Curve.) In our example, I lowered the magenta from 54% to 47%, and raised the yellow from 42% to 50%. This gives at least 3% more yellow than magenta in the flesh tones.

So what do you do if you've used Curves to properly set the highlights, midtones, and shadows, but the flesh tones in your photo still look too red? You can't use the "getting proper flesh tones for a printing press" trick, because that's only for CMYK images going to press. Instead, try this quick trick for getting your flesh tones in line by removing the excess red.

Adjusting RGB Flesh Tones

Step One:

Open the photo you corrected with Curves earlier. If the whole image appears too red, skip this step and go on to Step Three. However, if it's just the flesh tone areas that appear too red, get the Lasso tool and make a selection around all the flesh tone areas in your photo. (Hold the Shift key to add other flesh tone areas to the selection, such as arms, hands, legs, etc.)

Step Two:

Next, go under the Select menu and choose Feather. Enter a Feather Radius of 3 pixels, and then click OK. By adding this feather, you're softening the edges of your selection, and this will keep you from having a hard visible edge show up where you made your adjustment.

Go under the Image menu, under Adjustments, and choose Hue/Saturation. When the dialog appears, click and hold on the Edit pop-up menu and choose Reds (as shown here) so you're just adjusting the reds in your photo (or in your selected areas if you put a selection around just the flesh tones).

Step Four:

The rest is easy—you're simply going to reduce the amount of saturation so the flesh tones appear more natural. Drag the Saturation slider to the left (as shown) to reduce the amount of red. You'll be able to see the effect of removing the red as you lower the Saturation slider.

TIP: If you made a selection of the flesh tone areas, you might find it easier if you hide the selection border from view (that makes it easier to see what you're correcting) by pressing Command-H (PC: Control-H). This works even while the Hue/Saturation dialog is open. When the flesh tones look right, just click the OK button and you're set.

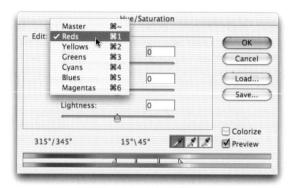

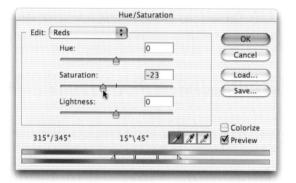

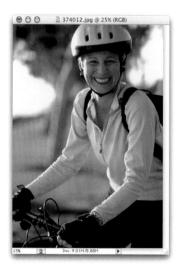

better results, all with just one click.

Getting Better Automated Color Correction

Step One:

Open a photo that needs correcting, but you don't feel warrants taking your time for a full manual color correction using Curves.

Step Two:

Go under the Image menu, under Adjustments, and choose Auto Color to apply an auto correction to your photo. When you apply Auto Color, it just does its thing. It doesn't ask you to input numbers or make decisions basically, it's a one-trick pony that tries to neutralize the highlight, midtone, and shadow areas of your photo. In some cases, it does a pretty darn decent job, in others, well...let's just say it falls a bit short. But in this tutorial, you'll learn how to supercharge Auto Color to get dramatically better results, and transform it from a "toy" into a real color-correction tool.

After you've applied Auto Color, one way you can tweak its effect on your photo is by going under the Edit menu and choosing Fade Auto Color. (Note: This is only available immediately after you apply Auto Color.) When the Fade dialog appears (as shown), drag the Opacity slider to the left to reduce the effect of the Auto Color. Move the slider until the photo looks good to you. You can also change the Blend Mode (from the Mode pop-up menu) to further adjust your photo (Multiply makes it darker, Screen makes it lighter, etc.). When you click OK in the Fade dialog, your Fade is applied.

Step Four:

So now you know the "Apply Auto Color and Fade" technique, which is fine, but there's something better: tweaking Auto Color's options before you apply it. Believe it or not, there are hidden options for how Auto Color works. (Note: They're not really hidden, they're just put someplace you'd probably never look.) To get to these Auto Color options, press Command-L (PC: Control-L) to bring up the Levels dialog. On the right side of the dialog, you'll see a button named Auto. That's not it. Instead, click on the button just below it, named Options. This is where Adobe hid the Auto Color options (along with other options, as you'll soon see).

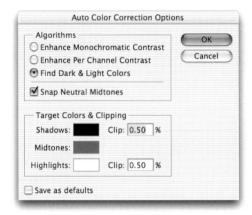

Step Five:

At the top of this dialog, under the Algorithms section, you can determine what happens when you click the Auto button within the Levels or Curves dialog boxes. If you click the topmost choice, "Enhance Monochromatic Contrast," clicking the Auto button will now apply the somewhat lame Auto Levels auto correction. If you choose "Enhance Per Channel Contrast," clicking the Auto button will apply the equally lame Auto Contrast auto correction. What you want instead is to choose both "Find Dark & Light Colors" (sets your highlight and shadow points), and "Snap Neutral Midtones" (which sets your midtones). With these settings, Auto Color (the most powerful of the auto correction tools) will now be applied if you click the Auto button in either Levels or Curves.

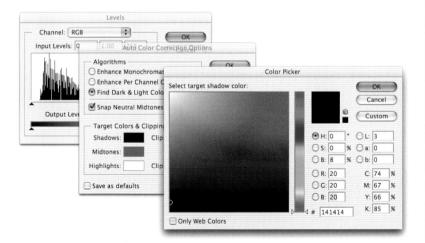

Step Six:

In the Target Colors & Clipping section, you can click on each Target Color Swatch (Shadows, Midtones, Highlights) and enter the RGB values you'd prefer Auto Color to use, rather than the defaults, which are...well, a bit yucky! I use the same settings that we entered in our manual Curves correction (Shadows: R=20, G=20, B=20; Midtones: R=128, G=128, B=128; and Highlights: R=240, G=240, B=240).

Step Seven:

Weirdly enough, changing these option settings works only once. If you reopen these options later, you'll find that they have all reverted to the original default settings. To keep that from happening, click the Save as Defaults checkbox at the bottom-left side of the dialog.

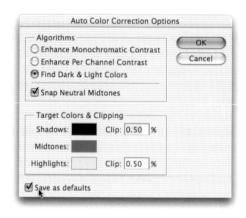

Step Eight:

When you click OK to close the options dialog and save the settings, you've done three very important things:

- (1) You've majorly tweaked Auto Color's settings to give you better results every time you use it.
- (2) You've assigned Auto Color as the default Auto correction when you click the Auto button in the Curves dialog.
- (3) You've turned Auto Color into a useful tool that you'll use way more than you'd think.

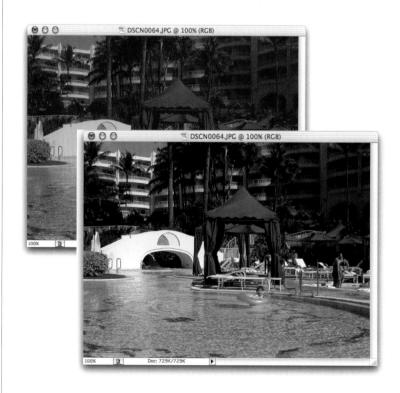

This particular technique really comes in handy when shooting outdoor scenes, because it lets you enhance the color in one particular area of the photo, while leaving the rest of it untouched. Real estate photographers often use this trick because they want to present the house on a bright sunny day, but the weather doesn't always cooperate. With this technique, a gray cloudy sky can become a beautiful blue sky in just seconds, and brownish grass in the front can quickly become a lush green yard (like it really looks in summer).

Color Correcting One Problem Area Fast!

Step One:

Open the image that has an area of color that you would like to enhance. In this example, we want to make the sky blue (rather than gray) and make the grass look greener.

Step Two:

Go to the Layers palette and choose Color Balance from the Adjustment Layer pop-up menu at the bottom of the Layers palette (it's the half black, half white circle icon, fourth from the left). A new layer named Color Balance will be added to your Layers palette (as shown at the near left), but the name will probably be cut off by default. If you want to see the layer's name, you'll have to widen your Layers palette.

When you choose Color Balance, the Color Balance dialog will appear (shown at right). Drag the top slider left toward Cyan to add some bright blue into your sky, and then drag the bottom slider right toward Blue until the sky looks as blue as you'd like it. When it looks right, click OK.

Step Four:

When you do this, the entire photo will have a heavy blue cast to it (as shown here).

Step Five:

Press the "d" key to set your Foreground color to black. Switch to the Brush tool in the Toolbox, choose a large, softedged brush, and paint over the areas in your photo that are *not* supposed to be blue (i.e., the house, the driveway, the roof, the mailbox, plants and trees in the yard—basically, everything but the sky). As you paint, the blue disappears (as shown at right). If you accidentally erase part of the blue in the sky, just press the "x" key to make white your Foreground, and then you can paint the blue tint right back in.

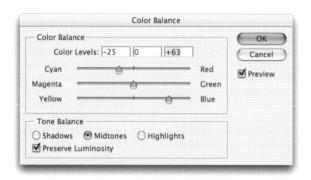

Step Six:

While you're painting over the non-blue areas, you may have to shrink the size of your brush and switch to a hard-edged brush while painting (erasing the blue) along well-defined areas such as the line of the roof or the edge of the walls. When you're done painting away the blue from the house, the photo will look like the one shown at left, with a deep blue sky.

Step Seven:

Although the sky is definitely more blue, it still doesn't look as sunny as we'd like, so you'll need to adjust its brightness. If you look in the Layers palette, on the Adjustment Layer we created, you'll see a Layer Mask thumbnail showing the areas we erased. Hold the Command key (PC: Control key) and click once directly on this Layer Mask thumbnail (it's the square just to the right of the Adjustment Layer thumbnail). This puts a selection around just the sky area.

Step Eight:

We'll soften the transition between the sky selection and the house by going under the Select menu and choosing Feather. Enter 2 pixels in the Feather Selection dialog and click OK. Then, in the Layers palette, choose Levels from the Adjustment Layer pop-up menu. The Levels dialog will appear, and you can drag the top-right highlight slider to the left to brighten just the selected area (the sky). Click OK when it looks right.

Step Nine:

Now that our sky is a bright blue, let's green up that grass in front of the house a bit. Switch to the Rectangular Marquee tool and draw a rectangular selection around the areas of grass. If you need to select more than one area, select the first area, and then hold the Shift key and select the others (as shown).

Step Ten:

In the Layers palette, choose Color Balance from the Adjustment Layer popup menu. The Color Balance dialog will appear. Drag the middle slider right, toward Green, and then drag the bottom slider left toward Yellow until the grass looks about right.

Step Eleven:

Switch to the Brush tool and paint away the excess areas of green (anything outside the grass). If the grass seems too green after you're done, you can lower the intensity of your green correction by lowering the Opacity of your Color Balance Adjustment Layer in the Layers palette. A before and after is shown at right.

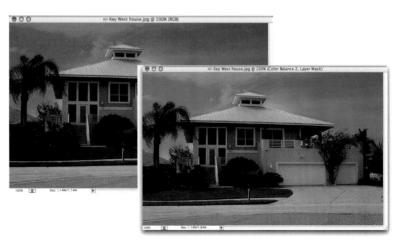

If you're shooting in a studio, whether you're shooting portraits or products, there's a technique you can use that makes the color correction process easy to the point that you'll be able to train laboratory test rats to correct photos for you. In the back of this book, I included a solid black/gray/white card (it's perforated so you can easily tear it out). After you get your studio lighting set the way you want it, and you're ready to start shooting, just put this black/gray/white card into your shot (just once) and take the shot. What does this do for you? You'll see.

Studio Portrait Correction Made Simple

Step One:

When you're ready to start shooting and the lighting is set the way you want it, tear out the black/gray/white card from the back of this book and place it within your shot (if you're shooting a portrait, have the subject hold the card for you), and then take the shot. After you've got one shot with the black/gray/white card, you can remove it and continue with the rest of your shoot.

Step Two:

When you open the first photo taken in your studio session, you'll see the black/gray/white card in the photo. By having a card that's pure white, neutral gray, and pure black in your photo, you no longer have to try to determine which area of your photo is supposed to be black (to set the shadows), which area is supposed to be gray (to set the midtones), or which area is supposed to be white (to set the highlights). They're right there in the card.

Step Three:

Press Command-M (PC: Control-M) to bring up the Curves dialog. Click the shadow Eyedropper on the black panel of the card (to set shadows), the middle Eyedropper on the gray (for midtones), and the highlight Eyedropper on the white panel (sets the highlights), and the photo will nearly correct itself. No guessing, no Threshold Adjustment Layers, no using the Info palette to determine the darkest areas of the image, because now you know exactly which part of that image should be black and which should be white.

Step Four:

Now that you have the Curve setting for the first image, you can correct the rest of the photos using the exact same curve: Just open the next photo and press Option-Command-M (PC: Alt-Control-M) to apply the exact same curve to this photo that you did to the black/gray/white card photo. Or, you can use the drag-and-drop color correction method I showed on page 115.

If you want to take this process a step further, many professionals use a Macbeth color-swatch chart (from GretagMacbeth; www.gretagmacbeth .com), which also contains midtone shades of gray and a host of other target colors. It's used exactly the same way: Just put the chart into your photo, take one shot, and then when you correct the photo, a solid black, solid white, and midtone gray swatch will be in the photo, just begging to be clicked on.

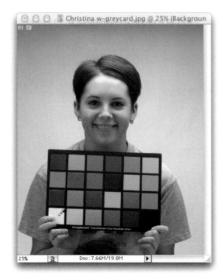

Because professionals are so concerned with maintaining the absolute highest quality in their photos, many now opt to do their color correction in 16-bit mode (called "high-bit" editing) even though the file size is nearly double, and many of Photoshop's tools aren't available when editing in 16-bit mode. So why do they do it? Because you can edit, tweak, and sharpen without the loss of quality normally associated with 8-bit images.

The Magic of Editing in 16-Bit

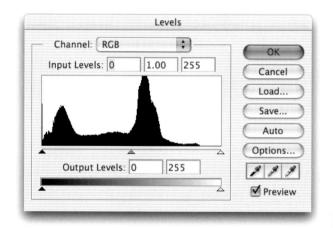

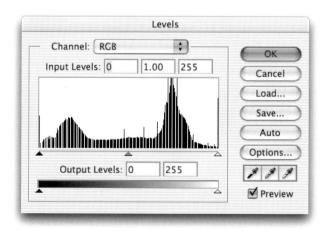

Before editing:

The Levels dialog capture at left shows the histogram (the graph) before the photo is edited.

Editing in 8-bit mode:

The Levels dialog shown here shows how the histogram looks after color correcting a photo in Photoshop's standard 8-bit mode. Notice the gaps in the histogram (white lines called combs) indicating a loss in quality. This degradation happens when working with 8-bit photos because there are only 256 possible levels (or shades) per channel. When you apply a correction (Levels, Curves, etc.), your image quality and detail degrade because your corrections leave you with less than the 256 possible levels per channel.

Editing in 16-bit mode:

This capture shows the histogram for the same photo, with the exact same correction applied; but this time the correction was done in 16-bit mode, rather than 8-bit. You don't see as many combs (loss of quality) in this histogram as you did when editing the photo in 8-bit mode. That's because rather than just 256 shades of gray (8-bit mode), 16-bit offers 65,536 possible levels in each channel, giving so much more information that when you correct a photo, you don't really see image degradation. Basically, you've got levels (shades) to burn. The histogram shown here proves just that. This is what all the fuss is about.

Shooting in 16-bit:

To get the benefits of editing in 16-bit, you'll need to shoot raw 16-bit photos (unfortunately, you don't get the same benefits if you start with a regular 8-bit JPEG and then simply switch to 16-bit mode). Luckily, today, most pro-quality digital cameras enable you to shoot in "RAW" 16-bit mode, but getting your RAW photo into Photoshop might require you to first open the photo in software from your digital camera maker (for example, Nikon users can use Nikon Capture, shown at right, to open 16-bit photos; Canon users can use Canon's Raw Image Converter for theirs; etc.).

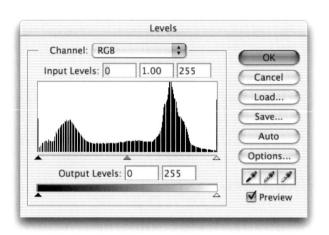

The bad news:

After you open a 16-bit photo in Photoshop, you'll find that you have a very limited set of tools at your disposal. For example, as you can see from the capture at left, you only have access to a few filters; but luckily, they include Unsharp Mask and Gaussian Blur. Although you do have access to most of Photoshop's tonal adjustment tools (like Curves, Levels, Color Balance, etc.), you don't have access to Layers, which means no Adjustment Layers. In fact, you can't even use the Brush tool, or most of Photoshop's Selection tools (there are a couple of tricks you can pull for making detailed selections with 16-bit photos, included in the chapter on masking). But all of this is a small price to pay for the absolutely superior quality that comes from making your tonal corrections on 16-bit photos.

Editing 16-bit photos:

While your photo is open in 16-bit mode, you'll correct it like any other (setting shadows, midtones, and highlights; applying sharpening; etc.). When you're done with all your tonal corrections, if you need to perform any retouching, add any special effects, or just about anything outside of tonal corrections, you'll now have to convert down to 8-bit mode. But the great news is you're creating a very high-quality 8-bit original that's already been corrected; so again, you're starting with a superior product.

Converting to 8-bit mode:

Downsampling in Photoshop to 8 bits is a no-brainer. Just go under the Image menu, under Mode, and choose 8 Bits/Channel. Now you can edit the photo using all of Photoshop's tools and filters.

If you've worked with 16-bit images, you probably already know the Dodge and Burn tools aren't available to you. With 8-bit images, we'd get around that by creating an Overlay Adjustment Layer and then using the Brush tool to dodge and burn, but in 16-bit you can't use layers or the Brush tool. Luckily, Russell Brown, Adobe's own Graphics Evangelist, came up with this great workaround that lets you dodge and burn, thanks to the fact that for some reason, Photoshop's History brush does work on 16-bit photos. Here's how he does it:

Dodging and Burning 16-Bit Photos

Step One:

Open a 16-bit photo in Photoshop. The background in the photo shown at left looks properly exposed, but the subject in the foreground could use a little brightening up (dodging). But as I mentioned in the introduction to this technique, the Dodge and Burn tools are not available to us in 16-bit mode (and neither are layers or the Brush tool).

Step Two:

Press Command-L (PC: Control-L) to bring up the Levels dialog (we're going to use Levels for this broad tonal adjustment, but you could just as easily use Curves—it's your choice). Drag the highlight and midtone Input Levels sliders to the left to brighten the overall image. Don't be afraid to really brighten things up because you'll be able to back things off in a later step, but it's harder to make the brightening more intense later. When it looks good and bright, click OK.

Step Three:

After you've lightened the overall tone, go under the Window menu and choose History to bring up the History palette, which keeps track of your last 20 steps in Photoshop (these steps are called History States). The two States you'll see are the two things you've done thus far: Open (you opened the photo) and Levels (you lightened the photo using Levels).

Step Four:

In the History palette, click on the State named Open to return your photo to what it looked like when you first opened it (before you lightened it with Levels). Then, click once in the first column beside the state named "Levels." The History brush icon will appear in this column (as shown at right), letting you know that if you were to paint with the History Brush, it would paint from what the photo looked like after you applied Levels.

Step Five:

In the Toolbox, switch to the History Brush (as shown in the capture at left), and then up in the Options Bar, lower the Opacity setting for the History Brush to 70%. Now you can start dodging (lightening) the subject to make him look properly exposed. If the effect is too intense, undo and then lower the Opacity to around 50% and try again. The final dodged photo is shown below at left.

Working with Photoshop's Camera Raw Plug-In

At PhotoshopWorld (the annual convention of the National Association of Photoshop Professionals) Adobe introduced a free plug-in for Photoshop 7 called Camera Raw (written by Thomas Knoll, the man who wrote Photoshop) that enables you to open raw images from your camera so you can adjust the white balance, exposure compensation, and tonal correction, and then open an original version directly in Photoshop as a 16-bit or 8-bit image, without losing any of the original data. Camera Raw supports numerous high-end digital cameras from Nikon, Canon, Minolta, Olympus, and Fuji (the complete list of supported cameras can be found on Adobe's site).

Before you get started:

Go to Adobe's Web site to purchase Camera Raw plug-in, and run the installer. After it is installed, you can open and process raw images from your camera. What does that mean to you? Well, here's just an idea of how this plug-in changes things: If you take a photo with a traditional film camera and send the film to a film lab for processing, they produce an original print from the negative (the negative remains intact, unchanged, throughout the entire process). Photoshop's Camera Raw plug-in lets you import a raw photo (the digital negative) from your camera, and you can decide how it's processed to create your own original, which you can then open and edit in Photoshop (while the digital negative remains intact, unchanged, throughout the entire process). How cool is that!

Step One:

After you install Camera Raw, the File Browser will now display thumbnails of raw photos (as shown), and you can open these raw images by double-clicking on them in the File Browser. You can also open them using the standard Open command from Photoshop's File menu.

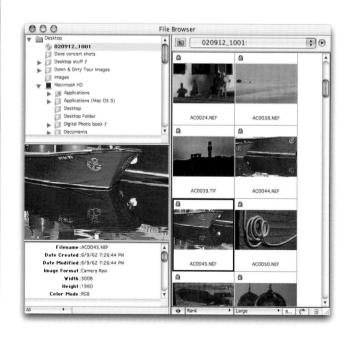

Step Two:

Either way you decide to open it, a raw image automatically opens in the Camera Raw interface (shown here). The camera, file name, and basic EXIF data appear across the Title Bar of Camera Raw. A large preview of your raw photo appears just below that. You can adjust the view size of the image preview either by using the Zoom tool (from the Toolbar on the left), the Select Zoom Level pop-up menu below the preview on the left, or by Control-clicking (PC: Right-clicking) within the preview window and choosing a view percentage from the resulting pop-up menu. You can change the rotation of your preview using the rotation buttons below the preview on the right, but they only rotate the preview. When the photo is imported into Photoshop, it will not be rotated.

Step Three:

Below the preview window are settings that will determine the size, resolution, bit-depth, and the color space that your raw photo will be when imported into Photoshop. The Space pop-up menu should match your current color space, which should be Adobe RGB (1998), as we mentioned earlier in the book. In the Depth pop-up menu, you choose whether the raw photo will be opened in Photoshop as a regular 8-bit image or a 16-bit image (maintaining as much of the original data as possible). The Size pop-up menu determines the size (in pixels). The default size shown is the size your camera captured the image. In the Resolution popup, you choose the desired resolution when the photo is opened in Photoshop.

Step Four:

There's also a pop-up histogram that appears within your preview area (as shown). The semi-transparent histogram simultaneously displays the red, green, and blue channels, and the white represents the image luminance. You can toggle this histogram on and off by pressing the letter "g," and you can move it to a new location within the preview window by clicking and dragging it. To see the RGB values in your image, move any tool over the preview area and the values at the point where the tool is located will be displayed just below the preview on the right-hand side.

Step Five:

The right column of the Camera Raw interface is where you make processing adjustments that are normally made within the camera, but now you can make them yourself before you import the photo into Photoshop (see, this is cool). We'll start at the top of the column (shown here) with the White Balance pop-up menu (we'll cover the Settings pop-up menu in a moment). If you leave it at the default setting (As Shot), the White Balance will remain as it was set in the camera at the time the photo was taken. However, you can choose from a popup list of White Balance options that compensate for various lighting conditions (as shown here) and see a live preview of how it affects the raw image in the preview window.

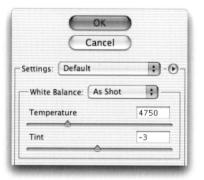

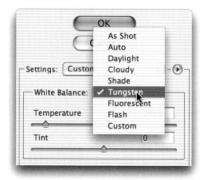

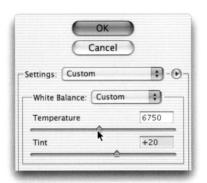

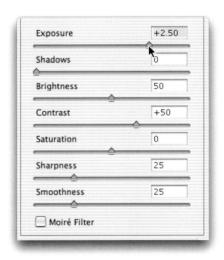

Step Six:

If you don't want to use any of the default settings, you can tweak the White Balance manually by using the Temperature slider to create your own custom color temperature (using the standard Kelvin scale). Dragging to the left cools the tone (making it look bluer), and dragging to the right warms the tone (making it appear more yellow). The Tint slider lets you further fine-tune the White Balance. Dragging to the left introduces more green into the image and dragging to the right introduces more magenta.

Step Seven:

The top five sliders in the next section are for tonal adjustments. The top slider is for Exposure compensation, and it enables you to increase the Exposure by up to four f-stops, and decrease it as much as two f-stops. (Note: Because the values are expressed in increments of f-stops, a +2.50 Exposure value would equal a 21/2-stop increase.) If you hold the Option key (PC: Alt key) while making an Exposure adjustment, the preview window will reveal any highlights that are being clipped by your changes.

Step Eight:

The Shadows slider lets you push the shadows much in the same way the shadow Input Levels slider in Levels works. To increase the values which will be pushed to black, drag the slider to the right.

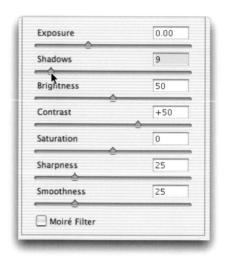

Step Nine:

The Brightness, Contrast, and Saturation sliders are somewhat more subtle versions of Photoshop's regular Brightness/Contrast adjustment and the Saturation slider in the Hue/Saturation dialog.

Step Ten:

At the bottom of this column is a slider for Sharpness (shown here) that is based on Photoshop's own Unsharp Mask filter. If you don't plan on doing a lot of image editing within Photoshop, you can use this slider to apply sharpening at this stage. The Smoothness slider is designed to help you remove High ISO noise, color aliasing, and other digital nasties that are introduced by some digital cameras. A setting of zero turns this feature off.

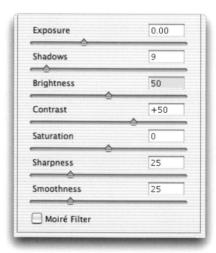

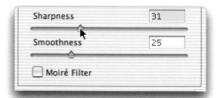

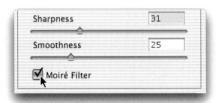

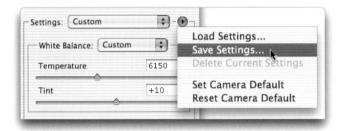

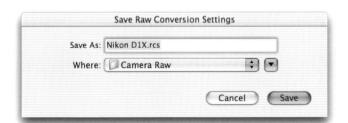

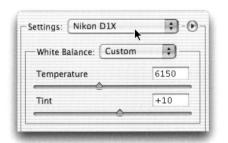

Step Eleven:

The raw photo you're importing might have a moiré pattern (these sometimes appear in digital photos with patterned clothing and certain fabrics). If you see a moiré pattern, turn on the Moiré Filter checkbox to remove it as the photo is imported into Photoshop.

Step Twelve:

Okay, now that you've entered all these settings, you can save them as a preset so every time you shoot with that camera, you can quickly pull up the settings that you commonly use with images from that camera. To save your settings, just choose Save Settings (as shown).

Step Thirteen:

This brings up a dialog where you can give your custom preset a name (as shown).

Step Fourteen:

Your custom preset now appears in the Settings pop-up menu. (See, I told ya we'd get to it.) Now just click OK and Camera Raw processes the photo according to your specs, and opens the photo in Photoshop ready to edit, all while leaving the original raw image untouched and preserved as your digital negative.

Using the JPEG 2000 Plug-In

This could actually be called "Not Using the JPEG 2000 Plug-In," because at this point, there's virtually no support outside of Photoshop for the JPEG 2000 standard, so Adobe is really leading the way on this one. But it's an important step as a number of camera manufacturers have announced that they will be including JPEG 2000 in future models, and the advantages of this new format include an optional "Lossless" compression algorithm and other cool features that might one day soon make the old JPEG obsolete.

Step One:

After you've installed the JPEG 2000 plug-in, you can choose JPEG 2000 as your file format choice in the Save As dialog (as shown).

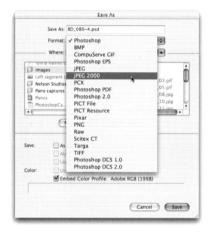

Step Two:

When you click Save, it brings up the JPEG 2000 dialog (shown here). There's a large preview that shows your photo. You can use either the dialog's Zoom tool or the Set Preview Zoom pop-up menu below the left side of the preview window. The column on the far right is where you make the decisions as to how this particular image will be compressed.

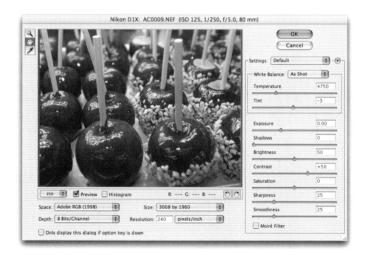

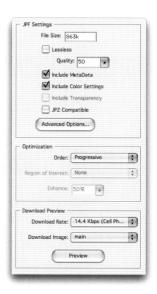

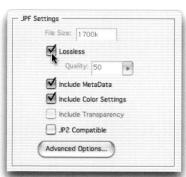

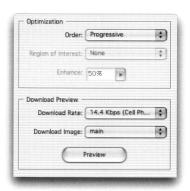

Step Three:

The anticipated final file size is displayed in the File Size field, but this field is live, and if you enter a new value in this field, JPEG 2000 will compress the photo using that value as a target. The Quality field is similar to the regular JPEG Quality field in that the lower the quality, the smaller the file size (and vice versa). However, the algorithm that JPEG 2000 uses for its compression is significantly better than previous algorithms, providing better quality at smaller file sizes. You can also choose to embed Photoshop's MetaData and EXIF data with your compressed file.

Step Four:

Of course, the big news is Lossless compression (smaller file sizes without the loss of quality). You turn it on by simply clicking the Lossless checkbox (as shown). You're probably wondering "Why would I ever turn this off?" It's because there's a tradeoff: Before the Lossless checkbox, the file size was going to be 863k. Now it's 1.7MB. But still, it's intriguing.

Step Five:

At the bottom of the column are options for optimizing your JPEG file for the Web (which is great, but so far I don't know of any Web browsers that support JPEG 2000, but you can be sure they're coming). My favorite Web feature is the ability to influence the compression so that important areas of the photo (like the subject) are higher quality than non-important areas (like a solid or blurred background). Click OK and your file is saved as a JPEG 2000, with the file extension .jpf.

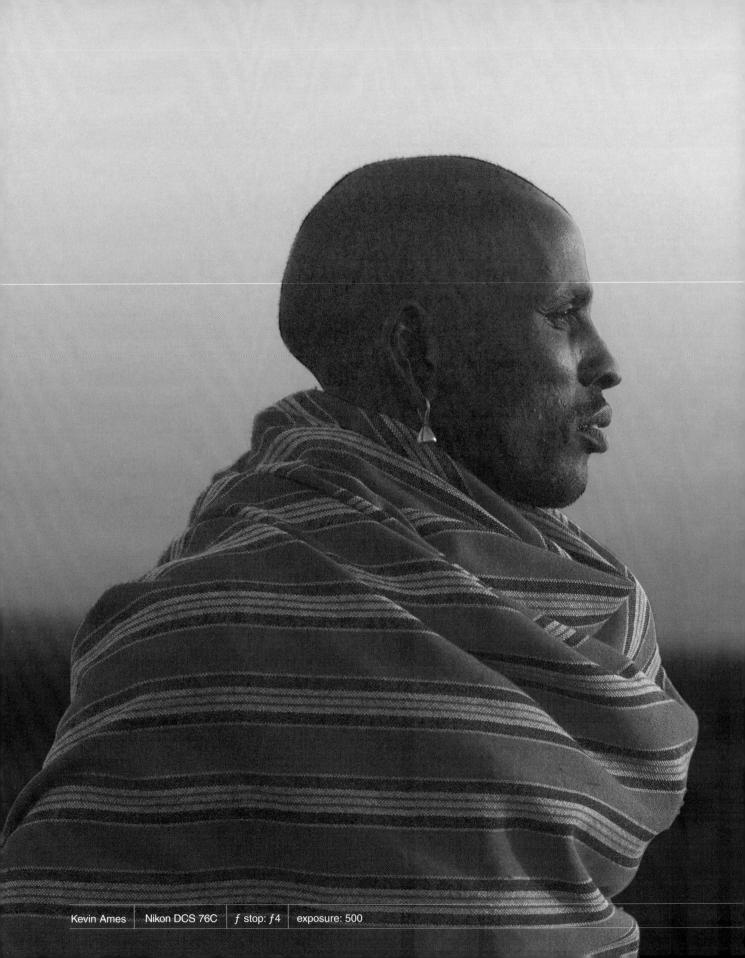

One of the problems with people is you can't always get them to stand in front of a white background so you can easily select them, so you can then place them on a different background. It's just not fair. If

The Mask masking techniques

I were elected president, one of my first priorities would be to sign an executive order requiring all registered voters to carry with them a white seamless roll at all times. Can you imagine how much easier life would be? For example, let's say you're a sports photographer and you're shooting an NFL Monday Night Football game with one of those Canon telephoto lenses that are longer than the underground tube for a particle accelerator; and just as the quarterback steps into the pocket to complete a pass, a fullback comes up from behind, quickly unfurls a white, seamless backdrop, and lets you make the shot. Do you know how fast you'd get a job at Sports Illustrated? Do you know how long I've waited to use "unfurl" in a sentence and actually use it in the proper context? Well, let's just say at least since I was 12 (three long years ago). In this chapter, you'll learn how to treat everyone, every object, everything, as though it was shot on a white seamless background.

Extracting People from Their Background

I figured I'd start with probably the most-requested masking task—removing someone from a background while keeping hair detail. We use Extract for this, and even if you've used Extract dozens of times, there's a trick near the end that is so simple, yet so incredibly effective, it will change the way you use Extract forever, or my name isn't Deke McClelland.

Step One:

Open the photo containing a person (or an object) that you want to extract from its background. Go under the Filter menu and choose Extract (it's the first filter from the top).

Step Two:

This brings up the Extract dialog. Get the Edge Highlighter tool (it's the top tool in Extract's Toolbar and looks like a marker) and use it to trace the edges of the object you want to remove. As you trace, leave half the marker border on the background and half on the edge of the object you want to extract.

TIP: Use a small brush size when tracing areas that are well defined (like along her shirt), and a very large brush for areas that are less defined, such as flyaway hair. You can change the brush size by holding down the Left Bracket key to make it smaller or the Right Bracket to make it larger.

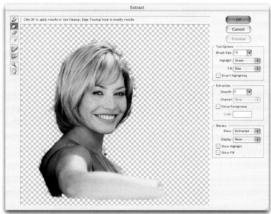

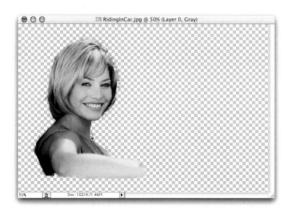

Step Three:

After your Highlighter edge is in place, you now have to tell Photoshop what parts of the photo to retain when extracting. This is pretty simple—you just switch to the Fill tool (it's the second tool from the top in Extract's Toolbar and looks like a paint bucket) and click it once inside the Highlighter edge border you drew earlier (as shown here). This fills the inside of your highlighter border with a light blue tint.

Step Four:

If the blue tint spills out to the rest of your photo when you click the Fill tool, that means your subject isn't completely enclosed by the edge border. If that happens, just press Command-Z (PC: Control-Z) to undo, then take the Edge Highlighter and make certain there are no gaps at the bottom or sides of your border. Now you can click the Preview button to see how your extraction looks.

Step Five:

Now it's time to take a good look at the photo and see if Extract did what you really wanted it to. Namely, did it work on the hair, which is the hard-to-select area. If it worked, then click OK because fixing the rest of the photo is a breeze, as you'll see. Even if part of her clothes are dropping out, or there are dropouts in her face, hands, etc., don't sweat it—as long as the edge of the hair looks good, click OK to perform the extraction.

Now that the extraction is done, it's "fix-up" time. Here, you can see dropouts (slightly transparent areas) in her coat, a few little spots in her hair, and a couple little spots in other places. Start by simply duplicating the layer. That's right, just press Command-J (PC: Control-J). The mere act of duplicating the layer will fix about 90% of the dropouts in your photo. It sounds weird, but it works amazingly well, and when you try it, you'll be astounded. Press Command-E (PC: Control-E) to merge these two layers.

Step Seven:

For the rest of the dropouts, just get the History Brush tool (shown here) and simply paint over these areas. The History Brush will paint those missing pieces back in because it's really an "undo on a brush" if you just grab it and go. So, if part of your subject drops out, use the History Brush to paint it right back in. You can usually fix the dropouts in about two minutes using this technique.

Step Eight:

Here's a capture taken during the fix-up stage, where I'm painting over dropouts in her shirt. The History Brush is painting the original image back in.

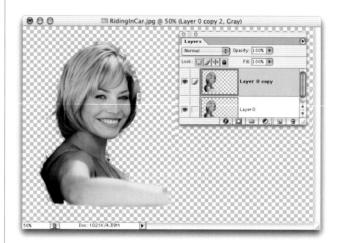

Step Nine:

Next, open the photo that you want to use as a background behind your extracted person. It's best to drag this background photo onto your extracted-person document, because as long as you work in the same document where you extracted, you'll have access to the History Brush for your extracted image. That way, if you see a dropout when you bring in the background, you can return to that layer and quickly touch it up with the History Brush.

Step Ten:

The background will appear over your extracted image on its own layer (as shown here).

Step Eleven:

Go to the Layers palette and drag the layer with your background photo behind the layer with your extracted photo, to put the person in front of this background. You'll usually have to switch to the Eraser tool to erase any little leftover "junk" outside the hair, and you can usually clean up these leftovers pretty easily once you see them over the background.

Precise Selections Using the Pen Tool

Of all the selection tools in Photoshop, this is probably the single most important one, and if you get good at it, it makes your life so much easier, because you'll be spending a lot of time making precise selections and no tool does it better. This tutorial is aimed at photographers who haven't really worked with the pen before, so if you're a pro with then pen, you can skip this, and I won't take any offense. OK, I might be a little hurt, but I'll get over it. In time.

Step One:

Get the Pen tool from the Toolbox. Click it once at a starting point within your photo (there is no "official" starting point, but in this case, you can start by clicking once on the left corner of the sign, as shown).

Step Two:

Move your cursor to the top of the sign, then click once more. A straight path will be drawn between the two points.

Step Three:

Continue moving the cursor along the sign and clicking on each corner to draw another straight line from the last point. Go down the post, across the bottom of the post, and back up to the bottom corner of the sign, and then move the cursor right over the point where you started. A tiny circle will appear on the bottom-right corner of your Pen tool cursor, letting you know you've come "full circle."

Step Four:

Click on your starting point to close your path. You should now have a path all the way around the sign and the post. If you need to adjust one of the points to make it fit the sign better, press Shift-A until you have the Direct Selection tool (the hollow arrow), click on the path to make the points active, and then click on the point you want to move and drag it into place. When your path looks nice and tight against the sign, press Command-Return (PC: Control-Enter) to turn your Path into a selection.

Step Five:

Now that you have a selection in place around the sign, you can isolate it from the background by pressing Command-J (PC: Control-J) to put it up on its own layer. Then, click on the Background layer in the Layers palette, press Command-A (PC: Control-A) to select the entire background, and then press Delete (PC: Backspace) to delete the background. Now, on to making curves with the Pen tool.

The previous Pen tool project used straight lines, but this project adds curves. (The ability to draw smooth paths around curved objects is where the real power of the Pen tool lies.) Click on a starting point. In the example shown here, I clicked once at the topright corner of the jet's tail for my starting point, then I moved down to the top of the engine and clicked again, and a straight path was drawn between the two points.

Step Seven:

Click once partway around the engine, but don't just click-click, hold, and drag, and as you drag, the path will begin to curve and two Curve Adjustment handles will appear (as shown here). As you drag, you'll be actually dragging out one of these handles. The farther you drag, the more your path will curve. It takes a minute to get the hang of how far to pull, and how the curve reacts to your pulling; but if you look at what you're trying to curve the path around as you drag, you'll be able to get a pretty snug fit fairly easily.

Step Eight:

After you've made sure your curved path is a snug fit (by that I mean it should extend a little bit into the object you're trying to isolate from its background), move your cursor to the base of the engine, then click, hold, and drag out another curve. It should wrap around the bottom side of the engine (as shown).

Step Nine:

You'll use these two techniques to trace the edges of your object with a path: (1) Click from point to point to draw straight lines, and (2) click, hold, and drag to curve around objects. Here, we're drawing a path along the top of the jet's fuselage.

Step Ten:

Continue down the far-right side of the jet, across the bottom, and up again toward the engine mounted on the tail (as shown). You're about to learn one of the annoying things about drawing curves with the Pen tool—the curve doesn't always go in the right direction. When you get to the base of the tail and then head up with a slight curve, the curve wants to go the opposite direction.

Step Eleven:

Here's a nearly 600% zoom-in on that spot, and you can see that although the point is placed in the right spot, the curve goes in toward the tail, rather than out along its edge. This type of thing will happen fairly often, but there's a quick fix to get your curves going back in the right direction.

Step Twelve:

Here's how to fix it: Press Command-Z (PC: Control-Z) to undo the point of curve that went the wrong way. Hold the Option key (PC: Alt key), and then click your previous point. Now, click, hold, and drag at the base of the engine just like before, but now when you draw your curve, it will go in the right direction.

Step Thirteen:

Continue your way around the engine, drawing straight lines, curved lines (around the back of the engine), and when necessary fixing curves that go in the wrong direction by (1) undoing the point, (2) Option/Alt clicking the previous point, and (3) continuing on. Just as in our first project, when you get back to where you started and put your Pen cursor over your starting point, a small circle will appear to let you know that a click will complete your path.

Step Fourteen:

After your path is in place, you can edit the placement of any point (to make it snug against the edge of the jet), or edit any existing curve using the Curve Adjustment handles. Just switch to the Add Anchor Point tool (choose it from the Pen tool's flyout menu in the Toolbox); when you place it over an existing point, it switches to the Direct Selection Arrow (the hollow arrow) so you can adjust the point.

Step Fifteen:

To make your path as smooth as possible (which is your goal), try not to add too many points as you're tracing a path around your object. But sometimes there's a spot that just doesn't look right because you didn't put a curve in where it was necessary. That's okay, because that's what the Add Anchor Point tool is for—just move it over the path where you want to add a curve, and click, hold, and drag to add a curve point along the path.

Step Sixteen:

After your path is complete, you have two choices: (1) You can turn it into a selection by pressing Command-Return (PC: Control-Enter), or (b) if you're going to be exporting this photo into a professional page-layout application (like Adobe InDesign or QuarkXPress) and you want only the jet, not the background, to be visible, you have to create a Clipping Path. This tells the page-layout application to clip away (hide) everything outside the path you created.

Step Seventeen:

First, we'll assume you're not exporting the file for placement in a page-layout application and that you just turned your path into a selection (as shown in Step Fifteen's capture). Now, press Command-J (PC: Control-J) to put the jet on its own separate layer. Then in the Layers palette, click on the Background layer, press Command-A (Control-A) to Select All, and then press Delete (PC: Backspace) to remove the background. The next steps cover creating a Clipping Path for export.

To create a Clipping Path, start by making the Paths palette visible. When you do, you'll see the path you created, and by default it's named "Work Path." Double-click on this path, and in the Save Path dialog, give it a name (name it anything you like. I named this one "Jet Path").

Step Nineteen:

After your path is named, choose Clipping Path from the Paths palette's pop-down menu to bring up the Clipping Path dialog. Make sure your named path is selected from the Path pop-up menu (shown here). Adobe has fixed it so you can leave the Flatness setting blank and it will work in almost all situations, but if for some reason you get a PostScript error when outputting to a high-resolution imagesetter, resave the file with a Flatness setting of between 7 and 10 so the paths will be interpreted correctly.

Step Twenty:

Last, save your file in EPS format (which supports the embedding of Clipping Paths). When you import this EPS file into a page-layout application (here it's shown in Adobe InDesign over a solid maroon background), only the jet will be visible and not the background.

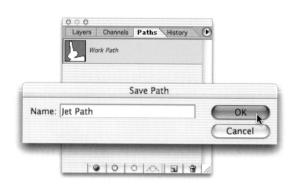

If you've spent 15 or 20 minutes (or even more) putting together an intricate selection, once you deselect it, it's gone. (Well, you might be able to get it back by choosing Reselect from the Select menu, as long as you haven't made any other selections in the meantime, so don't count on it. Ever.) Here's how to save your finely honed selections and bring them back into place anytime you need them.

Saving Your Intricate Selections

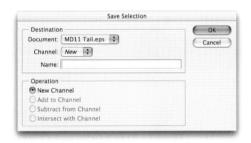

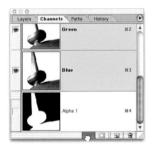

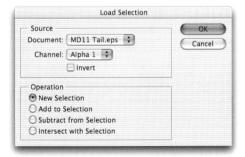

Step One:

To save a currently active selection, go under the Select menu and choose Save Selection. This brings up the Save Selection dialog (as shown). Just click OK to save your selection.

Step Two:

You can view your saved selection by going to the Channels palette, where your selection is saved as an extra channel named "Alpha 1" (by default). You can turn this channel into a selection anytime by dragging it to the Load Channel as Selection icon at the bottom of the Channels palette (as shown).

Step Three:

Another way to load a saved selection is to choose Load Selection from the bottom of the Select menu. This brings up the Load Selection dialog, where you can choose which channel you want to load from the Channel pop-up menu (handy if you've saved multiple selections). You can use it to either add or subtract a saved selection from a currently active selection.

Loading the Highlights as a Selection

Instant loading of the highlights (the luminosity of a photo) enables you to quickly lighten your photo without disturbing the midtone or shadow areas. Also, loading the highlights makes it very easy to inverse the selection and have just the shadows selected so you can enhance the shadow detail.

Step One:

Open the photo that has highlights you want to correct. In this case, we want to lighten the highlights without disturbing the midtone or shadow areas.

Step Two:

Press Option-Command-~ (PC: Alt-Control-~) (that's the Tilde key, right above the Tab key on your keyboard). This loads the highlights (luminosity) in your photo (as shown).

Step Three:

Press Command-J (PC: Control-J) to put the loaded selection on its own layer.

Step Four:

Now that the highlights are separated out onto their own layer, you could use Levels or Curves to lighten them, or you could simply change the Blend Mode from Normal to Screen in the Layers palette as I've done here. Choosing Screen made the highlights a little too hot, and if that's the case, you can lower the Opacity until it looks right to you.

Step Five:

In the example shown here, I lowered the Opacity of the highlight layer to 86% to complete the technique.

NOTE: This technique works equally well for selecting just the shadows, enabling you to open up the shadows with Levels, Curves, or a change to Screen Mode. Start by loading the selection (as in Step Two) and after the highlights selection is in place, go under the Select menu and choose Inverse to select the Shadows.

Making Selections in 16-Bit Images

Another limitation of editing 16-bit photos is that some of Photoshop's most important selection tools just aren't available. Well, that doesn't stop Adobe's own Russell Brown, whose technique for tricking Photoshop into giving you full access to every single selection tool in the program can surely make your 16-bit editing life easier.

Step One:

Open the 16-bit photo you want to make selections within (stuff like Quick Mask, Color Range, and even the Magic Wand tool just aren't available for use on 16-bit photos).

Step Two:

Go under the Image menu and choose Duplicate. This brings up the Duplicate Image dialog, where you can name the duplicate image (I named mine with the same name; I just added the suffix 8-bit). Click OK, and Photoshop makes an exact duplicate of your 16-bit photo.

Step Three:

Go under the Image menu, under Mode, and choose 8 Bits/Channel. This converts your duplicate to regular 8-bit mode, leaving your original untouched and still in 16-bit mode.

Step Four:

Now that this duplicate is just a regular 8-bit photo, all of Photoshop's selection tools are available, so select to your heart's content. Here, I wanted to make a simple selection of the gray background areas on her left and right, so I clicked the Magic Wand tool on the left, held the Shift key, and clicked on the right to quickly select those areas.

Step Five:

Position your 8-bit photo so you can see the 16-bit original at the same time (as shown). Make sure your 8-bit photo is active and in front, then take a selection tool (like the Magic Wand), and click-and-hold within the selected area. Now hold down the Shift key and drag your selection directly from the 8-bit photo and drop it right on the 16-bit photo.

Step Six:

By holding the Shift key, you're assured that your dragged selection will appear in the exact same spot in the 16-bit photo that it did in the 8-bit (that is, as long as you haven't cropped the 8-bit photo, resized it, or changed its resolution before dragging your selection). The dragged selection now appears perfectly in place in the 16-bit photo (as shown). But there's another way that you may prefer.

Step Seven:

Rather than dragging-and-dropping the selection from the 8-bit photo to the 16-bit photo, after the selection is in place in the 8-bit photo, go under the Select menu and choose Save Selection to save this selection as an Alpha channel.

Step Eight:

Although you can't save Alpha channels in 16-bit images, you can load channels from other open documents; so keep your 8-bit photo open, but click on your 16-bit photo to make it active. Then go under the Select menu and choose Load Selection. The Load Selection dialog (shown here) will appear. Under Source, choose your 8-bit document from the Document pop-up menu; for Channel, choose Alpha 1.

Step Nine:

Click OK, and this loads the saved selection from the 8-bit photo right into the 16-bit photo (as shown). With the selection in place, I was able to use Hue/Saturation's Colorize mode to tint the background blue. By the way, don't go looking for an Alpha channel in the Channels palette—it won't be there, because remember, 16-bit mode doesn't allow Alpha channels to be saved; but surprisingly, you can pull a selection in from an 8-bit photo.

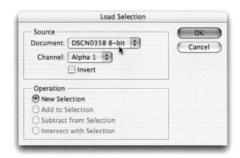

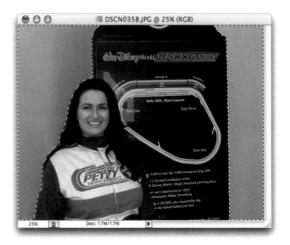

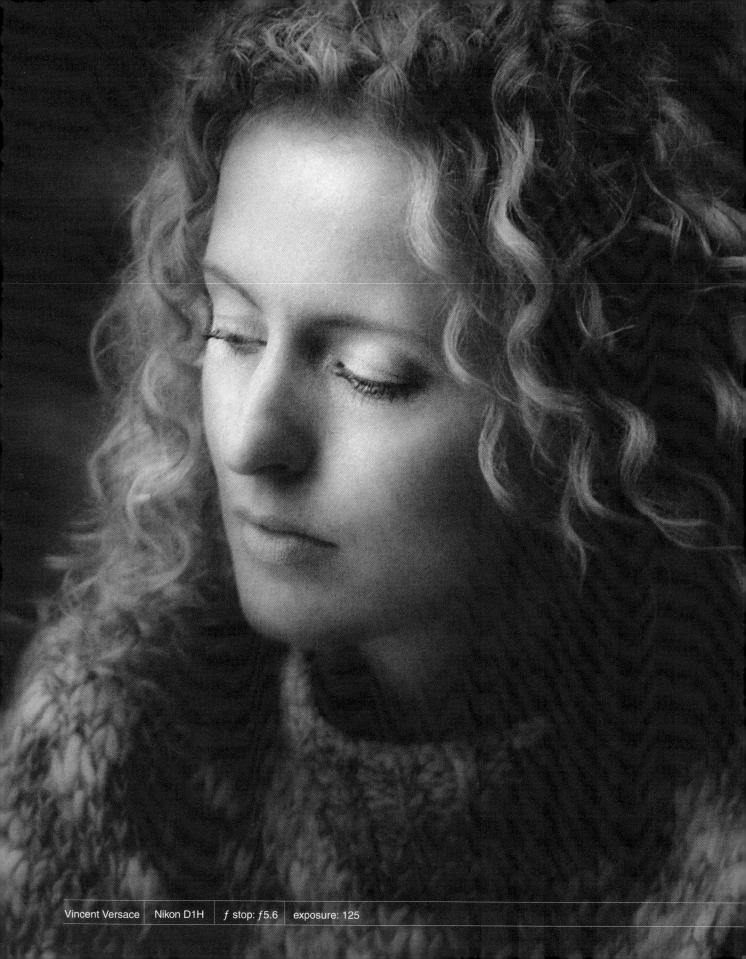

This should be called "The Kevin Ames Chapter."
Actually, it really should be called the "I Hate Kevin Ames Chapter" because I already had this entire chapter written, until I stopped by Kevin's studio in

Head Games retouching portraits

Atlanta one night to show him the rough draft of the book. What should have been a 15-minute visit went on until after midnight, with him showing me some amazing portrait retouching tricks for the book. So I had to go back home and basically rewrite, update, and tweak the entire chapter. Which I can tell you, is no fun once you think a chapter is done and you're about a week from deadline, but the stuff he showed me was so cool, I literally couldn't sleep that night because I knew his techniques would take this chapter to the next level. And even though Kevin was incredibly gracious to let me share his techniques with my readers (that's the kind of guy Kevin is), there was no real way I was going to name this chapter "The Kevin Ames Chapter." That's when it became clear to me-I would have to kill him. But then I remembered Kevin had mentioned that Jim DiVitale had developed some of the techniques that he had showed me, so now it was going to be a double murder. I thought, "Hey, they both live in Atlanta, how hard could this be?" but the more I thought about it, what with having to fly back up there and having to fly on Delta (stuffed in like human cattle), I figured I'd just give them the credit they deserve and go on with my life. Thus far, it's worked out okay.

Removing **Blemishes**

When it comes to removing blemishes, acne, or any other imperfections on the skin, our goal is to maintain as much of the original skin texture as possible. That way, our retouch doesn't look pasty and obvious. Here are three techniques we use that work pretty nicely, and when you have all of these methods in your retouching arsenal, if one doesn't carry out the repair the way you'd hoped, you can try the second or even the third.

TECHNIQUE #1 Step One:

Open a photo containing some skin imperfections you want to remove.

Step Two:

Choose the Clone Stamp tool in the Toolbox. From the Brush Picker up in the Options Bar (click on the Brush thumbnail on the left-hand side), choose a soft-edged brush that's slightly larger than the blemish you want to remove. You can use the Master Diameter slider at the top of the Brush Picker to dial in just the size you need. Once you're working, if you need to quickly adjust the brush size up or down, use the Bracket keys on your keyboard: the Left Bracket key makes your brush smaller; the Right larger.

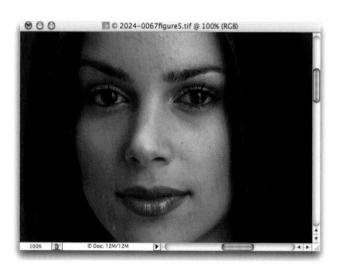

Up in the Options Bar, change the Blend Mode of the Clone Stamp tool to Lighten. With its Mode set as Lighten, the Clone Stamp will affect only pixels that are darker than the sampled area. The lighter pixels (the regular flesh tone) will pretty much stay intact, and only the darker pixels (the blemish) will be affected.

Step Four:

Find an area right near the blemish that's pretty clean (no visible spots, blemishes, etc.), hold the Option key (PC: Alt key), and click once. This samples the skin from that area. Try to make sure this sample area is very near the blemish so the skin tones will match. If you move too far away, you risk having your repair appear in a slightly different color, which is a dead giveaway of a repair.

Step Five:

Now, move your cursor directly over the blemish and click just once. Don't paint! Just click. The click will do it—it will remove the blemish instantly (as shown at left), while leaving the skin texture intact. But what if the blemish is lighter than the skin, rather than darker? Simply change the Blend Mode to Darken instead of lighten—it's that easy. On to Technique #2.

Continued

TECHNIQUE #2 Step One:

Switch to the Lasso tool in the Toolbox. Find a clean area (no blemishes, spots, etc.) near the blemish that you want to remove. In this clean area, use the Lasso tool to make a selection that is slightly larger than the blemish (as shown at right).

Step Two:

After your selection is in place, go under the Select menu and choose Feather. When the Feather Selection dialog box appears, enter 2 pixels as your Feather Radius and click OK. Feathering blurs the edges of our selected area, which will help hide the traces of our retouch. Feathering (softening) the edges of a selection is a very important part of facial retouching, and you'll do this quite a bit, to "hide your tracks" so to speak.

Step Three:

Now that you've softened the edges of the selection, hold Option-Command (PC: Alt-Control), and you'll see your cursor change into two arrowheads—a white one with a black one overlapping it. This is telling you that you're about to copy the selected area. Click within your selection and drag this clean skin area right over the blemish to completely cover it.

Step Four:

When the clean area covers the blemish, release the keys (and the mouse button, of course) to drop this selected area down onto your photo. Now, press Command-D (PC: Control-D) to Deselect. The photo at left shows the final results, and as you can see, the blemish is gone. Best of all, because you dragged skin over from a nearby area, the full skin texture is perfectly intact, making your repair nearly impossible to detect.

TECHNIQUE #3

You can also use the Healing Brush (shown at left) to remove blemishes effectively and quickly. (A full tutorial is coming up soon, so I won't put you through the whole thing twice.) Just like the Clone Stamp tool, the key thing to remember when using the Healing Brush for repairing blemishes is to choose a brush size that's just slightly larger than the blemish you're trying to remove. The default for the Healing Brush is hard-edged, and that's fine—it works great that way. However, you'll have to choose your brush size from the Diameter slider (as shown at left). From that point, you can use it much as you would the Clone Stamp (Option-/Altclicking in a clean area), but you don't have to choose Lighten from the Options Bar-the Healing Brush doesn't need it.

Removing Dark Circles Under Eyes

Here are two different techniques for removing the dark circles that sometimes appear under a person's eyes. Especially after a hard night of drinking. At least, that's what I've been told.

TECHNIQUE #1 Step One:

Open the photo that has the dark circles you want to lessen.

Step Two:

Select the Clone Stamp tool in the Toolbox. Then (from the Brush Picker in the Options Bar) choose a soft-edged brush that's half as wide as the area you want to repair.

Go up to the Options Bar and lower the Opacity of the Clone Stamp tool to 50%. Then, change the Blend Mode to Lighten (so you'll only affect areas that are darker than where you'll sample from).

Step Four:

Hold the Option key (PC: Alt key) and click once in an area near the eye that isn't affected by the dark circles. If the cheeks aren't too rosy, you can click there, but more likely you'll click (sample) on an area just below the dark circles under the eyes.

Step Five:

Now, take the Clone Stamp tool and paint over the dark circles to lessen or remove them (the result is shown at left). It may take two or more strokes for the dark circles to pretty much disappear, so don't be afraid to go back over the same spot if the first stroke didn't work.

Continued

Go to the Toolbox and choose the Patch tool (click-and-hold on the Healing Brush until the flyout menu appears as shown at right).

Step Two:

With the Patch tool, make sure that it's set to Source in the Options Bar and draw a selection around one of the dark circles under the eye (as shown at right). The Patch tool operates much like the Lasso tool for drawing selections. Also, like the Lasso tool, once your selection is in place, if you need to add to it, just hold the Shift key and "lasso" in some more area. If you need to subtract from your Patch tool selection, hold the Option key (PC: Alt key) instead.

Step Three:

After your selection is in place, click directly within the selected area and drag it to a part of the face that's clean and doesn't have any edges. By that I mean you don't want your dragged selection to overlap the edge of any other facial features such as the nose, lips, eyebrows, edge of the face, and so on. You need a clean uninterrupted area of skin.

Step Four:

After you've found that clean area, release the mouse button and the Patch tool will automatically sample it, snap back to the original selected area, and perform the retouch for you.

Step Five:

Press Command-D (PC: Control-D) to Deselect, and you'll see the dark circle is completely gone (as shown at left). The Healing Brush can also be used to diminish or erase dark circles, but the Patch tool does it so quickly and effortlessly that I greatly prefer it when it comes to dark circles.

Lessening Freckles or Facial Acne

This technique is popular with senior class portrait photographers who need to lessen or remove large areas of acne, pockmarks, or freckles. This is especially useful when you have a lot of photos to retouch (like a senior portrait retoucher) and don't have the time to use the methods shown previously, where you deal with each blemish individually.

Step One:

Open the photo that you need to retouch.

Step Two:

Go under the Filter menu, under Blur, and choose Gaussian Blur. When the Gaussian Blur dialog appears, drag the slider all the way to the left, and then drag it slowly to the right until you see the acne blurred away. The photo should look very blurry, but we'll fix that in just a minute, so don't let that throw you off—make sure it's blurry enough that the acne is no longer visible.

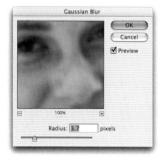

Go under the Window menu and choose History to bring up the History palette. This palette keeps track of the last 20 things you've done in Photoshop. If you look in the list of steps (called "History States"), you should see two States: the first will read "Open" (this is when you opened the document), and the second will read "Gaussian Blur" (this is where you added the blur).

Step Four:

Click on the Open State to return your photo to what it looked like when you originally opened it (as shown at left). The History palette also works in conjunction with a tool in the Toolbox, called the History Brush. When you paint with it, by default it paints back to what the photo looked like when you opened it. It's like "Undo on a brush." That can be very handy, but the real power of the History Brush is that you can have it paint from a different State. You'll see what I mean in the next step.

Step Five:

In the History palette, click in the first column next to the State named "Gaussian Blur." If you painted with the History Brush now, it would paint in what the photo looked like after you blurred it (which would do us no good), but we're about to fix that.

Continued

Step Six:

To keep from simply painting in a blurry version of our photo, go up to the Options Bar and change the History Brush's Blend Mode to Lighten. Now when you paint, it will affect only the pixels that are darker than the blurred state. Ahhh, do you see where this is going?

Step Seven:

Now you can take the History Brush and paint over the acne areas, and as you paint you'll see them diminish quite a bit (as shown at right). If they diminish too much, and the person looks "too clean," undo your History Brush strokes, then go up to the Options Bar and lower the Opacity of the brush to 50% and try again.

Before

After

Photoshop 7.0 introduced two new tools that are nothing short of miracle workers when it comes to removing wrinkles, crowsfeet, and other facial signs of aging. We've touched on these tools slightly in previous techniques in this chapter, but here's a closer look at how to use these amazing tools to quickly take 10 or 20 years off a person's appearance.

Removing the Signs of Aging

Step One:

Open the photo of the person whose signs of aging you want to remove.

Step Two:

Choose the Healing Brush from the Toolbox (as shown).

Hold the Option key (PC: Alt key) and click on an area of smooth skin (as shown). This samples the texture of the area you're clicking on and uses it for the repair.

Step Four:

With the I lealing Brush, paint a stroke over the wrinkles you want to remove (I painted over the wrinkles at the curve of his cheek). When you first paint your stroke, for a moment the tones won't match and it'll look like an obvious retouch; but a second later, the Healing Brush does its calculations and presents you with its final "magic" that beautifully blends in the original texture, seamlessly removing the wrinkle.

Step Five:

Continue this process of sampling a clean area and painting over a wrinkled area until all the signs of aging are removed. (The capture at right shows 30 seconds of retouching with the Healing Brush—a total of about five strokes.)

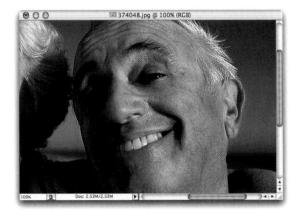

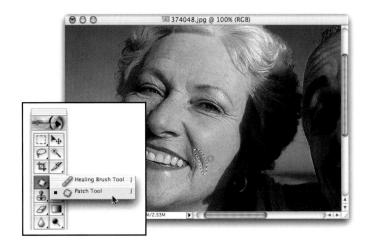

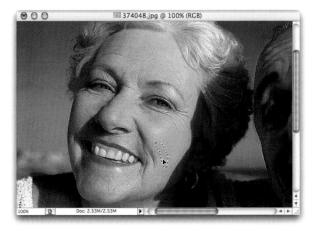

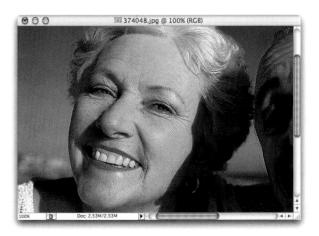

Step Six:

You can achieve similar results using the Patch tool (shown at left), and personally, I prefer this tool over the Healing Brush for most instances, because the Patch tool lets you correct larger areas faster. After you have the Patch tool, make sure that it's set to Source in the Options Bar and draw a selection around the wrinkled area (as shown here). It works like the Lasso tool, so if you need to add to your selection, hold the Shift key. To subtract from it, hold Option (PC: Alt).

Step Seven:

After your selection is in place, drag it to an area on the person's face that has a clean texture (as shown at left). Make sure your selected area doesn't overlap any other facial features (such as the nose, lips, eyes, edge of the face, etc.), and then release the mouse button. When you do, the selection will snap back to the area that you originally selected.

Step Eight:

After your Patch tool selection has snapped back into place, the wrinkles are gone. Press Command-D (PC: Control-D) to Deselect and view the amazing job the Patch tool did (as shown here).

Pro Wrinkle Removal

The Healing Brush and Patch tools are pretty amazing for removing wrinkles, but the problem may be that they do just that—they completely remove wrinkles. Depending on the age of the subject you're retouching, the photo may look obviously retouched (in other words, if you're retouching someone in their 70s and you make them look as if they're 20 years old, it's just going to look weird). Here's a simple trick Kevin Ames uses for more realistic healing.

Step One:

Open the photo you want to "heal."

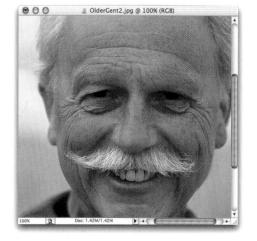

Step Two:

Duplicate the Background layer in the Layers palette by pressing Command-J (PC: Control-J). You'll perform your "healing" on this duplicate layer.

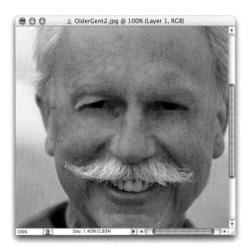

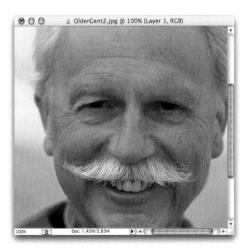

Use the Healing Brush to remove the wrinkled area. As you can see, with every wrinkle removed, this photo looks obviously retouched.

Step Four:

Go to the Layers palette and reduce the Opacity of this layer to bring back some of the original wrinkles. What you're really doing here is letting a small amount of the original photo (on the Background layer, with all its wrinkles still intact) show through. Keep lowering the Opacity until you see the wrinkles so they're visible but not nearly as prominent.

Step Five:

Here's the final retouch with the Opacity of the healed layer lowered to 47% so I'm getting just a little more than half the wrinkles back, and the photo looks much more realistic.

Dodging and Burning **Done Right**

If you've ever used Photoshop's Dodge and Burn tools, you already know how lame they are. That's why the pros choose this method instead—it gives them a level of control that the Dodge and Burn tools just don't offer, and best of all, it doesn't "bruise the pixels." (Photoshop-speak for "it doesn't mess up your original image data while you're editing.")

Step One:

In this tutorial, we're going to dodge areas of this person to add some highlights, and then we're going to burn in the background a bit to darken some of those areas. Start by opening the photo you want to dodge and burn.

Step Two:

Go to the Layers palette, and from the pop-down menu, choose New Layer. The reason you need to do this (rather than just clicking on the Create New Layer icon) is that you need to access the New Layer dialog box for this technique to work, and you don't get the dialog when you use the Create New Layer icon. If you're a pop-down menu hater or shortcut freak (you know who you are), you can Option-click (PC: Altkey) the Create New Layer icon instead to bring up the dialog.

In the New Layer dialog box, change the Mode to Overlay; then, right below it, choose "Fill with Overlay-neutral color (50% gray)." This is normally grayed out, but when you switch to Overlay mode, this choice becomes available. Click the checkbox to make it active, and then click OK.

Step Four:

This creates a new layer, filled with 50% gray, above your Background layer. (When you fill a layer with 50% gray and change the Mode to Overlay, Photoshop ignores the color. You'll see a gray thumbnail in the Layers palette, but the layer will appear transparent in your image window.)

Step Five:

Switch to the Brush tool, choose a large soft-edged brush, and then go up to the Options Bar and lower the Opacity to approximately 30%.

Press "d" then "x" to set your Foreground color to white. Begin painting over the areas that you want to highlight (dodge). As you paint, you'll see white strokes appear in the thumbnail of your gray transparent layer, and in the image window you'll see soft highlights.

Step Seven:

If your first stab at dodging isn't as intense as you'd like, just release the mouse button, click again, and paint over the same area. Because you're dodging at a low Opacity, the highlights will "build up" as you paint over previous strokes. If the highlights appear too intense, just go to the Layers palette and lower the Opacity setting until they blend in.

Step Eight:

If there are areas you want to darken (burn), just press "d" to switch your Foreground color to black and begin painting in the areas that need darkening. In this example, the basket looked a little light, so I burned it in a bit to darken it and make it less prominent. Okay, ready for another dodging and burning method? Good, 'cause I've got a great one.

Soft Light

Lock: 🖸 🖋 💠 🚨

Step Nine:

This really isn't Step Nine; it's another way of dodging and burning that I learned from Jim DiVitale, and I have to admit—I'm starting to really dig it. You still do the dodging and burning on a separate layer (no bruising pixels), but you don't have to go through all the New Layer dialog hoops. Just click the New Layer icon, and then change the Mode in the Layers palette to Soft Light (as shown at left).

Step Ten:

This is really Step Two of Jim's technique. Now, just set white as your Foreground color, and you can dodge right on this layer using the Brush tool set to 30% Opacity. To burn, just as before—switch to black. The dodging and burning using this Soft Light layer does appear a bit softer and milder than the previous technique, and you should definitely try both to see which one you prefer.

Colorizing Hair

This technique (that I learned from Kevin Ames) gives you maximum control and flexibility while changing or adjusting hair color, and because of the use of Layer Masks and an Adjustment Layer, you're not "bruising the pixels." Instead, you're following the enlightened path of "non-destructive retouching."

Step One:

Open the photo you want to retouch.

Step Two:

Choose Color Balance from the Adjustment Layer pop-up menu at the bottom of the Layers palette. When the dialog appears, move the sliders toward the color you'd like as the hair color. You can adjust the shadows, midtones, and highlights by selecting each in the Tone Balance section of the Color Balance dialog and then moving the color sliders.

Step Three:

In this case, we want to make the hair more red, so we'll move the top slider toward Red for the shadows, then the midtones, and then the highlights. Now, click OK, and the entire photo will have a heavy red cast over it (as shown).

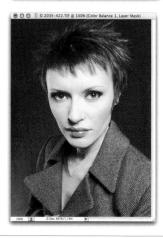

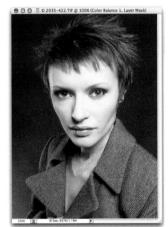

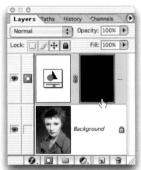

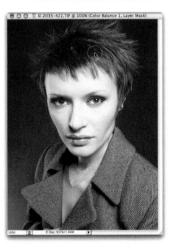

Step Four:

Press "x" until your Foreground color is black, and press Option-Delete (PC: Alt-Backspace) to fill the Color Balance mask with black. Doing so removes the red tint from the photo.

Step Five:

Get the Brush tool in the Toolbox, choose a soft-edged brush, press "d" to set your Foreground color to white, and begin painting over her hair. As you paint, the red tint you added with Color Balance is painted back in (as shown).

Step Six:

Continue painting on the hair until it's fully tinted (far left). You may want to paint a few strokes over her eyebrows as well. Once the hair is fully painted, change the Blend Mode of your Color Balance Adjustment Layer to Color, and then lower the Opacity until the hair color looks natural (as shown at near left).

This is a great little technique for quickly whitening the whites of the eyes, and it has the added benefit of removing any redness in the eye along the way.

Step One:

Open the portrait you want to retouch.

Step Two:

Choose the Lasso tool from the Toolbox and draw a selection around the whites of one of the eyes. Hold the Shift key and draw selections around the whites of the other eye, until all the whites are selected in both eyes.

Step Three:

Go under the Select menu and choose Feather. You'll need to use Feather to soften the edges of your selection so your retouch isn't obvious. In the Feather Selection dialog, enter 2 pixels and click OK.

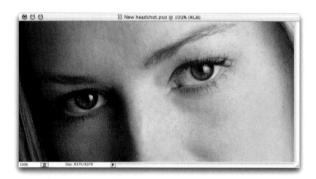

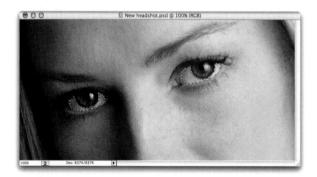

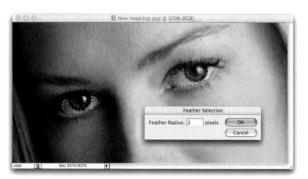

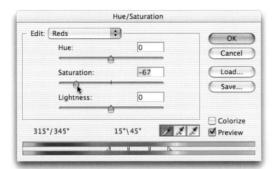

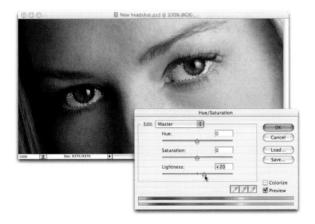

Step Four:

Go under the Image menu, under Adjustments, and choose Hue/Saturation. When the Hue/Saturation dialog appears, choose Reds from the Edit pop-up menu at the top (to edit just the reds in the photo). Now, drag the Saturation slider to the left to lower the amount of saturation in the reds (which removes any bloodshot appearance in the whites of the eyes).

Step Five:

While you're still in the Hue/Saturation dialog, from the Edit menu switch back to Master. Drag the Lightness slider to the right to increase the lightness of the whites of the eyes (as shown here).

Step Six:

Click OK in the Hue/Saturation dialog to apply your adjustments, and then press Command-D (PC: Control-D) to Deselect and complete the enhancement.

Whitening Eyes

Here's Kevin's technique for brightening the whites of the eyes, and I have to say, even though it takes a little longer and has a few more steps, it really does a brilliant job, and offers the most realistic whites brightening I've seen.

Step One:

Open the photo with eyes you want to whiten.

Step Two:

Go to the Layers palette and choose Curves from the Adjustment Layer popup menu at the bottom of the palette. When the Curves dialog appears, don't make any adjustments—just click OK. When the Curves Adjustment Layer appears in your Layers palette, change the Blend Mode of this Adjustment Layer to Screen.

Step Three:

When you switch to Screen Mode, the entire photo will lighten. Press the letter "x" until your Foreground color is black; then press Option-Delete (PC: Alt-Backspace) to fill the Curves Adjustment Layer mask with black. This removes the lightening effect brought on by changing the Mode to Screen.

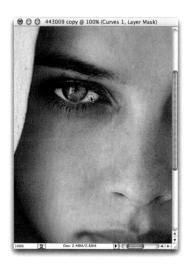

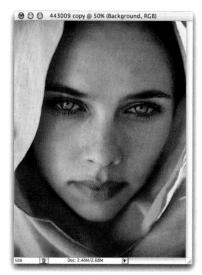

Before

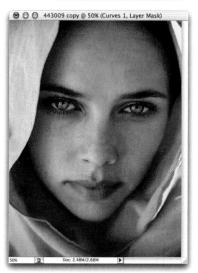

After

Step Four:

Press the letter "d" to switch your Foreground color to white. Then get the Brush tool, choose a very small, softedged brush, and paint over the whites of the eyes and along the bottom of the eyelid. As you paint, it brings back the Screen effect you applied earlier, lightening the areas where you paint.

Step Five:

The eyes will look too white (giving your subject a possessed look), so lower the Opacity of this Curves Adjustment Layer to make the whitening more subtle and natural.

Step Six:

Here's the final whitening with the Opacity of the Curves Adjustment Layer down to just 35%. Compare this with the original photo (far left), and you can see the difference, yet the eyes still look natural.

Enhancing and Brightening Eyes

This is another one of those "30-second miracles" for brightening eyes, enhancing the catch lights, and generally drawing attention to the eyes by making them look sharp and crisp (crisp in the "sharp and clean" sense, not crisp in the "I burned my retina while looking at the sun" kind of crisp).

Step One:

Open the photo you want to retouch.

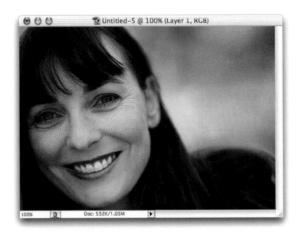

Step Two:

Go under the Filter menu, under Sharpen, and choose Unsharp Mask. When the Unsharp Mask dialog appears, enter your settings (if you need some settings, go to the first technique in the Sharpening chapter); then click OK to sharpen the entire photo.

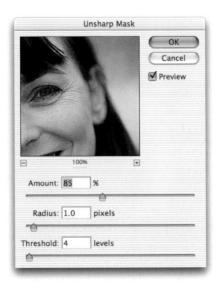

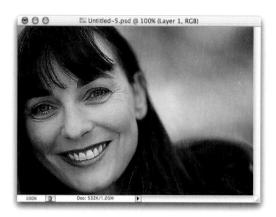

After you've applied the Unsharp Mask filter, apply it again using the same settings by pressing Command-F (PC: Control-F), and then apply it one more time using the same keyboard shortcut (you'll apply it three times in all). The eyes will probably look nice and crisp at this point, but the rest of the person will be severely oversharpened, and you'll probably see lots of noise and other unpleasant artifacts.

Step Four:

Go under the Window menu and choose History to bring up the History palette. This palette keeps track of your last 20 steps, and you'll see the four steps you've done thus far listed in the palette (an Open step, followed by three Unsharp Mask steps. By the way, these steps are actually called "History States"). Click on the Open State to return your photo to how it looked before you applied the Unsharp Mask filter.

Step Five:

In the History palette, click once in the first column beside the last Unsharp Mask State (as shown in the previous capture). Now, switch to the History Brush and choose a soft-edged brush about the size of the iris. Click once right over the iris, and it will paint in the crisp, thrice-sharpened eye, leaving the rest of the face untouched. It does this because you clicked in that first column in the History palette. That tells Photoshop "paint from what the photo looked like at this point." Pretty cool!

Enhancing Eyebrows and Eyelashes

After Kevin Ames showed me this technique for enhancing eyebrows and eyelashes, I completely abandoned the method I'd used for years and switched over to this method because it's faster, easier, and more powerful than any technique I've seen yet.

Step One:

Open the photo that you want to enhance.

Step Two:

Get the Lasso tool from the Toolbox and draw a loose selection around the eyebrow. It isn't necessary to make a precise selection; make it loose like the one shown here. In this example, there's only one eyebrow, but if there are two (meaning they don't have a uni-brow), after you select one eyebrow, hold the Shift key down and select the other eyebrow.

Step Three:

After your eyebrow(s) is selected, press Command-J (PC: Control-J) to put the eyebrow(s) on its own separate layer (as shown).

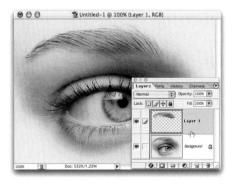

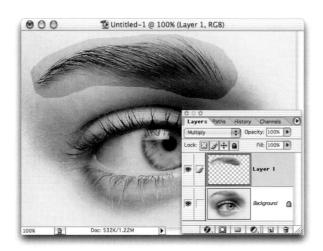

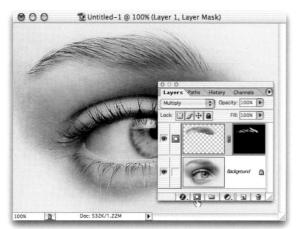

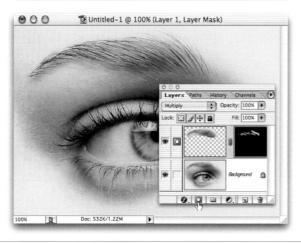

Step Four:

In the Layers palette, switch the Blend Mode of this eyebrow layer from Normal to Multiply, which will darken the entire layer (as shown here).

Step Five:

Hold the Option key (PC: Alt key) and click on the Layer Mask icon at the bottom of the Layers palette (as shown). Holding down the Option/Alt key fills the Layer Mask with black, which hides the Multiply effect from view. As you can see, the eyebrow looks normal again. Next, press the letter "d" to make white your Foreground color.

Step Six:

Choose a soft-edged brush that's about the size of the largest part of the eyebrow. Go up in the Options Bar and lower the Opacity of your brush to 50%. Now, paint over the eyebrows, going from right to left. As you paint, hold the Left Bracket key to make your brush smaller as you trace the eyebrow. As you do, it darkens the eyebrow by revealing the Multiply effect.

Continued

Step Seven:

Now on to the eyelashes. Get the Lasso tool again and draw a loose selection around the eye(s), and make sure your loose selection fully encompasses the eyelashes (as shown here).

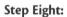

Once the eye and eyelash area is fully selected, press Command-J (PC: Control-J) to copy it up to its own separate layer. Change the Blend Mode of this layer to Multiply, which darkens the entire layer (as shown).

Step Nine:

Hold the Option key (PC: Alt key) and click on the Layer Mask icon at the bottom of the Layers palette to add a Layer Mask filled with black to this layer. Just like on the eyebrows, doing this will hide the Multiply effect (as shown).

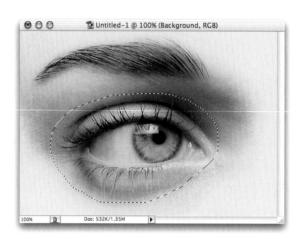

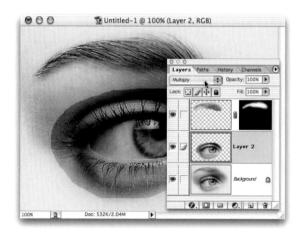

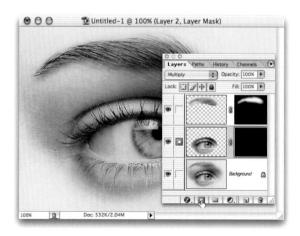

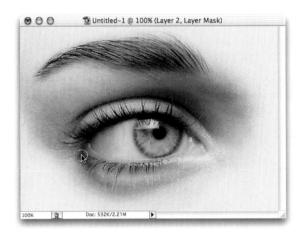

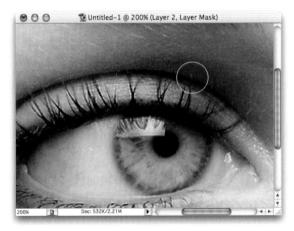

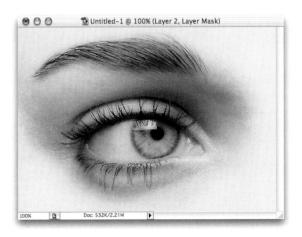

Step Ten:

Make sure your Foreground color is still set to white, and then choose a very small soft-edged brush and paint along the base of the eyelashes to darken that area (as shown). Also paint along the top eyelid, at the base of the eyelashes to make the lashes appear thicker, fuller, longer, and more luxurious. (Maybe she's born with it, maybe it's Maybelline, or just maybe it's a Photoshop Multiply layer with a Layer Mask and a soft-edged brush.)

Step Eleven:

When it comes to enhancing individual lashes, zoom in close on the eye and choose a very, very small brush (as shown). Then start at the base of the eyelash (where it meets the lid) and trace the eyelash, following its contours to darken them. You may have to use a 1- or 2-pixel-sized brush to trace the lashes, but it will be worth it.

Step Twelve:

When you're done painting over the eyelashes, zoom back out to reveal your final retouch (as shown here). Compare the eyelashes shown here with the ones in Step Seven to see the difference. If the effect seems a bit too intense to you, just lower the Opacity of either layer. (Incidentally, the reason we put the eyelashes and eyebrows on separate layers, rather than doing them at the same time, is so you can control the Opacity of each part individually.)

Whitening Teeth

This really should be called "Removing Yellowing, Then Whitening Teeth" because almost everyone has some yellowing, so we remove that first before we move on to the whitening process. This is a simple technique, but the results have a big impact on the overall look of the portrait, and that's why I do this to every single portrait where the subject is smiling.

Step One:

Open the photo you need to retouch.

Step Two:

Switch to the Lasso tool, and carefully draw a selection around the teeth, being careful not to select any of the gums (as shown here).

Step Three:

Go under the Select menu and choose Feather. When the Feather Selection dialog appears, enter 1 pixel and click OK to smooth the edges of your selection. That way, you won't see a hard edge along the area you selected after you've whitened the teeth.

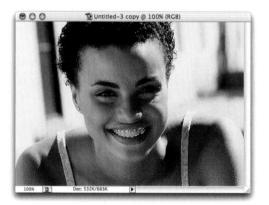

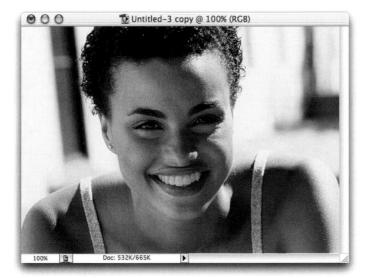

Step Four:

The Photoshop Book

Go under the Image menu, under Adjustments, and choose Hue/Saturation. When the dialog appears, choose Yellows from the Edit pop-up menu at the top. Then, drag the Saturation slider to the left to remove the yellowing from the teeth.

Step Five:

Now that the yellowing is removed, switch the Edit pop-up menu back to Master, and drag the Lightness slider to the right to whiten and brighten the teeth. Be careful not to drag it too far, or the retouch will be obvious.

Step Six:

Click OK in the Hue/Saturation dialog, and your enhancements will be applied. Last, press Command-D (PC: Control-D) to Deselect and see your finished retouch (shown here).

Removing **Hot Spots**

If you've ever had to deal with hot spots (shiny areas on your subject's face caused by uneven lighting or the flash reflecting off shiny surfaces, making your subject look as if he or she is sweating), you know they can be pretty tough to correct. That is, unless you know this trick.

Step One:

Open the photo that has hot spots that need to be toned down.

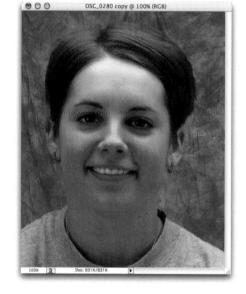

Step Two:

Select the Clone Stamp tool in the Toolbox. Up in the Options Bar, change the Blend Mode from Normal to Darken, and lower the Opacity to 50%. By changing the Blend Mode to Darken, we'll only affect pixels that are lighter than the area we're sampling, and those lighter pixels are the hot spots.

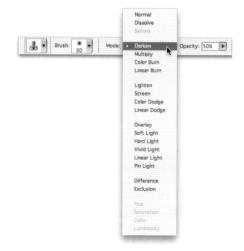

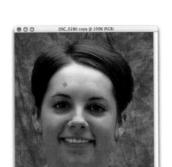

DSC, 0280 crey © 100% GCB

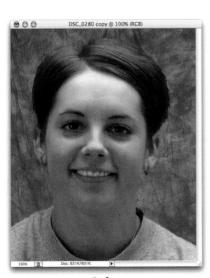

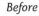

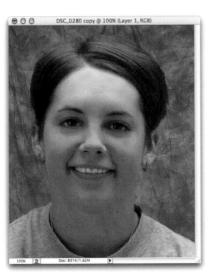

After

Step Three:

Make sure you have a large, soft-edged brush; then hold the Option key (PC: Alt key) and click once in a clean area of skin (an area with no hot spot) as shown here, above her left eye. This will be your sample area, or reference point, so Photoshop knows to affect only pixels that are lighter than this.

Step Four:

Start gently painting over the hot spot areas with the Clone Stamp tool, and as you do, the hot spots will fade away. As you work on different hot spots, you'll have to resample (Option-/Alt-click) on nearby areas of skin so the skin tone matches. For example, when you work on the hot spots on her nose, sample an area of skin from the bridge of her nose where no hot spots exist.

Step Five:

Here's the result after about 60 seconds of hot-spot retouching using this technique. Notice how the hot spots on her forehead and tip of her nose are now gone. Much of this was done with brush strokes, but just clicking once or twice with the Clone Stamp tool often works too.

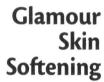

This is another technique I learned from Chicago-based retoucher David Cuerdon. David uses this technique in fashion and glamour photography to give skin a smooth, silky feel.

Step One:

Open the photo that you want to give the glamour skin-softening effect and duplicate the Background layer. The quickest way to duplicate a layer is to press Command-J (PC: Control-J).

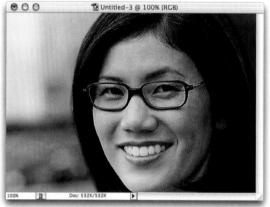

Step Two:

Go under the Filter menu, under Blur, and choose Gaussian Blur. When the dialog appears, enter between 3 and 6 pixels of blur (depending on how soft you want the skin), to put a blur over the entire photo.

Next, lower the Opacity of this layer by 50% (as shown at left). At this point, the blurring effect is reduced, and now the photo has a soft glow to it. In some cases, you may want to leave it at this, with an overall soft, glamorous effect (you sometimes see portraits of senior citizens with this overall softening) so your retouch is complete. If this is too much softening for your subject, go on to the next step.

Step Four:

What really pulls this technique together is selectively bringing back details in some of the facial areas. Switch to the Eraser tool, choose a soft-edged brush, and erase over the facial areas that are supposed to have sharp detail (her eyes, eyebrows, lips, and teeth). What you're doing is erasing the blurry eyes, eyebrows, lips, and teeth, and thereby revealing the original features on the layer beneath your blurry layer.

Step Five:

David completes his retouch at Step Four, leaving the subject's clothes, hair, background, etc. with the soft glow. I prefer to switch to a larger soft-edge Eraser tool and erase over everything else except her skin—so I erase over her hair, and the background so everything has sharp detail except her skin. This is totally a personal preference, so I recommend trying both and seeing which fits your particular needs.

This is a technique I picked up from Kevin Ames that does an amazing job of simulating a Hasselblad Softar #2 filter in that it softens the skin tones, but at the same time introduces a little bit of soft flare and lowers the contrast of the image. Perfect for fashion photography.

Step One:

Open the photo you want to soften.

Step Two:

Press Command-J (PC: Control-J) twice to create two duplicates of your Background layer in the Layers palette. Then, hide the top copy (Layer 1 copy) by clicking on the Eye icon next to it in the Layers palette, and then click on the middle layer (Layer 1) to make it active (as shown).

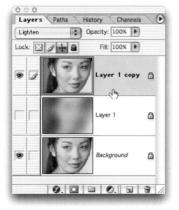

In the Layers palette, switch the Blend Mode of this middle layer to Darken.

Step Four:

Go under the Filter menu, under Blur, and choose Gaussian Blur. Apply a 40-pixel blur to the photo.

Step Five:

In the Layers palette, hide the middle layer from view, and then click on the top layer (Layer 1 copy). Change the Blend Mode of this top layer to Lighten.

Continued

Step Six:

Now, run a 60-pixel Gaussian Blur on this top layer.

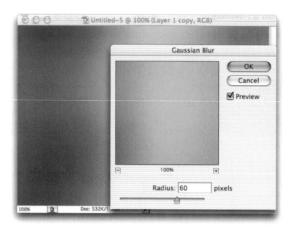

Step Seven:

After you've applied the blur, click back on the middle layer (Layer 1) and lower its Opacity to 40% in the Layers palette.

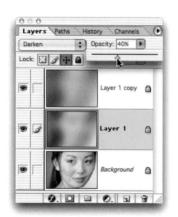

Step Eight:

Hide the Background layer from view, and then create a new layer by clicking on the Create New Layer icon at the bottom of the Layers palette. Click-and-drag this layer to the top of your layer stack (as shown). Then, hold the Option key (PC: Alt key) and choose Merge Visible from the Layers palette's pop-down menu. This creates a flattened version of your document in your new layer.

Step Nine:

In the Layers palette, make the Background layer visible again (as shown), but hide the two duplicate layers in the middle (Layer 1 and Layer 1 copy).

Step Ten:

Make sure the top layer in the stack (Layer 2) is the active layer, and then lower the Opacity of this layer to 40%.

Step Eleven:

Lowering the Opacity of that layer creates the overall softening effect (which is fine if you want an overall effect), but in most cases, you won't want to soften the detail areas (eyes, lips, etc.).

Step Twelve:

Click on the Layer Mask icon at the bottom of the Layers palette to add a layer mask to your blurred layer. Press the letter "x" until your Foreground color is black, get the Brush tool, use a soft-edged brush, and paint over the areas that should have full detail (lips, eyes, eyebrows, eyelashes, hair, clothing—pretty much everything but the skin). The upper photo shows the results of the softening effect. The photo below it shows the original (from Step One) without the softening.

The original photo before applying the skin softening technique.

The final photo with softened skin.

This is a pretty slick technique for taking a photo where the subject was frowning and tweaking it just a bit to add a pleasant smile in its place—which can often save a photo that otherwise would've been ignored.

Transforming a Frown into a Smile

Step One:

Open the photo that you want to retouch.

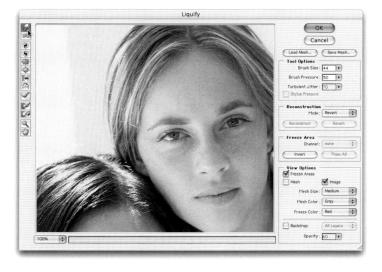

Step Two:

Go under the Filter menu and choose Liquify. When the Liquify dialog appears, choose the Zoom tool (it looks like a magnifying glass) from the the Liquify Toolbar (found along the left edge of the dialog). Click it once or twice within the preview window to zoom in closer on your subject's face. Then, choose the Warp tool (it's the top tool in Liquify's Toolbar, as shown here).

Continued

Press the Left/Right Bracket keys on your keyboard to adjust the brush size until it's about the size of the person's cheek. Place the brush near the corner of their mouth (as shown at right), click and "tug" slightly up. This tugging of the cheek makes the corner of the mouth turn up, creating a smile.

Step Four:

Repeat the "tug" on the opposite side of the mouth, using the already tugged side as a visual guide as to how far to tug. Be careful not to tug too far, or you'll turn your subject into the Joker from Batman Returns.

Step Five:

Click OK in Liquify to apply the change, and the retouch is applied to your photo (as shown at right).

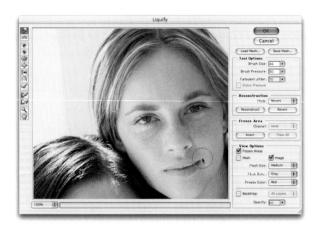

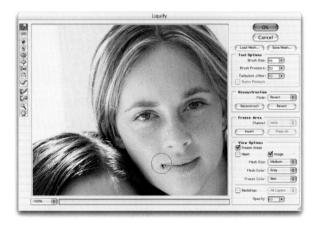

This is a very simple technique for decreasing the size of your subject's nose by 15 to 20%. The actual shrinking of the nose part is a breeze and only takes a minute or two—you may spend a little bit of time cloning away the sides of the original nose, but since the new nose winds up on its own layer, it makes this cloning a lot easier. Here's how it's done:

Digital Nose Job

Step One:

Open the photo that you want to retouch. Get the Lasso tool, and draw a loose selection around your subject's nose. Make sure you don't make this selection too close or too precise—you need to capture some flesh tone area around the nose as well (as shown here).

Step Two

To soften the edges of your selection, go under the Select menu and choose Feather. When the Feather Selection dialog appears, for Feather Radius enter 10 pixels (for high-res, 300-ppi images, enter 22 pixels), and then click OK.

Step Three:

Now, press Command-J (PC: Control-J) to copy your selected area onto its own layer in the Layers palette.

Continued

Step Four:

Press Command-T (PC: Control-T) to bring up the Free Transform bounding box. Hold Shift-Option-Command (PC: Shift-Alt-Control); then grab the upperright corner point of the bounding box and drag inward to add a perspective effect to the nose. Doing this gives the person a pug nose, so release all the keys, and then grab the top-center point (as shown) and drag straight downward to undo the "pug effect" and make the nose look natural again, but now it's smaller.

Step Five:

When the new size looks about right, press Return (PC: Enter) to lock in your changes. If any of the old nose peeks out from behind the new nose, click on the Background layer and use the Clone Stamp tool to clone away those areas: Sample an area next to the nose, and then paint (clone) right over it. Compare the before shot (middle right) with the retouched version (bottom right) and you can see what a dramatic change our 30-second retouch made in the image.

Before

After

Don't ask me how Kevin Ames came up with this one, but as soon as he showed it to me, I knew I had to include it in the book. It's the easiest, most direct, and most effective way that I've seen of reducing the intensity of nostrils.

De-Emphasizing Nostrils

Step One:

Open a photo where you want to de-emphasize the subject's nostrils.

Step Two:

Choose the Healing Brush tool from the Toolbox.

Option-click (PC: Alt-click) the Healing Brush in a clean area of skin on the cheek or general face area (as shown).

Step Four:

Paint with the Healing Brush over the nostril areas (as shown). As you paint, the bright skin area will appear over the nostril.

Step Five:

When you release the mouse button, the texture of the area you sampled will appear in the nostril. It will appear darker than it did in Step Four (as the Healing Brush does its "thing"), but it will most likely be too light and look a bit milky.

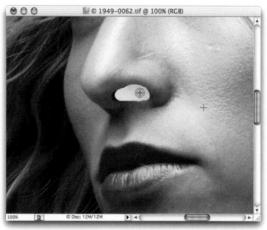

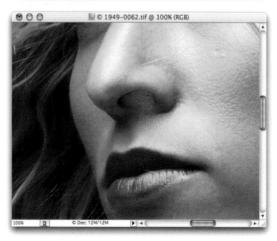

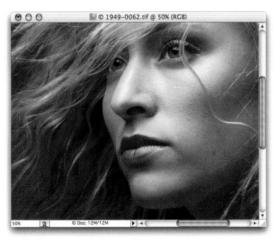

After

Before

Step Six:

Go under the Edit menu and choose Fade Healing Brush. When the Fade dialog appears (shown here), lower the Opacity slider until the nostril looks more natural—lighter and less distracting because of your retouch with the Healing Brush.

Step Seven:

Here's the final photo with the Healing Brush faded to 32%. The retouch should be somewhat subtle, but compare the capture shown here with the original photo shown below it, and you can see how the emphasis is taken off the nostril and is returned to the eyes.

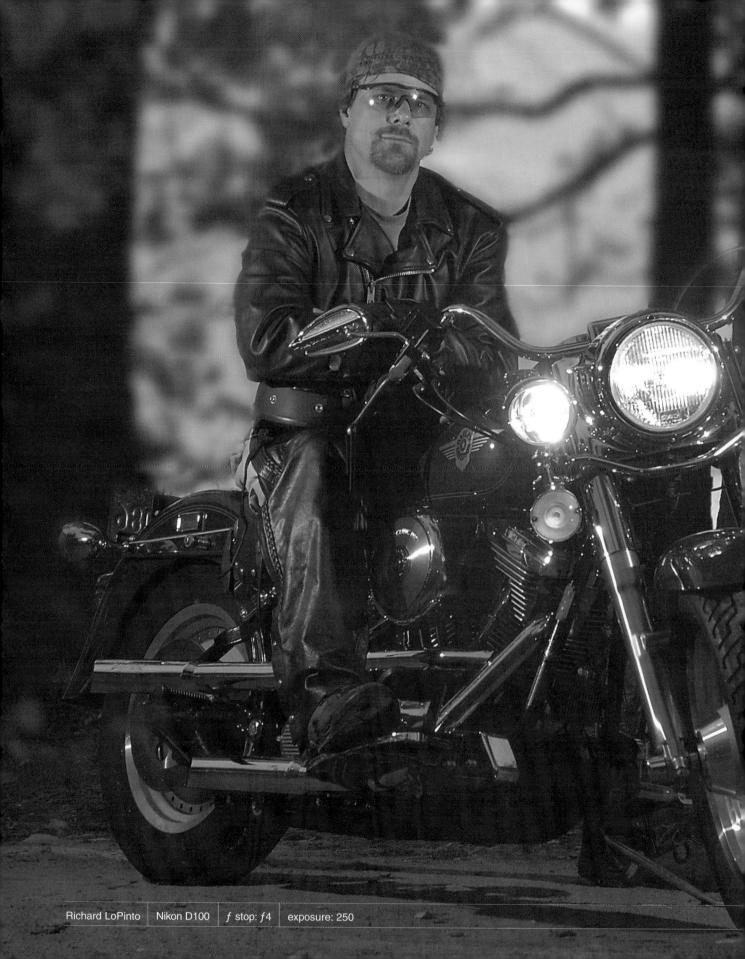

Okay, if you remember that movie (*Invasion of the Body Snatchers*), you're way older than I am (remember, I'm only 19); therefore, for the rest of this chapter intro, I'll refer to you as either "gramps" or "meemaa"

Invasion of the Body Snatchers body sculpting

(depending on your gender and what kind of mood I'm in). This chapter is a testament to the fact that people's bodies are simply not perfect, with the possible exception of my own, which I might say is pretty darn fine because of all the healthy food I eat at sundry drive-thru eating establishments that shall remain nameless (Wendy's). Anyway, your goal (my goal, our common goal, etc.) is to make people look as good in photos as they look in real life. This is a constant challenge because many people eat at McDonald's. Luckily, there are a ton of tricks employed by professional retouchers (who use terms like digital plastic surgery, botox in a box, digital liposuction, liquid tummy tucks, noselectomies, stomalectomies, and big ol' nasty feetalectomies) that can take a person who hasn't seen a sit-up or a stomach crunch since they tested for the President's Council on Physical Fitness and Sports (which for me, was just one year ago, when I was a senior). In this chapter, you'll learn the pros' secrets for transforming people who basically look like Shrek into people who look like the person who produced Shrek (I don't really know who that is, but those Hollywood types always look good, what with their personal trainers and all).

Slimming and Trimming

This is an incredibly popular technique because it consistently works so well, and because just about everyone would like to look about 10-15 pounds thinner. I've never applied this technique to a photo and (a) been caught, or (b) not had the client absolutely love the way they look. The most important part of this technique may be not telling the client you used it.

Step One:

Open the photo of the person that you want to put on a quick diet.

Step Two:

Press Command-A (PC: Control-A) to put a selection around the entire photo. Then press Command-T (PC: Control-T) to bring up the Free Transform function. The Free Transform handles will appear at the corners and sides of your photo. These handles might be a little hard to reach, so I recommend expanding your image window a little bit by dragging its bottom-right corner outward. This makes some of the gray canvas area visible (as shown here), and makes grabbing the Free Transform handles much easier.

Before

After

Grab the left-center handle and drag it horizontally toward the right to slim the subject. The farther you drag, the slimmer they become. How far is too far (in other words, how far can you drag before people start looking like they've been retouched)? Look up in the Options Bar at the W (width) field for a guide.

Step Four:

You're pretty safe to drag inward to around 95%, although I've been known to go to 94% or even 93% once in a while (it depends on the photo).

Step Five:

Press Return (PC: Enter) to lock in your transformation. Now that you've moved the image area over a bit, you'll have to use the Crop tool to crop away the white background area that is now visible on the left side of your photo.

Step Six:

Press the Return key (PC: Enter key) to complete your crop. Compare this photo (after) with the before image (far left), and you can see how effective this simple little trick is at slimming and trimming your subject. Also, notice that because we didn't drag too far, the subject still looks very natural.

Removing Love Handles

This is a very handy body-sculpting technique, and you'll probably be surprised at how many times you'll wind up using it. It uses Liquify, which many people first dismissed as a "toy" for giving people "bug-eyes" and "huge lips," but it didn't take long for professional retouchers to see how powerful this tool could really be.

Step One:

Open the photo that has a love handle repair just waiting to happen. (In the photo at right, we're going to remove the love handle on the man's left side.)

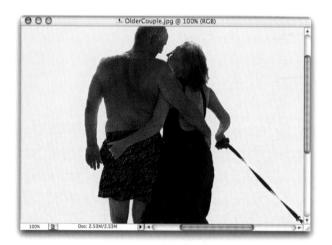

Step Two:

Go under the Filter menu and choose Liquify. When the Liquify dialog appears, click on the Zoom tool in the Toolbar on the left-hand side of the dialog, and then drag out a selection around the area you want to work on to give you a close-up view for greater accuracy.

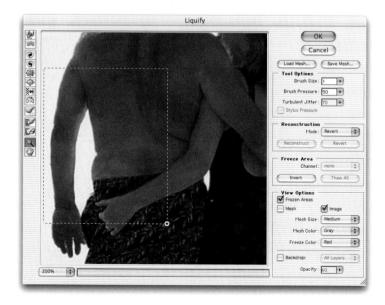

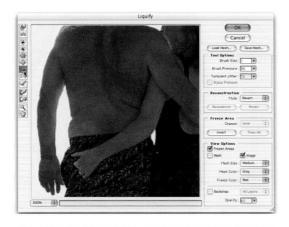

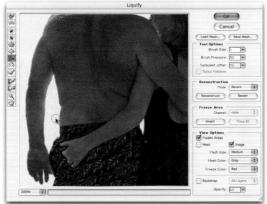

Try to disregard the fact that by all appearances, she's grabbing his butt, and get the Shift Pixels tool from Liquify's Toolbar (it's the seventh tool down).

Step Four:

Choose a relatively small brush size (like the one shown here) using the Brush Size field near the top-right of the Liquify dialog. With it, paint a downward stroke starting just above and outside the love handle and continuing downward. The pixels will shift back in toward his body, removing the love handle as you paint. (Note: If you need to remove love handles on his right side, paint upward rather than downward. Why? That's just the way it works.)

Step Five:

When you click OK, the love handle repair is complete. (Compare the retouch here with the original photo in Step One and you'll see the difference a quick 30-second retouch can make.)

Slimming Thighs and Buttocks

This is a technique I picked up from Helene DeLillo that works great for trimming up thighs and buttocks by repositioning parts of the existing areas. It's deceptively simple and amazingly effective.

Step One:

Open the photo that you need to retouch.

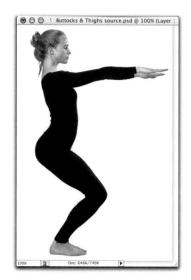

Step Two:

Get the Lasso tool from the Toolbox and make a selection loosely around the area you want to retouch. It's important to select some background area (as shown here) because that background will be used to cover over the existing area. The more you need to trim from the person, the more background area you need to select.

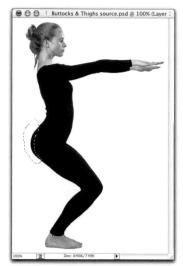

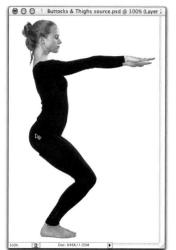

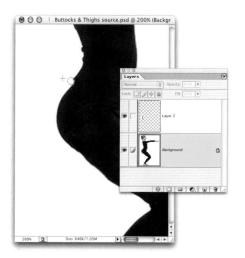

Once you have your selection in place, press Command-J (PC: Control-J) to put the selected area up on its own layer.

Step Four:

Press "v" to switch to the Move tool, click on the area you had selected (it's on its own separate layer now), and drag inward toward the rest of her body. You're literally moving the edge of her body inward, thereby reducing the width of her thigh and buttocks.

Step Five:

When you do this, you'll usually have a small chunk of the old body left over that you'll have to remove from the original Background layer. Use the Zoom tool to zoom in; then click on the Background layer. Get the Clone Stamp tool, make sure its Mode in the Options Bar is set to Normal, and Option-click (PC: Alt-click) in an area very near where you need to retouch (as shown here, where I sampled from the area just next to the tiny chunk at the base of her spine). Then clone the background over the body to produce smooth curves.

Continued

Step Six:

After you've removed those little chunks (I know, "chunks" probably isn't the best word to use, but yet on some level, it fits), this side of the retouch is done. Now on to the other thigh.

Step Seven:

This time, we're going to select the bottom of her right thigh with the Lasso tool (as shown), and once it's selected, press Command-J (PC: Control-J) to put that selected area up on its own layer (see the Layers palette top right).

Step Eight:

Switch to the Move tool, and drag inward toward the rest of her leg to slim the thigh.

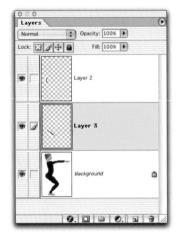

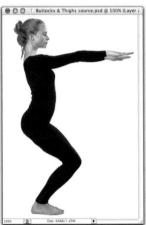

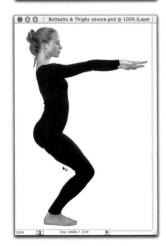

Step Nine:

Again, you'll probably have little chunks (okay, how about "shards" or "pieces" instead? Nah. It's chunks) that you'll have to remove, so switch to the Background layer, get the Clone Stamp tool again, Option-click (PC: Alt-click) near the area you need to retouch, and clone the background area over the chunks.

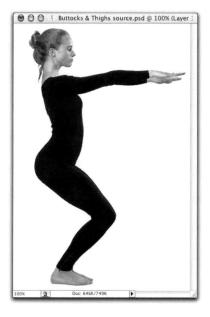

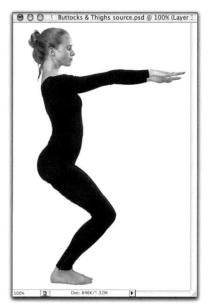

Before

After

Step Ten:

After you've cloned over all the chunks (this process is called "dechunkinization"—not really, but it should be), the retouch is complete. Compare the before photo (left) and the after photo (right) to see the difference.

NOTE: What made this retouch easier was the fact that the photo had a relatively simple background and she was wearing black pants. If you perform this retouch on actual skin, when you move it, you may have a visible hard line to deal with (especially if a lot of shadows are present on the subject's skin). The trick is to lower the Clone Stamp tool's Opacity to 50% in the Options Bar, sample just outside the hard line, and then clone over the line to make it blend in with the existing skin. It's easier than it sounds. Also, if the background is more detailed, you may have to do more cloning to remove any leftover areas. It may not be just little chunks but a bit of tedious cloning to fill in the gaps, but the Clone Stamp will usually do the trick.

Fixing Grannies

This is a body-sculpting technique I picked up (once again) from Kevin Ames, and it's great for trimming any excess skin from underarms (these excess areas are sometimes referred to as "grannies" by mean retouchers).

Step One:

Open the photo that has an arm you want to tuck in, making it look thinner.

Step Two:

Get the Pen tool from the Toolbox and click it once at the base of her arm (near her armpit); then, moving to her elbow area, click-and-drag to create the second point. As you drag, the path will curve. Your goal is to have this part of the path dig a little bit into her skin (as shown), because you're now determining where the arm's edge will soon be.

Step Three:

Draw any points you need to close this path (bringing the path back to the point where you started). Then, press Command-Return (PC: Control-Enter) to turn the path into a selection.

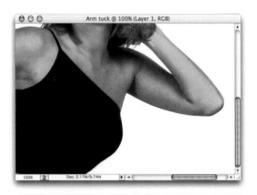

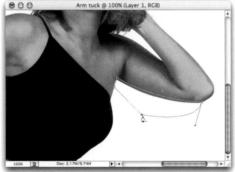

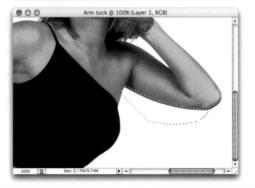

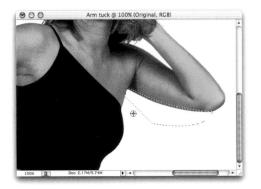

Step Four:

Get the Clone Stamp tool from the Toolbox and Option-click (PC: Alt-click) on a background area near the arm you want to retouch (as shown).

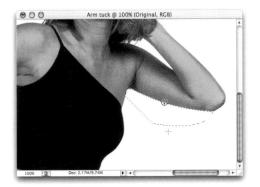

Step Five:

Choose a soft-edged brush, and clone over the edge of the arm that falls within the selected area. Because you isolated the area first, you can't accidentally erase too much of her arm—Photoshop won't let you clone outside the selected area. Also, it's okay to use a soft-edged brush, because whichever brush you use, hard or soft, it will be stopped at the edge of the selected area.

Step Six:

Press Command-D (PC: Control-D) to Deselect and view the final result. Compare this photo with the one shown in Step One.

Borrowing Body Parts (Cheating)

This is a body-sculpting technique that is done more often than you think, and I call it cheating because you basically clone body parts onto your client's body from a photo of somebody with a better body. Of course, these "stolen" body parts usually don't match up, so you'll need some Photoshop magic to blend them in so even the subject won't know what you've done. What does all this mean? It usually means your client will be your best friend for life (as long as you never reveal your secret).

Step One:

Open the photo that you want to apply some body sculpting to. In this example, we're going to sculpt two parts: We're going to reduce the hips on the woman on the far right, and then we're going to add a stomach with more definition (and a visible belly button) to the woman in the middle.

Step Two:

First the hips: Choose the Clone Stamp tool from the Toolbox, hold the Option key (PC: Alt key), and click in a background area right beside the area you want to retouch (as shown here, where I'm sampling from just to the left of her hip). Note: You may want to zoom in a little to get a close-up view of the area you're working on (as seen in the capture in Step Three).

Choose a hard-edged brush and literally "dig in" to the skin (as shown here) and paint a downward stroke. As you do, the edge of her hip is replaced with the cloned sample background. The key here is the hard-edged brush; because her skin has a hard edge (it's not delicate, like hair), then you have to choose a brush that matches the edge. If you tried this with a soft-edged brush, it would look blurry on the edges, and be an absolute dead giveaway.

Step Four:

Here's what the final hip reduction looks like after you complete the downward stroke. Now, on to adding a new tummy. (I use the word tummy, rather than stomach, because I have a 51/2-year-old, which totally changes your vocabulary. Okey-dokey?)

Step Five:

Add a new blank layer by clicking on the Create New Layer icon at the bottom of the Layers palette (as shown near left). We'll add the new tummy on this layer, so later, if we need to, we can lower the Opacity, rotate the tummy, change Blend Modes, and so on.

Continued

Step Six:

Open the photo containing body parts that you want to steal. In this example, we'll be stealing the stomach from a photo of this model. When I first opened the photo, the angle of her stomach was the opposite of what you see here, so I opened Free Transform and chose Flip Horizontal to make the model's stomach the same angle as our retouch stomach.

Step Seven:

Make sure both photos are visible on screen at the same them. Get the Clone Stamp tool, hold the Option key (PC: Alt key), and click once on the area in the stomach source photo to sample (clone) from that photo (notice the Clone Stamp target just below her bellybutton). This tells Photoshop you're cloning from this image.

Step Eight:

Now, click on the photo you're retouching (to make it active) and start painting over the stomach area of your subject. You'll see the target crosshair appear in the source photo (the toned stomach) and a brush-sized cursor appear in the photo where you're adding the tummy (as shown).

After

Before

Step Nine:

Continue cloning the full tummy in. If you accidentally paint over her swimsuit, just switch to the Eraser tool, get a hard-edged brush, and erase the overlap (remember, you're cloning onto a separate layer so you can just erase it). Chances are, the skin tone of the cloned stomach isn't going to perfectly match that of your subject's original stomach, so we'll have to fix that.

Step Ten:

You could jump through a lot of fancy color-correction hoops, but usually, if you just lower the Opacity of this layer, you can get the cloned stomach to blend right in. If it still looks too dark, press Command-L (PC: Control-L) to bring up Levels, and use the left Output Levels Slider (on the bottom) to lighten the overall tone of the new tummy (as shown). The final retouch is shown here, and the original photo is shown below.

This is where the fun begins. Okay, I don't want to discount all the immeasurable fun you've had up to this point, but now it gets really fun. Mondo-crazy fun. This is where we get to play around in Photoshop

38 Special photographic special effects

and change reality, and then send the client an invoice for our "playtime." Did the model not have the right color blouse on? No sweat, change it in Photoshop. Was it an overcast day when you shot the exterior of your client's house? Just drop in a new sky. Do you want to warm up a cold photo like you did in the old days by screwing on an 81A filter? Now you can do it digitally. Do you want to take your income to the next level? Just shoot a crisp shot of a \$20 bill, retouch it a bit, print out a few hundred sheets on your color laser printer and head for Vegas. (Okay, forget that last one, but you get the idea.) This is where the rubber meets the road, where the nose gets put to the grindstone, where the meat meets the potatoes... (Where the meat meets the potatoes? Hey, it's late.)

Blurred Lighting Vignette

This technique is very popular with portrait and wedding photographers. It creates a dramatic effect by giving the appearance that a soft light is focused on the subject, while dimming the surrounding area (which helps draw the eye to the subject).

Step One:

Open the photo that you want to vignette. Get the Elliptical Marquee tool from the Toolbox and draw an oval-shaped selection where you'd like the soft light to fall on your subject.

Step Two:

Go to the Layers palette and add a new layer by clicking on the Create New Layer icon. Hold the Option key (PC: Alt key) and click once on the Layer Mask icon at the bottom of the Layers palette. This will create a Layer Mask from the oval, and holding the Option/Alt key automatically fills your oval mask with black. Next, in the Layers palette, click once directly on the regular Layer thumbnail. Press "d" to set your Foreground color to black, then press Option-Delete (PC: Alt-Backspace) to fill the layer with black. Then, lower the Opacity to 50% and your photo should look like the one shown here—a clear oval over your subject with a dark tint surrounding the oval area.

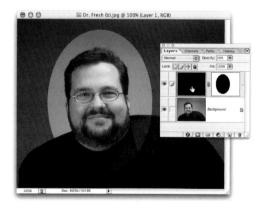

pixels

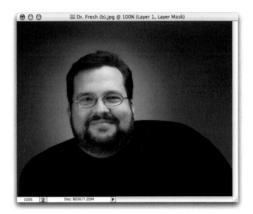

Radius: 43.6

Step Three:

In the Layers palette, click once directly on the Layer Mask thumbnail for your layer (the thumbnail with the black oval in it). Go under the Filter menu, under Blur, and choose Gaussian Blur. When the Gaussian Blur dialog appears, drag the slider all the way to the left, then start dragging it to the right to soften the edges of the oval until the oval area in your photo looks like a soft light.

Step Four:

When you click OK to apply the Gaussian Blur, the effect is complete, and now you have a soft lighting vignette falling on your subject and fading as it moves farther away.

NOTE: If this photo will be printed on a press (in an ad, brochure, and so on), some banding could appear within the vignette when it appears in print. Luckily, you can prevent that banding by going under the Filter menu, under Noise, and choosing Add Noise. When the Add Noise dialog appears, for Amount choose 3%, for Distribution choose Gaussian, and make sure you turn on the Monochromatic checkbox at the bottom of the dialog. Click OK and a tiny amount of noise will be applied. The noise may be slightly visible onscreen, but will disappear when printed at high resolution.

Using Color for Emphasis

This technique is popular in commercial advertising because the client can focus the consumer's attention on their product in an artistic way. The tutorial shown here came from a very effective use of the technique I saw in an in-store display for Bruce Hardwood Floors, where they showed their floors in a variety of office and home settings, but the focus was clearly on the floor because it was the only part of the photo left in color. In the example here, we're going to focus the attention on a swimming pool.

Step One:

Open the photo that contains an object you want to emphasize through the use of color.

Step Two:

Get the Brush tool from the Toolbox and choose a large, hard-edged brush. Go up in the Options Bar and change the Blend Mode of the Brush tool to Color.

Step Three:

Set your Foreground color to black by pressing the letter "d" and begin painting on the photo. As you paint, the color in the photo will be removed. The goal is to paint away the color from all the areas except the areas you want emphasized.

Step Four:

Here's the final image with the color clearly drawing your attention to the focal point.

Step Five:

If you make a mistake while painting away the color, just get the History Brush from the Toolbox (as shown), paint over the "mistake" area, and the original color will return as you paint.

Adding Motion Where You Want It

This is a painless way to add motion to a still photo, and because you're using a Layer Mask, you have a lot of flexibility in where the effect is applied, making it easy to remove or edit any excess motion.

Step One:

Open the photo you want to give a motion effect.

Step Two:

Duplicate the Background layer in the Layers palette by pressing Command-J (PC: Control-J). Go under the Filter menu, under Blur, and choose Motion Blur.

Step Three:

The Motion Blur dialog appears, presenting two settings: Angle lets you choose which direction the blur comes from and Distance actually determines the amount of blur. In this case, set the Angle to 4° so the blur is almost horizontal, and increase the Distance slider (amount) until it looks realistic.

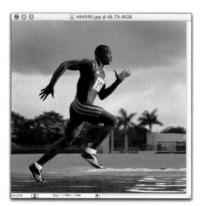

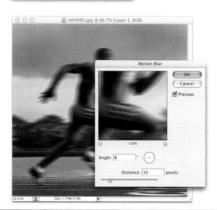

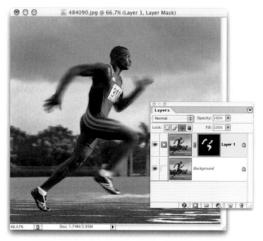

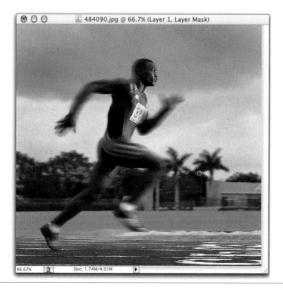

Step Four:

Hold the Option key (PC: Alt key) and click on the Layer Mask icon at the bottom of the Layers palette. Holding the Option/Alt key fills the Layer Mask with black, hiding the Motion Blur effect you applied to this layer.

Step Five:

Get the Brush tool from the Toolbox, and choose a medium-sized, soft-edged brush. Press the letter "x" until your Foreground color is white, then begin painting over the areas you want to have motion (as shown). As you paint, you'll reveal the Motion Blur that's already applied to the layer.

Step Six:

Complete the effect by painting over all the areas that you want to have motion. If you make a mistake and reveal motion on an area where you don't want it, simply switch your Foreground to black, then paint over the "mistake" area and the blur will be removed.

Focus Vignette Effect

This is another technique for focusing attention. This time, instead of using light (as we did in the first tutorial in this chapter), we're focusing attention by blurring non-critical areas, and leaving the focal point sharp.

Step One:

Open the photo that you want to give the focus vignette effect. Press Command-J (PC: Control-J) twice to make two duplicates of the Background layer in your Layers palette (as shown below).

Step Two:

Hide the top layer (Layer 1 copy) by clicking on the Eye icon next to it in the far-left column of the Layers palette. Then click on the middle layer to make it active.

Step Three:

Go under the Filter menu, under Blur, and choose Gaussian Blur. When the dialog appears, increase the Radius to make it "good and blurry." (That's a technical term used by highly technical people, like myself.)

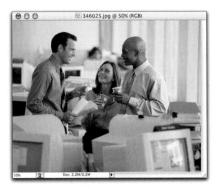

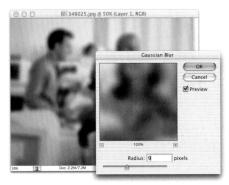

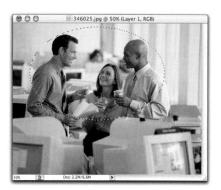

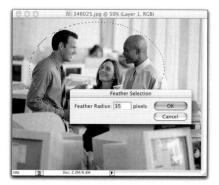

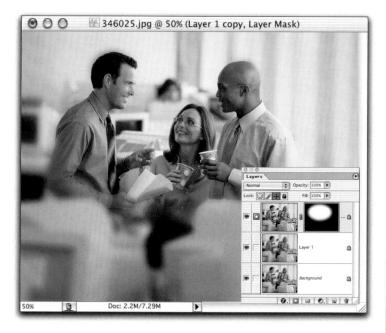

Step Four:

Go to the Layers palette and click on the top layer (Layer 1 copy) to make it active. Get the Elliptical Marquee tool from the Toolbox and draw an oval around the area you want to remain in focus.

Step Five:

To soften the edges of your selection, go under the Select menu and choose Feather. For Feather Radius, enter 35 pixels (or higher if you want a smoother transition) and click OK. Remember, a 5-megapixel photo will require more blur than a 3-megapixel photo to get the same effect. The higher the resolution of the photo, the higher you'll have to adjust your settings to get the same effect.

Step Six:

Click on the Layer Mask icon (as shown at the far left) to activate the effect (much in the same way parmesan cheese activates pasta).

Adjusting the Color of Individual Objects

This effect is one of the most called upon by art directors working with photographers because of the cardinal rule of working with clients—they were born to change their minds. Now, if the client wishes they had sent a different color shirt for the photo shoot, you don't reshoot, you just retouch.

Step One:

Open the photo that contains an element that needs to be a different color. Select the area you want to recolor using any selection tool you'd like (Lasso tool, Pen tool, Extract—it doesn't matter which you use, but you have to have a pretty accurate selection).

Step Two:

Choose Hue/Saturation from the Adjustment Layer pop-up menu at the bottom of the Layers palette.

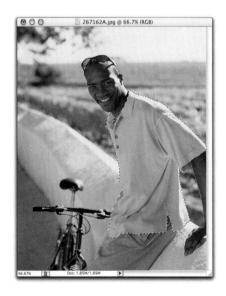

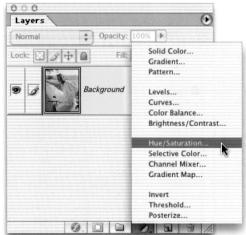

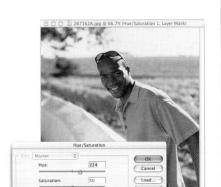

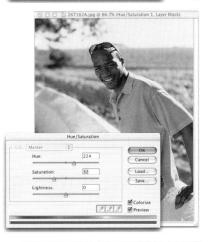

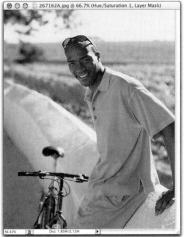

Step Three:

When the dialog appears, click on the Colorize checkbox at the bottom right of the dialog and then start dragging the Hue slider. As you drag, the color of the selected area will begin to change.

Step Four:

If the color appears too intense after dragging the Hue slider, just drag the Saturation slider (as shown) to the left to decrease the saturation of the color.

Step Five:

Click OK in the Hue/Saturation dialog to complete the color change. (Here we changed the color and lowered the Saturation.)

Replacing the Sky

This is the absolute #1 request I get from real estate photographers: how to replace the sky in exterior shots taken for their clients. In the world of selling homes, "every day should be a bright sunny day," and with a little Photoshop magic, it can be.

Step One:

Open the photo that needs a new, brighter, bluer sky.

Step Two:

You have to select the sky, and in the example shown here I used the Magic Wand to select most of it. Then I chose Similar from the Select menu to select the rest of the sky, but as usual, it also selected part of the house. So I had to hold the Option key (PC: Alt key) and use the Lasso tool to deselect some excess areas on the roof. You can use any combination of selection tools you'd like.

Step Three:

Shoot some nice sunny skies (like the one shown here) and keep them handy for projects like this. Open one of these "sunny sky" shots, and then go under the Select menu and choose Select All to select the entire photo. Then, press Command-C (PC: Control-C) to copy this sky photo into memory.

Step Four:

Switch back to your original photo (the selection should still be in place), go under the Edit menu, and choose Paste Into.

Step Five:

When you choose Paste Into, the sky will be pasted into your selected area, appearing over the old sky. If the sky seems too bright for the photo, simply lower the Opacity of the layer in the Layers palette to help it blend in better with the rest of the photo.

Replicating Photography Filters

This is a totally digital way to replicate some of the most popular photography filters, such as the 81A and 81B Color Correction filters used by many photographers. These are primarily used to warm photos, especially those taken outdoors where a bright sky radiates to give photos a bluish cast. They're also useful when shooting in shade on a sunny day, or for correcting bluish light from overcast days. Luckily, it's fairly easy to replicate both filters in Photoshop. (Note: The 81B filter normally provides more warming than the 81A.)

Step One:

Open the photo that needs the warming effect you'd get by applying an 81A Color Correction filter to your lens.

Step Two:

Click on the Foreground Color Swatch in the Toolbox to bring up the Color Picker and choose a cream color. (I used R=252, G=241, and B=211.)

NOTE: For an 81B filter, which provides more warmth than the 81A, try R=250, G=228, and B=181. To replicate the 80A and 80B filters (used by traditional photographers to correct the cast created by using daylight film in indoor artificial lighting), try a light blue shade instead. A starting point for the 80A might be R=101, G=102, and B=169, and for the 80B, which is more pronounced, try R=171, G=170, and B=214.

Step Three:

Go to the Layers palette and create a new blank layer by clicking on the Create New Layer icon. Fill this new layer with your new Foreground color by pressing Option-Delete (PC: Alt-Backspace).

Step Four:

In the Layers palette, change the Blend Mode of this cream layer from Normal to Color. This lets the color blend into the photo without covering the detail. The only problem is that it's way too warm. In fact, it looks as if it has an intentional tint, when what you're really after is a more natural appearance with no visible tint. But we'll fix that.

Step Five:

In the Layers palette, lower the Opacity of this Color layer until the color comes back and the photo looks balanced. In the example shown here, I lowered the Opacity of this layer to 35%, but you can go as low as 20% depending on how much effect you want the filter to have, and how blue the cast was when you started. If the 81A replication doesn't do the trick, try the 81B using the figures I listed in Step Two as a starting point.

Layer Masking for Collaging

Photoshop collage techniques could easily fill a whole chapter, maybe a whole book; but the technique shown here is probably the most popular—and one of the most powerful—collage techniques used today by professionals. Best of all, it's easy, flexible, and even fun to blend photos together seamlessly.

Step One:

Open the photo that you want to use as your base photo (this will serve as the background of your collage).

Step Two:

Open the first photo that you want to collage with your background photo.

Step Three:

Switch to the Move tool in the Toolbox, and then click-and-drag the photo from this document right onto your background photo. It will appear on its own layer.

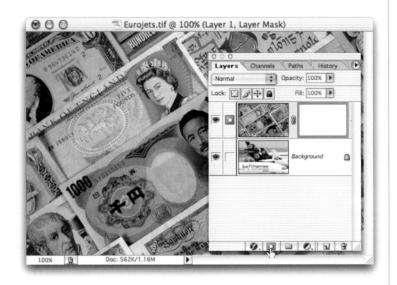

Step Four:

Click on the Layer Mask icon at the bottom of the Layers palette (as shown).

Step Five:

Get the Gradient tool from the Toolbox, and then press Return (PC: Enter) to bring up the Gradient Picker (it appears at the location of your cursor within your image area). Choose the Black to White gradient (it's the third gradient in the Picker, as shown).

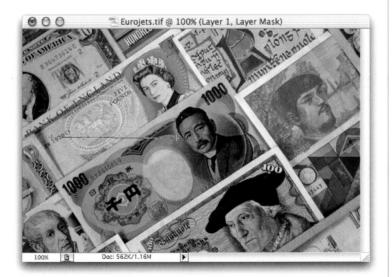

Step Six:

Click the Gradient tool in the center of your photo and drag to the left. The point where you first click will make the top layer totally transparent, and the point where you stop dragging will have 100% opacity. Everything else will blend in between.

Continued

Step Seven:

When you release the mouse, the top photo blends into the background. As you can see from the capture shown here, the top layer is totally transparent at the center, and the opacity increases toward the left until it becomes solid.

Step Eight:

Open another photo you'd like to blend in with your existing collage. Switch to the Move tool, and click-and-drag this photo onto the top of your collage in progress. Click on the Layer Mask icon at the bottom of the Layers palette to add a Layer Mask to this new layer.

Step Nine:

Click the Gradient tool in the center of your photo, and drag to the right to blend this new photo. Then, get the Brush tool, choose a large, soft-edged brush (I used a 200-pixel brush here), and with your Foreground set to black, paint over any areas you want to blend in with the background. In this example, I painted over the jet in the foreground, but since I was on the layer with the Wall Street Journal photo, it painted away the WSJ, revealing the plane on the Background layer.

Step Ten:

Switch to the Layer Mask on the foreign currency layer by clicking on its thumbnail in the Layers palette and paint over the jet in the foreground to erase the currency on that layer. Because you're using such a large, soft-edged brush, as you paint, the blend is soft and subtle.

Step Eleven:

To complete this quick collage, I used the Type tool and added the words "Global Reach" in all caps using the font Trajan (from Adobe). I then duplicated the layer (Command-J, PC: Control-J), rasterized it (so I could apply a filter), and then applied the Motion Blur filter (Filter>Blur>Motion Blur) with the Angle set at 0° and Distance (amount) set to 64. Then I added the words "Worldwide Presence" in all caps (same font) and then used Free Transform (Command-T, PC: Control-T) to rotate the type 90° counterclockwise, to complete the collage.

Adding Depth of Field

This is a digital way to create the classic in-camera depth of field effect, and thanks to Photoshop's Quick Mask, it's easy to pull off. Of course, for this technique to be effective, you have to start with the right photo, one that would benefit from a depth of field effect. (Close-up photos of people are ideal, as are product shots, as long as they're not shot straight on or, if they are, they need to have a detailed background behind them.)

Step One:

Open the photo on which you want to apply a depth of field effect. Switch to Quick Mask mode by pressing the letter "q".

Step Two:

Get the Gradient tool from the Toolbox, and press the Return key (PC: Enter key) to make the Gradient Picker appear within your image area. Double-click on the third gradient in the picker (the Black to White gradient) to choose it.

Step Three:

Click the Gradient tool on your photo starting in the area you want to remain in focus, and then dragging toward the area you want to appear out of focus.

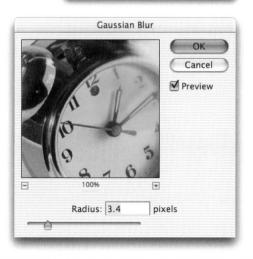

Step Four:

Since you're in Quick Mask mode, you'll see a red-to-transparent gradient appear onscreen.

Step Five:

Press the letter "q" again to leave Quick Mask and return to Standard mode. You'll see the selection you created in Quick Mask mode appear within your image area.

NOTE: If the selected area in your image is the opposite of what is shown here, double-click on the Quick Mask icon just below the Color Swatches in the Toolbox to bring up the Quick Mask Options dialog. Under Color Indicates, choose Masked Areas. Click OK to enter Quick Mask mode and then redraw your gradient.

Step Six:

Go under the Filter menu, under Blur, and choose Gaussian Blur. When the dialog appears, enter the amount of blur you'd like for the farthest point in your image, then click OK. Although you see a hard selection within your image area, it's actually a smooth blend from full blur to no blur. As you apply this filter, you'll see what I mean because the right side of your photo should be blurred, and progressing to the left, the photo becomes less and less blurry.

Continued

Step Seven:

Go under the Select menu and choose Inverse, which switches the selected area from the blurred area to the in-focus area.

Step Eight:

Now, to exaggerate the effect, apply an Unsharp Mask filter to the area that's supposed to be in focus, by going under the Filter menu, under Sharpen, and choosing Unsharp Mask. When the dialog appears, try 150 for Amount, 1 for Radius, and 4 for Threshold, then click OK. (In the example here, I used 127 for Amount, 1 for Radius, and 3 for Threshold.)

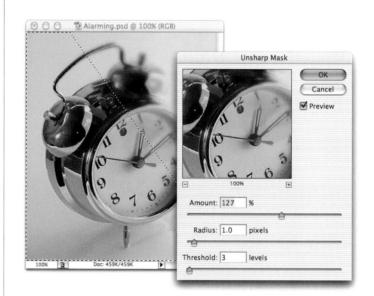

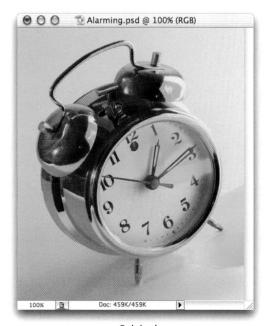

Original

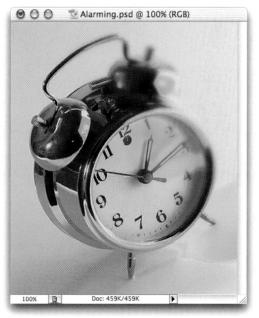

Depth of field effect added

Step Nine:

Deselect by pressing Command-D (PC: Control-D). As you can see, the final effect (bottom) has the area closest to the lens in sharp focus, and the depth of field effect increases for the part that appears farther away.

Stitching Panoramas Together

You don't need a \$500 stand-alone application to stitch together simple panoramas because Photoshop can do it for you. You can, however, make the process dramatically easier if you follow these two simple rules before you shoot your pano: (1) Use a tripod. That's not to say you can't shoot panos handheld, but the consistency a tripod brings to panos makes a world of difference when you try to stitch the photos together. And (2), when you shoot each segment, make sure that part of the next segment overlaps at least 15% of your previous segment (you'll see why this is important in the tutorial).

Step One:

Open the first segment of your pano. The photo shown here is the first of three segments that we'll be stitching together.

Step Two:

Next, go under the Image menu and choose Canvas Size. In the capture shown here, you can see the Width of the first segment is 8.862 inches. We're stitching three segments together, so we'll need to add enough blank canvas to accommodate two more photos of the same size, so make sure the Relative checkbox is turned on, then enter 16 inches as the Width setting. This extra blank canvas needs to be added to the right of your first segment, so in the Anchor grid (at the bottom of the dialog) click the left center grid square (as shown here).

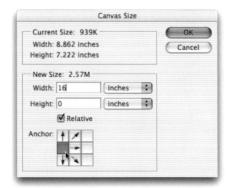

Step Three:

Click OK and 16" of white canvas space is added to the right of your photo (if it doesn't look like the capture shown here, Undo, then go back and check your Anchor grid setting and make sure you clicked on the left center grid square).

Step Four:

Now, open the second segment of your pano. Notice that the building on the far right of the first segment also appears in the second segment. That's absolutely necessary because now we have a common object that appears in both photos, and we can use that building as a target to line up our panos.

Step Five:

Get the Move tool from the Toolbox and click-and-drag your second segment into the first segment's document window. Drag the second segment over until it overlaps the first segment a bit. I've zoomed in here so you can see the two segments overlapping.

Continued

Step Six:

Go to the Layers palette and lower the Opacity of this second segment's layer to 70% (as shown here). This is pretty much the secret of stitching together panos. As long as there's a common element in both photos, you can lower the Opacity of the top layer, and drag it until the two objects line up perfectly together.

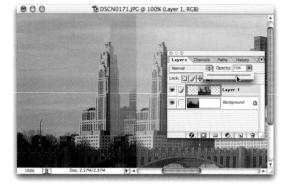

Step Seven:

As the two buildings (your target object) get close together, it's easier if you take your hands off the mouse and do the final aligning using the Arrow keys on your keyboard. Start nudging the top layer with the Left Arrow key to line them up. Because the Opacity has been lowered on the top layer, things will look kind of blurry (almost out of focus), but as the two target objects get closer to each other, the blur lessens.

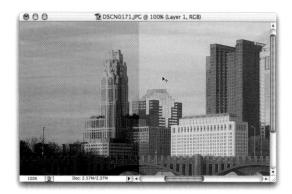

Step Eight:

Keep nudging with the Arrow keys, and when the building doesn't look fuzzy anymore and is perfectly clear, your two segments are lined up right on the money (as shown here).

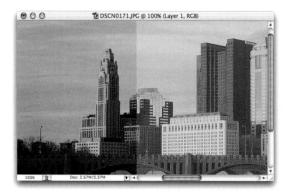

Step Nine:

Now, go to the Layers palette and raise the Opacity of the top layer to 100% (as shown) to see how your stitch looks. The two images should look like one (that is if you shot them using a tripod and didn't bump the camera along the way). If you see a hard edge along the left-hand side of the top layer, switch to the Eraser tool, choose a 200-pixel, soft-edged brush, and lightly erase over the edge. Since the photos overlap, as you erase the edge, the top photo should blend seamlessly into the bottom photo.

Step Ten:

Now, open the third segment of your three-segment pano (as shown here).

Step Eleven:

Repeat the same technique of dragging this photo into your main pano, lowering the Opacity of this layer to 70%, and dragging the segment over your target object. (In this example, it's the rightmost of the two taller buildings.)

Step Twelve:

Don't forget, as you get close to lining up the buildings, take your hands off the mouse and use the Arrow keys on your keyboard to perfectly align the two segments (as shown here where the two versions of the building line up perfectly). Again, after you raise the Opacity of the top layer back to 100%, if you see a hard edge between the two, use a soft-edged Eraser to erase away that seam.

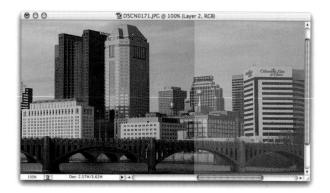

Step Thirteen:

Here are the three segments stitched together in Photoshop. As you can see, by guessing that we'd need 16 inches, I over-estimated a bit, and there's some blank canvas space to the right of my pano. No sweat. There's a quick way to get rid of it without even using the Crop tool.

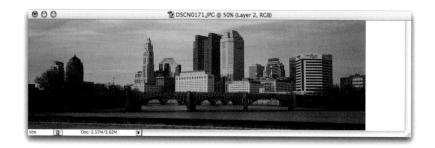

Step Fourteen:

Go under the Image menu and choose Trim to bring up the Trim dialog (shown here). The area we no longer need is on the right-hand side (the extra white area), so in the dialog, under Based On, choose Bottom Right Pixel Color and it will trim away everything outside your photo that is white (which is the color of your bottom-right pixel).

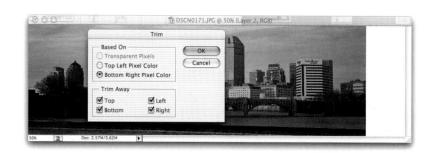

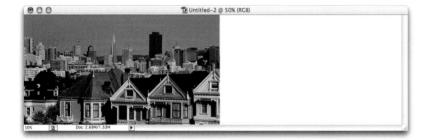

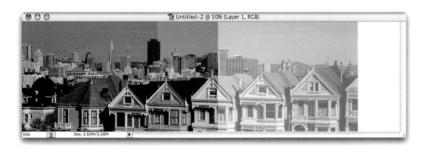

Step Fifteen:

Click OK in the Trim dialog, and the excess Canvas area is trimmed away and your pano is complete (as shown here). Now this was the ideal situation: You shot the panos on a tripod, so the stitching was easy; and you didn't use a fisheye or wide angle lens, so there wasn't much stretching or distorting to deal with. (Incidentally, we use Free Transform's Distort and Perspective functions to deal with segments that appear to bow upward or outward.)

Step Sixteen:

However, one thing that will absolutely happen from time to time is that the colors of each segment won't precisely match. Technically, they should match—they're shot at the same time, under the same lighting conditions, using the same camera settings, yet—it happens. Luckily, Adobe's own Graphics Guru (and Photoshop Hall of Famer) Russell Preston Brown came up with a great technique for dealing with that common occurrence. Here's how Russell does it: Open the first segment (this will be just a two-segment pano) and add the Canvas size as shown previously.

Step Seventeen:

Open the second segment, drag it on top of the first segment, lower the Opacity, and line up your photo using the common target object (in this case, it's the house in the center).

Continued

Step Eighteen:

After the segments are lined up and the Opacity is raised back to 100% on the top layer, you can see the problem—although the two segments line up perfectly, the tone of the right side differs from the tone of the left side (as shown).

Step Nineteen:

Take the Zoom tool and zoom in on the border between the two and you can really see the difference. Your goal is to make the photo on the right (the top layer) match the tone from the photo on the left (the Background layer). You'll do this by making simple grayscale edits to the top layer's channels.

Step Twenty:

Make the Channels palette visible, then click on the Red channel (as shown). Your pano will now appear in grayscale (by default, all the channels display as grayscale). As you can see, the tonal difference is very visible here in the grayscale Red channel as well.

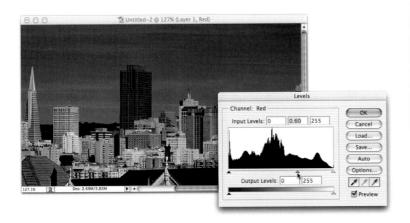

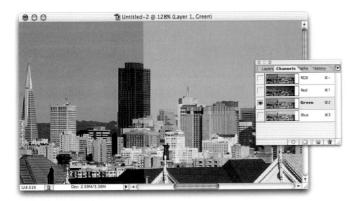

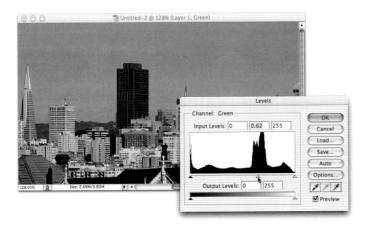

Step Twenty-One:

Next, press Command-L (PC: Control-L) to bring up the Levels dialog (shown here). What you're going to do is drag the midtone Input Levels slider (the center one, directly under the histogram) to the right (as shown) to balance the Red channel of your right image (your top layer) with that of the left image (your bottom layer). When they match, click OK to apply the adjustment.

Step Twenty-Two:

Go to the Channels palette, and click on the Green channel (as shown).

Step Twenty-Three:

Press Command-L (PC: Control-L) to bring up the Levels dialog, and drag the midtone Input Levels slider until the two sides match (as shown), and then click OK to apply the adjustment.

Step Twenty-Four:

Go to the Channels palette and click on the Blue channel (as shown).

Step Twenty-Five:

Press Command-L (PC: Control-L) to bring up the Levels dialog, drag the midtone Input Levels slider until the two sides match (as shown), and then click OK to apply the adjustment.

Step Twenty-Six:

Go to the Channels palette, and click on the RGB channel to see your adjustments. As you can see here, if you matched up each channel, the color image will now match up as well.

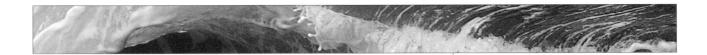

Step Twenty-Seven:

Here's the final pano after removing the excess Canvas area using the Trim command and using a soft-edged eraser to hide the edge between the two segments.

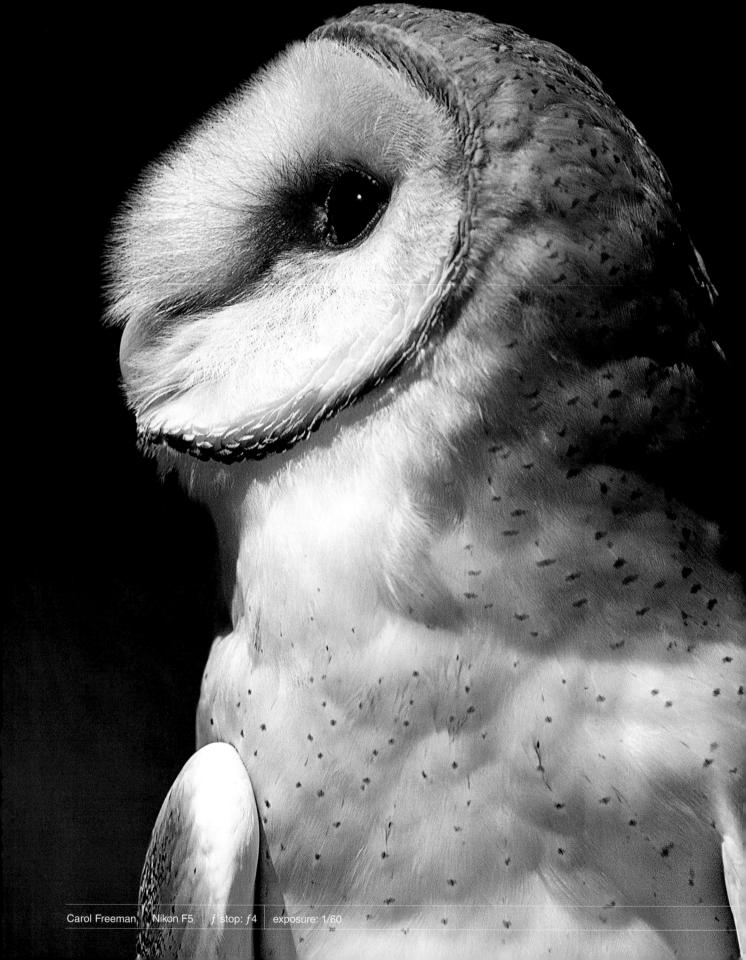

If you've ever converted a color photo to a grayscale (black-and-white) photo by going under the Image menu, under Mode, and choosing Grayscale, you were probably pretty disappointed with the results.

Back in Black from color to grayscale

It probably looked less like Ansel Adams, and more like Anson Williams (the guy who played Potsie on *Happy Days*, which I'm told is a TV show that aired long before I was born, seeing as though I'm just 17 years old, which doesn't really explain how I came up with the chapter title "Back in Black" from AC/DC, which is another band that I guess my parents used to listen to. Freaks). Anyway, Photoshop has a number of different ways to convert from color to black-and-white that can give you dramatically better results than Photoshop's default conversion, which...well...emits a pungent odor not unlike a dachshund that dined on a leftover chalupa. Which method is right for you? Try them and find out which one suits your style.

This method of converting an RGB image to grayscale lets you isolate just the luminosity in the photo, separating out the color; and by doing so, you often end up with a pretty good grayscale image. However, because this uses the Lightness channel, we also add one little twist that lets you "dial in" a perfect grayscale photo almost every time.

Step One:

Open the color photo that you want to convert to grayscale using the Lightness method.

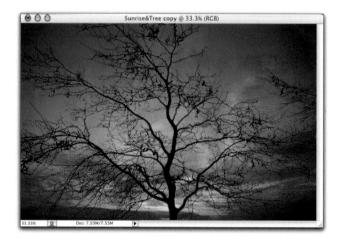

Step Two:

Go under the Image menu, under Mode, and choose Lab Color to convert your RGB photo into Lab Color mode. You won't see a visual difference between the RGB photo and the Lab Color photo—the difference is in the channels that make up your color photo (as you'll see in a moment).

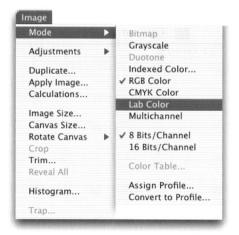

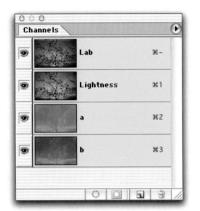

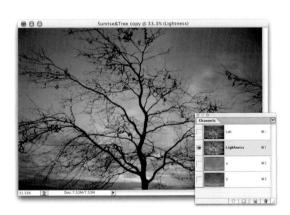

Step Three:

Go to the Channels palette and you'll see that your photo is no longer made up of a Red, a Green, and a Blue channel. Instead, the luminosity (the Lightness channel) has been separated from the color data, which now resides in two channels named "a" and "b" (as shown here).

Step Four:

We're interested in the grayscale image that appears in the Lightness channel, so click on the Lightness channel in the Channels palette to make it active (your photo will now look grayscale onscreen as it displays the current active channel).

Step Five:

Now, go under the Image menu, under Mode, and choose Grayscale. Photoshop will ask if you want to discard the other channels. Click OK. You'll notice that you now only have a Gray channel in the Channels palette.

Step Six:

Go to the Layers palette, click on the Background layer, and then press Command-J (PC: Control-J) to duplicate the Background layer. Switch the Blend Mode of this duplicated layer to Multiply, and you'll see the photo become much darker on screen.

Step Seven:

Chances are, changing that top layer to Multiply (which has a multiplying effect) made your photo too dark. This is where you get to "dial in" your ideal tone. Just lower the Opacity for this layer in the Layers palette until you have the tonal balance you've been looking for.

274

Step Eight:

Here's the final conversion from color to grayscale. This method gives you much more control, and depth, than just choosing Grayscale mode from the Image menu.

Custom Grayscale Using Channel Mixer

This has become the favorite of many professionals (and some will argue that this is the absolute best way to create grayscale photos from color photos) because it lets you blend together all three RGB channels to create a custom grayscale image, and it's easier to use (and more intuitive) than using the Calculations feature that I'll show you later in this chapter. Here's how it works:

Step One:

Open the color photo you want to convert to grayscale.

Step Two:

Choose Channel Mixer from the Adjustment Layers pop-up menu at the bottom of the Layers palette (as shown here). Channel Mixer is also found under the Image menu, under Adjustments; however, by choosing it as an Adjustment Layer, you have the added flexibility of being able to edit your grayscale conversion later in your creative process, or to change your mind altogether and instantly return to a full-color photo.

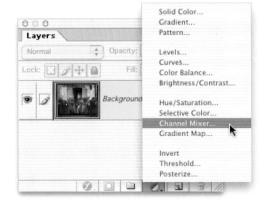

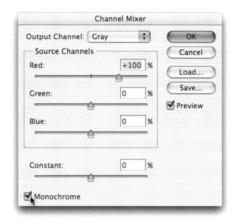

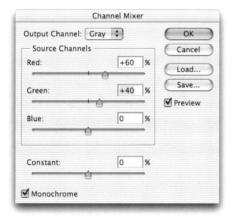

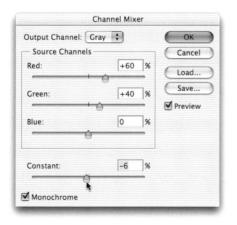

By default, the Channel Mixer is set to blend color RGB channels. When you're using this tool to create a grayscale image, you have to turn on the Monochrome checkbox at the bottom of the dialog to enable the blending of these channels as grayscale.

Step Four:

Now that you're blending the channels as grayscale, you can use the three sliders to combine percentages of each channel to create your grayscale photo. When blending channels, a rule of thumb is to make sure that whatever your percentages are, they add up to a total of no more than 100% (as shown here).

Step Five:

You can tweak the overall brightness of your grayscale image using the Constant slider at the bottom of the dialog.

Continued

Step Six:

Click OK and the Channel Mixer is applied to your photo to create a grayscale image.

Step Seven:

After you've clicked OK, if you decide you want to edit your Channel Mixer settings, just double-click on the Channel Mixer layer in your Layers palette (as shown here) and the Channel Mixer dialog will appear with the last settings you applied to your photo. If you decide that you don't want your photo to be grayscale at all, just click-and-drag the Channel Mixer Adjustment Layer onto the Trash icon at the bottom of the Layers palette.

Ansel Adams Effect Step One:

Got a great shot of a mountainous landscape and want to convert it to grayscale with an Ansel Adams-style conversion (one with intense contrast and depth)? Try Jim DiVitale's great trick for an instant Ansel-like effect. Just increase the Red to +160%, the Green to +140% (which adds up to 300, I know), but then lower the Blue to -200% (bringing you back to 100%).

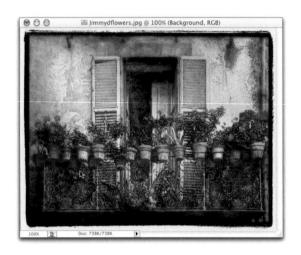

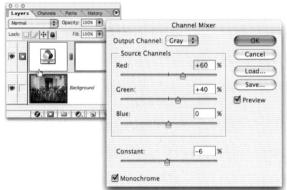

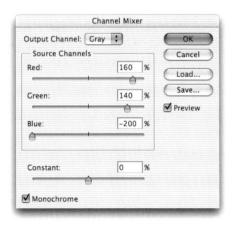

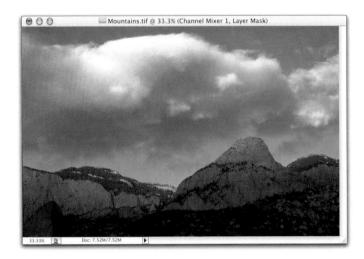

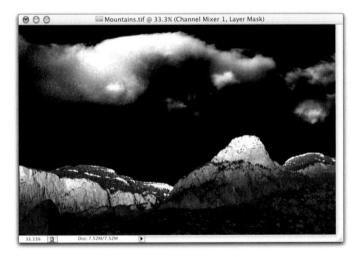

Step Two:

Click OK to apply this "Ansel Adams" Channel Mixer setting, and you'll have a conversion that looks similar to the one shown here.

Calculations Method

If there's one dialog box in Photoshop that scares the living daylights out of people, it's the Calculations dialog. It's got an awfully intimidating layout for a dialog that simply lets you combine channels, and that's part of the beauty of it. After you learn this technique, you can "name drop" with it to impress other Photoshop users. For example, if you're talking color-to-grayscale converstions, just mention in passing, "Oh I don't use Channel Mixer. I do my conversions using Calculations," and they'll act like Puffy just walked in the room. Bling, bling!

Step One:

Open the color photo that you want to convert to grayscale using Calculations.

Step Two:

Go under the Image menu and choose Calculations to bring up the Calculations dialog. This scary-looking dialog lets you choose two channels from your photo that you can blend together to create an entirely new channel. That way, if you have one channel that looks too dark, and one that looks too light, you can combine the two into one gloriously perfect channel (at least, that's the theory). After you realize that's what you're doing in Calculations, the dialog becomes much less intimidating.

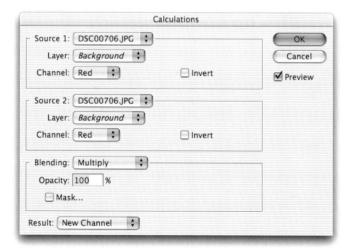

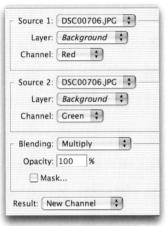

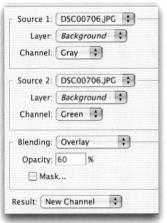

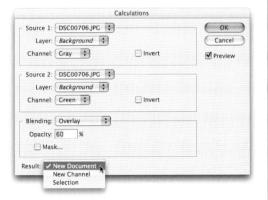

So your job is to choose two channels from your color photo and blend them together (using the Blend Modes in Calculations) to create a new grayscale channel that looks better than if you had used Photoshop's default grayscale conversion. It's easier than it sounds. First, start by choosing the Red channel in the Source 1 Channel pop-up menu. Then, choose Green in the Source 2 Channel pop-up menu, as shown here.

Step Four:

In this case, with the Blending Mode set to Multiply and the Opacity at 100%, the photo looks too dark. So, to get a better-looking grayscale photo, you can: (a) try different channel combinations (rather than Red and Green, try Red and Blue, or Red and Gray, or Green and Blue, or Blue and Gray, etc.); (b) change the Blend Mode to something other than Multiply and see how it looks; or (c) lower the Opacity setting and see how a more subtle blending works.

Step Five:

When you've come up with a combination that looks good to you, go to the Result pop-up menu at the bottom of the dialog (by "Result" they mean "what should Photoshop do with this new channel you've created?") and choose New Document. Click OK and a new document will appear with your custom-calculated channel as the Background layer. One last thing: In this new document, go under the Image menu, under Mode, and choose Grayscale.

Creating **Duotones**

For some reason, creating a duotone in Photoshop (a photo that uses just two colors), is immeasurably more complex than creating one with four colors (as in CMYK). You definitely have to jump through a few hoops to get your duotones to look and separate properly, but the depth added by combining a second, third, or fourth color with a grayscale photo is awfully hard to beat.

Step One:

Open the photo that you want to convert to a duotone. If you're starting with a color photo, you'll have to convert to grayscale first by going under the Image menu, under Mode, and choosing Grayscale.

Step Two:

After your photo is converted to grayscale, you can go under the Image menu, under Mode, and choose Duotone.

Step Three:

This might seem weird, but the first time you open the Duotone Options dialog, for some reason Adobe set the default Type of Duotone to Monotone (I know, it doesn't make sense). So, to actually get a duotone, you'll first have to select Duotone from the Type pop-up menu at the top left of the dialog.

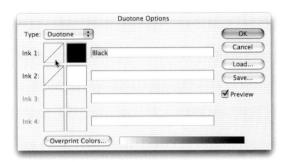

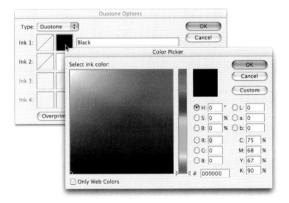

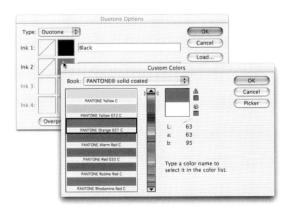

Step Four:

Now that Duotone is your selected Type, you have to choose which two inks you want to use. First, we'll look at Ink 1. The first box (the one with the diagonal line through it) is called the "Curve Box," and this is where you determine how the color you choose will be distributed within your photo's highlights, midtones, and shadows. You determine this distribution using a Curve. (Now don't stop reading if you don't know how to use Curves. You don't need to know Curves to create a duotone, as you'll soon see.)

Step Five:

The black box to the right of the Curve Box is the Color Box (where you choose the color of Ink 1). By default, Ink 1 is set to the color black (that's actually pretty handy, because most duotones are made up of black and one other color). If you decide you don't want black as your Ink 1 color, just click the Color Box and Photoshop's Color Picker will appear so you can choose a different color.

Step Six:

You'll notice that Ink 2's Color Box is blank. That's because it's waiting for you to choose your second ink color. To do so, click on the box to bring up Photoshop's Custom Color Picker, where you can choose the color you'd like from the list of Pantone® colors. (Photoshop assumes you're going to print this duotone on a printing press, and that's why it displays the Pantone Coated colors as the default.)

Continued

Step Seven:

When you click OK in the Pantone Custom Colors Picker, the name of your Ink 2 color will appear beside the Color Box. Now that you've selected the two colors that will make up your duotone, it's time to determine the balance between them. Do you want more black in the shadows than your spot color? Should Ink 2 be stronger in the highlights? These decisions are determined in the Duotone Curve dialog for each ink, so click once on the Curves Box next to Ink 2 to bring up the dialog.

Step Eight:

If you look at the set of fields on the right side of the dialog (as shown in Step Seven's screen capture), the default curve is flat. It mimics your black color in that equal amounts of orange (Ink 2) will appear in the highlight, midtones, and shadows. For example, in the field marked 100%, a value of 100 indicates that 100% shadow areas will get 100% orange ink. However, If you wanted less orange in the shadows, type in a lower number in the 100% field (for example, in the capture shown here. I entered 80% for the 100% shadow areas, so now the darkest shadow areas will get 20% less orange, and will appear more black). For 70% ink density areas, I lowered it to 60%, and for the 50% midtone I entered 35%. When you enter these numbers manually like this, you'll see that Photoshop builds the Curve for you. Vice versa if you click-and-drag in the Curve—Photoshop fills in the amounts in the corresponding fields.

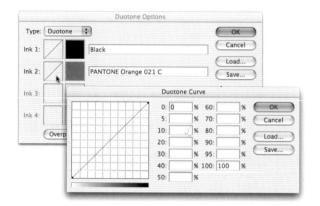

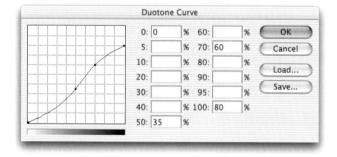

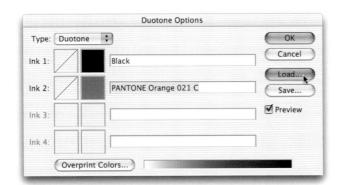

Step Nine:

If the idea of creating your own curve freaks you out, all is not lost. Adobe figured that first-time Duotoners might get the "willies," so they included a bunch of presets using popular colors and pre-built duotone curves. All you have to do is try some out to find the one that looks good to you, and use it. These duotone presets were loaded on your computer when you first installed Photoshop. To load them into Photoshop's Duotone dialog, first click the Cancel button in the Duotone Curve dialog we've been working in, and then click on the Load button in the Duotone Options dialog.

Step Ten:

The Load dialog will appear and by default Photoshop targets the Duotone folder on your drive. If for some reason it doesn't (it's been changed, or you don't see the Duotone folder), then the search is on. In this Load dialog, navigate to your Photoshop application folder. Look inside for a folder called Presets, and inside that look for a folder called Duotones. Inside that folder you'll find another folder named Duotones (you'll also see a folder called Tritones for mixing three colors and Quadtones for mixing four).

Step Eleven:

In the Load dialog, click on this Duotone folder, and inside that folder is (believe it or not) yet another folder called PAN-TONE Duotones. This is where Adobe carefully buried the individual presets, which you can choose from. Each color listed gives you four choices. The first one includes a duotone curve that gives you the strongest amount of spot color ink, progressing to the least amount with the fourth choice. Try a couple out by double-clicking on the duotone color that you want to load. You'll get an instant onscreen preview, so you can decide if the color and amount of Ink 2 is right. If it isn't, click Load again and pick another from the list to try.

Step Twelve:

When you've got the combination that looks right to you, click OK and the duotone is applied to your photo (as shown).

Step Thirteen:

Okay, you've got what looks like a perfect duotone (onscreen anyway), but if it's going to press, before you save your file, you have to do a couple of simple but absolutely critical steps to make sure your duotone separates properly. Go under the File menu and choose Print with Preview. When the Print with Preview dialog appears, click on the Show More Options checkbox (as shown). Make sure the pop-up menu just below the checkbox is set to Output.

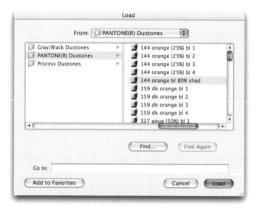

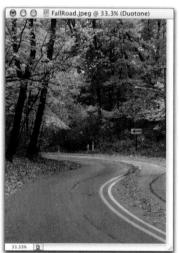

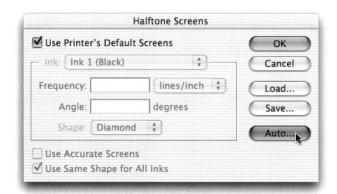

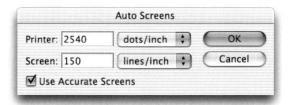

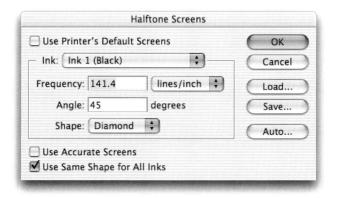

Step Fourteen:

As your duotone sits right now, both colors have the same screen angle. This will likely cause a distracting pattern (called a moiré pattern) to appear across your entire photo when printing on a printing press. To avoid this, you have to make Photoshop assign separate screen angles for your duotone. You do this by clicking on the Screen button in the Print Preview dialog. This brings up the Halftone Screens dialog. Click the Auto button to bring up the Auto Screens dialog.

Step Fifteen:

In the Printer field of the Auto Screens dialog, enter the dpi of the device your duotone will be output to. (In this case, I entered 2540, the resolution of the imagesetter that the prepress department of our print shop uses.) Then call the print shop that's printing your duotone, and ask them at what line screen your job will be printed. Enter that number in the Screen field. Also, turn on Use Accurate Screens (it could help, depending on the imagesetter that is used, otherwise, it will be ignored. Either way, no harm done).

Step Sixteen:

Click OK to close the Auto Screens dialog with your new settings. You'll see in the Halftone Screens dialog that the screen frequencies have now been set for you. Don't change these settings or you'll undo the "Auto Screens" function you just applied (and risk ruining your print job).

Continued

Step Seventeen:

Click OK in the Halftone Screens dialog, and those settings are saved. Now, the trick is how to embed that information into your duotone so it separates and prints properly. Easy—save your duotone as an EPS (choose EPS from the Format pop-up menu in the Save As dialog). This will enable you to embed the screen info into your file to make sure it separates properly on press.

Step Eighteen:

After you choose EPS as your file format, you'll be presented with the EPS Options dialog (shown here). You only have to choose one option: Include Halftone Screen. The screen angles that you set earlier are now included with your file. Click OK to save your file, and now your duotone is ready to be imported into your page-layout application.

NOTE: When creating duotones, we recommend always printing a test to your color inkjet to make sure it separates correctly (giving you just two plates: one black and one with your color tint).

ANOTHER NOTE: Again, if you're printing straight from Photoshop to a color inkjet printer or some other desktop printer, you can skip all this "setting screens, halftone dialogs, etc." and just hit print. These extra steps are only necessary if you're going to output your duotone for reproduction on a printing press.

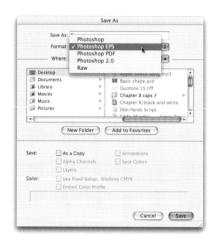

Sharp-Dressed Man professional sharpening techniques

images exactly as shown in that tutorial (applying the Unsharp Mask to the RGB composite—I'm not even sure what that means, but it sounds good). There's a name for these professionals. They're called "lazy professionals." But then one day, they think to themselves, "Gees, I'm kind of getting tired of all those color halos and other annoying artifacts that keep showing up in my sharpened photos," and they wish there was a way to apply more sharpening, and yet avoid these pitfalls. At that point, they're looking for some professional sharpening techniques that will avoid those problems (and the best of those techniques are included in this chapter—the same sharpening techniques used by today's leading digital photographers and retouchers). But as soon as they learn these advanced techniques, they turn around and write Actions for them so they'll be applied with just the touch of one button. But automating this process in this way is not seen as lazy. In fact, now they're seen as being "productive," "efficient," and "smart." Why? Because life ain't fair. How unfair is it? I'll give you an example. A number of leading professional photographers have worked for years to come up with these advanced sharpening techniques, which took tedious testing, experimentation, and research, and then you come along, buy this book, and suddenly you're using the same techniques they are, but you didn't even expend a bead of sweat. You know what that's called? Cool!

Basic Sharpening

After you've color corrected your photos and right before you save your file, you'll definitely want to sharpen your photos. I sharpen every digital camera photo, either to help bring back some of the original crispness that gets lost during the correction process, or to help fix a photo that's slightly out of focus. Either way, I haven't met a digital camera (or scanned) photo that I didn't think needed a little sharpening. Here's a basic technique for sharpening the entire photo.

Step One:

Open the photo that you want to sharpen. Because Photoshop displays your photo in different ways at different magnifications, it's absolutely critical that you view your photo at 100% when sharpening. To ensure that you're viewing at 100%, after your photo is open, double-click on the Zoom tool in the Toolbox and your photo will jump to a 100% view. (Look up in the image window's Title Bar to see the actual percentage of zoom, circled at the right.)

Step Two:

Go under the Filter menu, under Sharpen, and choose Unsharp Mask. (If you're familiar with traditional darkroom techniques, you probably recognize the term "unsharp mask" from when you would make a blurred copy of the original photo and an "unsharp" version to use as a mask to create a new photo whose edges appeared sharper.) Of Photoshop's sharpening filters, Unsharp Mask is the undisputed choice of professionals because if offers the most control over the sharpening process.

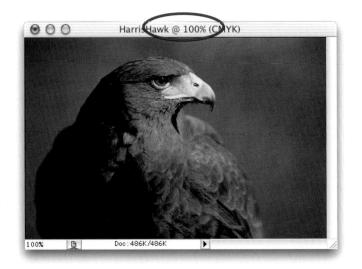

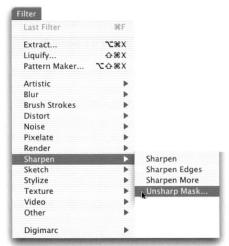

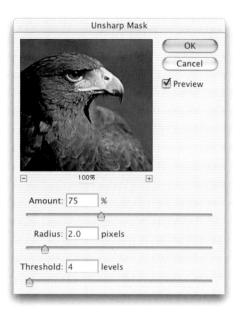

Because we're just applying a basic sharpening, we're going to apply it to the entire RGB photo. (Later in this chapter, we'll look at more advanced sharpening techniques.) When the Unsharp Mask dialog appears, you'll see three sliders. The Amount slider determines the amount of sharpening applied to the photo; the Radius slider determines how many pixels out from the edge the sharpening will affect; and the Threshold slider works the opposite of what you might think—the lower the number, the more intense the sharpening effect. Threshold determines how different a pixel must be from the surrounding area before it's considered an edge pixel and sharpened by the filter.

Sharpening soft subjects:

At right is an Unsharp Mask setting (Amount 150%, Radius 1, Threshold 10) that works well for images where the subject is of a softer nature (for example, flowers, puppies, people, rainbows, and so on). It's a subtle application of sharpening that is very well suited to these types of subjects.

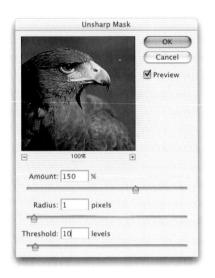

Maximum sharpening:

I use these settings (Amount 65%, Radius 4, Threshold 3) in only two situations: (1) The photo is visibly out of focus and it needs a heavy application of sharpening to try to bring it back into focus; (2) This high level of sharpening also works well where the photo contains lots of well-defined edges (for example, buildings, coins, cars, machinery, and so on).

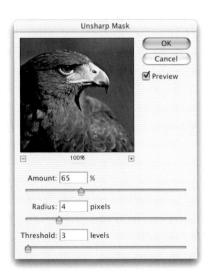

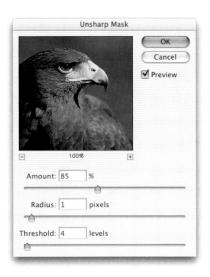

All-purpose sharpening:

This is probably my all-around favorite sharpening setting (Amount 85%, Radius 1, Threshold 4), and I use this one most of the time. It's not a "knock-you-over the-head" type of sharpening—maybe that's why I like it. It's subtle enough that you can apply it twice if your photo doesn't seem sharp enough the first time you run it, but once will usually do the trick.

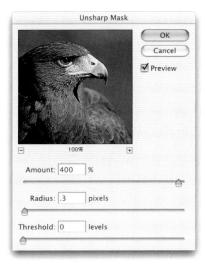

Web sharpening:

I use this setting (Amount 400%, Radius 0.3, Threshold 0) for Web graphics that look blurry. (When you drop the resolution from a high-res, 300 ppi photo down to 72 ppi for the Web, the photo often gets a bit blurry and soft.) If the effect seems too intense, try dropping the Amount to 200%. I also use this same setting (Amount 400%) on out-of-focus photos. It adds some noise, but I've seen it rescue photos that I would have otherwise thrown away.

Coming up with your own settings:

If you want to experiment and come up with your own custom blend of sharpening, I'll give you some typical ranges for each adjustment so you can find your own sharpening "sweet spot."

Amount

Typical ranges go anywhere from 50% to 150%. This isn't a rule that can't be broken, just a typical range for adjusting the Amount, where going below 50% won't have enough effect, and going above 150% might get you into sharpening trouble (depending on how you set the Radius and Threshold). You're fairly safe to stay under 150%.

Radius

Most of the time, you'll use just 1 pixel, but you can go as high as (get ready)—2. You saw one setting I gave you earlier for extreme situations, where you can take the Radius as high as 4. I once heard a tale of a man in Cincinnati who used 5, but I'm not sure I believe it. (Incidentally, Adobe allows you to raise the Radius amount to [get this]—250! If you ask me, anyone caught using 250 as their Radius setting should be incarcerated for a period not to exceed one year, and a penalty not to exceed \$2,500.)

Threshold

A pretty safe range for the Threshold setting is anywhere from 3 to around 20 (3 being the most intense, 20 being much more subtle. I know, shouldn't 3 be more subtle and 20 more intense? Don't get me started). If you really need to increase the intensity of your sharpening, you can lower the Threshold to 0, but keep a good eye on what you're doing (watch for noise appearing in your photo).

This sharpening technique is probably the most popular technique with professional photographers because it helps to avoid the color halos that appear when you add a lot of sharpening to a photo. And because it helps to avoid those halos, it allows you to apply more sharpening than you normally could get away with.

Step One:

Open the photo you want to sharpen using Lab sharpening.

Step Two:

Go to the Channels palette and you can see that your RGB photo is made up of three channels—a Red, a Green, and a Blue channel. Combining the data on these three channels creates a full-color RGB image (and you can see that represented in the RGB thumbnail at the top of the palette).

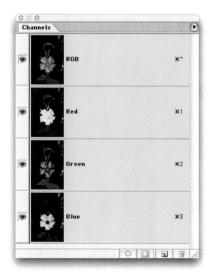

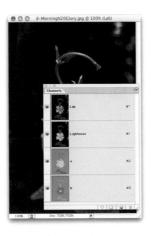

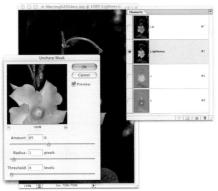

Go under the Image menu, under Mode, and choose Lab Color. Now look in the Channels palette and you'll see that although your photo still looks the same onscreen, the channels it comprises have changed. There are still three channels (besides your full-color composite channel), but now they're a Lightness channel (the luminosity and detail of the photo), an "a" channel, and a "b" channel, which hold the color data.

Step Four:

By switching to Lab color, you've separated the detail (Lightness channel) from the color info (the a and b channels), so click on the Lightness channel to select it. Now you'll apply the Unsharp Mask filter to just this black-and-white Lightness channel, thereby avoiding the color halos, because you're not sharpening the color (pretty tricky, eh?). Note: If you need some settings for using Unsharp Mask, look in the "Basic Sharpening" section at the beginning of this chapter.

Step Five:

After you've sharpened the Lightness channel (and again, you may be able to apply the filter twice here), go under the Image menu, under Mode, and choose RGB Color to switch your photo back to RGB. Now, should you apply this brand of sharpening to every digital camera photo you take? I would. In fact, I do, and since I perform this function quite often, I automate the process (as you'll see in the next step).

Continued

Step Six:

Open a new photo, and let's do the whole Lab sharpening thing again, but this time before you start the process, go under the Window menu and choose Actions to bring up the Actions palette. The Actions palette is a "steps recorder" that records any set of repetitive steps and lets you instantly play them back (apply them to another photo) by simply pressing one button. You'll dig this.

Step Seven:

From the Actions palette's pop-down menu, choose New Action to bring up the New Action dialog (shown at right). The Name field is automatically highlighted, so go ahead and give this new action a name. (I named mine "Lab sharpen." I know—how original!) Then, from the Function Key pop-up menu, choose the number of the Function key (F-key) on your keyboard that you want to assign to this action (it's this key that you'll hit to make this action do its thing). I've assigned mine to F12, but you can choose any open F-key that suits you (but everybody knows F12 is, in fact, the coolest of all F-keys. Just ask anyone).

Step Eight:

You'll notice that the New Actions dialog has no OK button. Instead, there's a Record button, because after you exit this dialog, Photoshop starts recording your steps. So go ahead and convert your photo to Lab color, click on the Lightness channel, and apply your favorite Unsharp Mask setting to it. If you generally like a second helping of sharpening, run the filter again. Then switch back to RGB mode.

Step Nine:

Now, in the Actions palette, click on the Stop button at the bottom of the palette (it's the square button, first from the left). This stops the recording process. If you look in the Actions palette, you'll see all your steps recorded in the order you did them. Also, if you expand the right-facing triangle beside each step, you'll see more detail, including individual settings, for the steps it recorded.

Step Ten:

Now, open a new photo and press the F-key you assigned to your action (you chose F12, right? I knew it!). Photoshop immediately applies the sharpening to the Lab channel for you (complete with conversions from RGB to Lab and back) and does it all faster than you could ever do it manually because it takes place behind the scenes with no dialogs popping up.

Continued

Step Eleven:

Now that you have an action written that will apply Lab sharpening, let's put this baby to work. Let's say you have a card of photos you took at the beach, in nice bright sun. The color looks okay, but you want to sharpen the 40+ photos you took. Certainly, you could open each photo, press F12 to sharpen each one quickly, and then close it; but there's a better way-after you've written an action that does what you want it to do, Photoshop will let you apply that action to an entire folder of photos, and Photoshop will totally automate the whole process. You can literally have it open every photo, apply your Lab sharpening, and then close every photo, all automatically, while you're watching CNN. How cool is that? This is called batch processing, and here's how it works: First, go under the File menu, under Automate, and choose Batch to bring up the Batch dialog.

Step Twelve:

Up at the top of the dialog, under the Play section, Photoshop wants you to choose which action you want to apply to your folder full of photos. From the Action pop-up menu, choose Lab sharpen. This will now be the action applied to the folder.

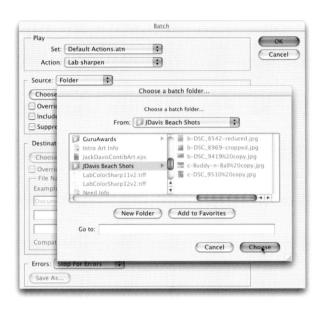

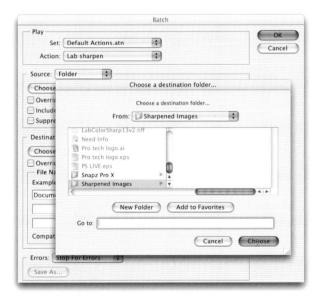

Step Thirteen:

In the Source section of the Batch dialog, you can tell Photoshop where the folder of photos you want to Lab sharpen is on your hard drive (or CD, or network, and so on). From the Source pop-up menu, you can choose a folder (which is what we're going to do), you can have selected photos batched from the File Browser, or you can import photos from another source. Again, we're doing a folder, so make sure Folder is selected in the Source pop-up menu, then click the Choose button. A standard "Open" dialog will appear. Navigate to your desired folder of photos, click on that folder, and then click the Choose button.

Step Fourteen:

In the Destination section of the Batch dialog, you can tell Photoshop where you want it to put these photos after it's finished applying the Lab sharpening to them. If you choose Save and Close from the Destination pop-up menu, it will save the images in the same folder where they started. It just opens them, applies the Lab sharpening, saves the files, and then closes them. If you select Folder from the Destination pop-up menu, then Photoshop will place your Lab sharpened photos into a totally different folder. Which folder? You have to tell Photoshop which folder (or create a new one) by clicking on the Choose button in the Destination section.

Step Fifteen:

If you choose a folder to save your newly sharpened photos into, you might also want to rename them (you don't have to, but if you want to rename them, now's the time). This is particularly handy if you're opening photos that still have the default names assigned by your camera. The field under the File Naming section is where you decide how the auto-naming will name your files. (Note: If you want detailed information on how Photoshop's automated file naming works, look in Chapter 1 [File Browser], for details). In short, here's how the file naming works: In the first field, you type the basic name you want the files to have. In the second field, you choose (from a pop-up menu) the automatic numbering scheme to use (adding a 1digit number, 2-digit number, and so on). In the third field, you choose the file extension (.jpg, .tif, and so on). Now, Photoshop will automatically rename the photos at the same time it applies your action.

Step Sixteen:

At the bottom of the dialog, there's a row of checkboxes for choosing compatibility with other operating systems. I generally turn all of these on, because "ya never know." For example, I often wind up putting digital camera photos on the Web, and you don't always know which kind of server (Mac, Win, UNIX) you might be uploading your files to. When you're finally done, click OK.

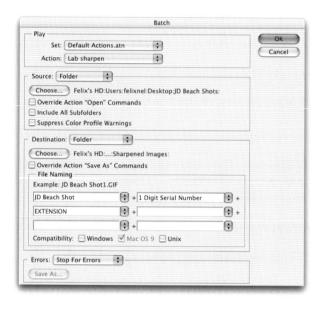

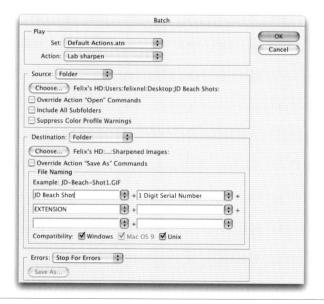

This is another sharpening technique popular with professionals, and one that sparks debate between photographers who prefer it to the Lab sharpening technique. Both sharpen just the luminosity (rather than the color data), so theoretically they do the same thing, but you'll hear pros argue that one method produces better results than the other. That's why I'm including both in the book, so you can decide which you like best and then argue about it with other photographers. (This is what we do for fun.)

Luminosity Sharpening

Step One:

Open a photo candidate for luminosity sharpening.

Step Two:

Go under the Filter menu, under Sharpen, and choose Unsharp Mask. Apply the filter directly to your RGB photo (don't switch to Lab color, and so on). Note: If you're looking for some sample settings for different situations, look at the "Basic Sharpening" tutorial at the beginning of this chapter, and on page 294, I list some settings that are popular with professionals.

Continued

Click OK to apply the Unsharp Mask filter. Then go under the Edit menu and choose Fade Unsharp Mask. When the Fade dialog appears, change the Mode to Luminosity (as shown).

Step Four:

When you click OK, the sharpening is now applied only to the luminosity of the photo, and not to the color data. This enables you to apply a higher amount of sharpening without getting unwanted halos that often appear when applying high levels of sharpening to color photos.

This is a sharpening technique that doesn't use the Unsharp Mask filter, but still leaves you with a lot of control over the sharpening, even after the sharpening is applied. It's ideal to use when you have an image that can really hold a lot of sharpening (a photo with a lot of edges), or one that really needs a lot of sharpening.

Edge-Sharpening Technique

Step One:

Open a photo that needs edge sharpening.

Step Two:

Duplicate the Background layer by pressing Command-J (PC: Control-J). The copy will be named Layer 1 in the Layers palette.

Go under the Filter menu, under Stylize, and choose Emboss. You're going to use the Emboss filter to accentuate the edges in the photo. You can leave the Angle and Amount settings at their defaults (135° and 100%) but if you want more intense sharpening, raise the Height amount from its default setting of 3 pixels to 5 or more pixels. Click OK to apply the filter, and your photo will turn gray, with neon-colored highlights along the edges.

Step Four:

In the Layers palette, change the Blend Mode of this layer from Normal to Hard Light. This removes the gray color from the layer, but leaves the edges accentuated, making the entire photo appear much sharper.

Step Five:

If the sharpening seems too intense, you can control the amount of the effect by simply lowering the Opacity of this layer in the Layers palette.

This edge-sharpening technique is great when you want to apply some intense sharpening to a particular object in your photo, but there are other areas that you don't want sharpened at all. This technique is different because you're going to actually enhance the edge areas yourself, by using some tricks to put a selection around only those edges that you want to sharpen.

Extreme Edge Sharpening

Step One:

Open the photo to which you want to apply edge sharpening. Press Command-A (PC: Control-A) to put a selection around the entire photo, then press Command-C (PC: Control-C) to copy the photo into memory.

Step Two:

Go to the Channels palette and click on the New Channel icon at the bottom of the palette. When the new channel appears, press Command-V (PC: Control-V) to paste a grayscale version of your photo into this new channel (as shown). Now Deselect by pressing Command-D (PC: Control-D).

Go under the Filter Menu, under Stylize, and choose Find Edges. There's no dialog, no settings to enter—the filter is simply applied and it accentuates any visible edges in your photo. The problem you'll probably encounter is that it accentuates too many edges, so you'll want to tweak things a bit so just the most defined edges remain visible.

Step Four:

Press Command-L (PC: Control-L) to bring up Levels. When the dialog appears, drag the top-right Input Levels slider (the highlights) to the left. As you do, you'll be "cleaning up" the excess lines: the lines that aren't that well defined and don't need to be sharpened.

Step Five:

Defining the edge areas within your photo is very important for this method of sharpening to be effective, so we're going to take another step to define those edges. It's going to sound kind of counter-productive, but you're going to blur the existing lines (don't worry, you'll remove the blur in the next step). Go under the Filter menu, under Blur, and choose Gaussian Blur. Enter a setting of 1 pixel and click OK to slightly blur your channel.

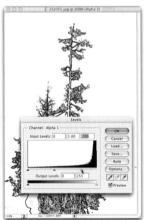

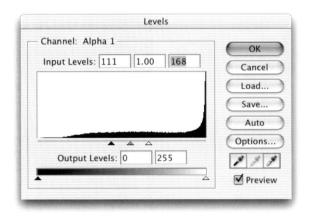

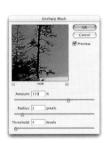

Step Six:

Press Command-L (PC: Control-L) to bring up the Levels dialog again. This time, you're going to use Levels to remove the blurring, and by doing so, further accentuate the edge lines. All you have to do is drag the Input Levels sliders at each end (the left shadow slider and the right highlight slider) toward the middle until the blurring is gone. You'll drag them until they almost meet the center midtone slider, or until the blurring is gone and the lines look much more defined. When it looks good to you, click OK.

Step Seven:

Go to the Channels palette, hold the Command key (PC: Control key), and click on the Alpha channel you created (Alpha 1) to load it as a selection. You'll notice that some of the background areas are selected, so go under the Select menu and choose Inverse to inverse the selection. Then click on the RGB channel to show the full-color photo (the selection will still be in place).

Step Eight:

Your selection is only around the well-defined edges in your photo, so now you can apply the Unsharp Mask filter using some extreme settings, and only the edges (the selected areas) will be affected, leaving other non-edge areas unaffected.

Sharpening with Layers to Avoid **Color Shifts** and Noise

This is another technique for avoiding noise and color shifts when sharpening but this one makes use of Layers and Blend Modes. The method shown here is a cross between a technique that I learned from Chicagobased retoucher David Cuerdon, and one from Jim DiVitale, in one of his columns for Photoshop User magazine.

Step One:

Open the photo you want to sharpen using this technique. Duplicate the Background layer by pressing Command-J (PC: Control-J).

Step Two:

Change the Blend Mode of this duplicate layer to Luminosity (as shown).

Step Three:

Apply the Unsharp Mask filter to this duplicate layer. (If you've read this far, you already know which settings to use, so have at it.)

Step Four:

Now, duplicate this sharpened luminosity layer by pressing Command-J (PC: Control-J).

Step Five:

Go under the Filter menu, under Blur, and choose Gaussian Blur. When the dialog appears, enter 3 pixels to add a slight blur to the photo. If this setting doesn't make your photo look as blurry as the one shown here, increase the amount of blur until it does. This hides any halo, or noise, but it makes the photo really blurry.

Color October 1 copy BCB)

Supera Operary 1 copy BCB)

Lest: 1 copy 1 co

Step Six:

To get rid of the blur on this layer, but keep the good effects from blurring (getting rid of the noise and halos), change the Blend Mode of this blurred layer from Luminosity to Color. Zoom in on edge areas that would normally have halos or other color shifts and you'll notice the problems just aren't there. Now you can flatten the photo and move on. Note: In some cases this technique mutes some of the red in your photo. If you notice a drop-out in red, lower the Opacity of the blurred layer until the color is restored.

Sharpening Close-Up Portraits of Women

If you need to sharpen a close-up portrait but want to keep your subject's skin as smooth as possible, here's a technique used by fashion photographers and retouchers that enables them to apply sharpening without overly enhancing pores, wrinkles, or any imperfections in the skin. It's simple, but it works.

Step One:

Open the close-up portrait you want to sharpen using this technique.

Step Two:

If you apply sharpening to the RGB composite, or even the luminosity of the image, you'll wind up accentuating the texture of the skin (which is a bad thing if your goal is to keep the skin looking smooth). (Shown at right.)

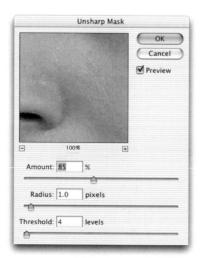

Step Three:

To avoid accentuating the skin texture, go to the Channels palette and click on the Red channel to make it active. Now when you apply the Unsharp Mask filter, the sharpening will only be applied to this channel.

Step Four:

Why only the Red channel? In portraits, the Red channel usually contains the least amount of edge detail and definition, and sharpening just this channel sharpens the areas you want (the eyes, lips, and so on) without having too much effect on the skin (leaving it smooth). In the capture shown at left, the Blue channel is selected, and you can see her skin texture clearly. Sharpen this channel, and you'll be intensifying that texture.

Step Five:

In the capture shown at left, the Green channel is selected, and although the texture isn't as pronounced as in the Blue channel, it's still more distinct than in the Red channel.

Step Six:

Here's the final portrait, using the Unsharp Mask filter on the Red channel only. The original image (top) is also shown for reference.

The original portrait.

The portrait sharpened on just the Red channel to avoid accentuating the skin texture.

This is a more advanced technique for sharpening portraits of women that I learned (not surprisingly) from fashion photographer Kevin Ames. It does a great job of enabling you to create an overall feeling of sharpness, without emphasizing the texture of the skin. It takes a few extra steps, but the final effect is worth it.

Advanced Sharpening for Portraits of Women

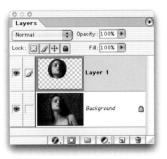

Step One:

Open the portrait you want to sharpen without accentuating the skin texture.

Step Two:

Get the Lasso tool in the Toolbox and make a loose selection around the face (as shown). This is one of the rare instances where there's no need to soften (feather) the edges of your selection, because we're not changing the size, tone, or position of this selected area.

Step Three:

After your selection is in place, press Command-J (PC: Control-J) to put the selected area up on its own layer.

Step Four:

Now you can go under the Filter menu, under Sharpen, and apply the Unsharp Mask filter to this layer. Although you'll see the texture in the skin appear to be accentuated as a result of the sharpening, it's okay, because in the next step we'll fix that.

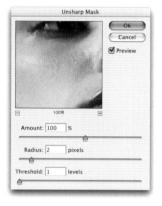

Step Five:

Hold the Option key (PC: Alt key) and click on the Layer Mask icon at the bottom of the Layers palette. Holding the Option/Alt key fills the Layer Mask with black, hiding the Unsharp Mask filter you just applied.

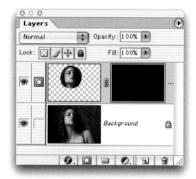

Step Six:

Get the Brush tool and choose a mediumsized, soft-edged brush. Press the letter "d" to switch your Foreground color to white, then begin to paint over the areas on her face that you want to have detail (lips, eyes, eyelashes, eyebrows). As you paint, it paints the sharpening back in, so avoid any skin areas (that's the whole point of sharpening using this method), and only paint over detail areas. You can also paint over hair and other areas outside the face that you want to sharpen.

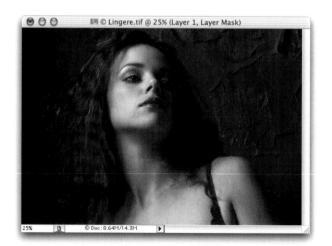

The Show Must Go On showing it to your clients

every sense of the word, a masterpiece. But now it's time to show it to the client. Hopefully, you'll get to show it to the client in person, so you can explain in detail the motivation behind collaging a 4x4 monster truck into an otherwise pristine wedding photo. (Answer: Because you can.) There's a good chance they'll see the photo first on your screen, so I included some cool tricks on how to make your presentation look its very best (after all, you want those huge 122" tires to look good), and I even included some techniques on how to provide your own online proofing service using Photoshop (in case your clients smell bad, and you don't want them coming back to your studio and stinkin' up the place). This is the last chapter in the book, so I want you to really sop up the techniques (like you're using a big ol' flaky biscuit) because once you're done with this chapter, once you've come this far, there's no turning back. At this point, some people will start to scour their studio, searching for that one last roll of traditional print film, probably knocking around at the bottom of some drawer (or hidden in the back of the refrigerator, behind some leftover Moo Shoo Pork), so they can hold it up toward the light, smile, and begin laughing that hysterical laugh that only people truly on the edge can muster. These people are not Kodak shareholders.

This two-part technique is particularly important if you're putting your proofs on the Web for client approval. In the first part of this technique, you'll add a see-through watermark, so you can post larger proofs without fear of the client downloading and printing them; and second, you'll embed your personal copyright info so if your photos are used anywhere on the Web, your copyright info will go right along with the file.

Step One:

First, the see-through watermark: Open the image for watermarking.

Step Two:

Choose the Custom Shape tool from the Toolbox as shown.

Step Three:

After you have the Custom Shape tool, go up to the Options Bar and click on the Shape thumbnail to bring up the Custom Shape Picker. Choose the Copyright symbol (as shown), which is included in the default set of the Custom Shape library.

Step Four:

Create a new blank layer by clicking on the Create New Layer icon at the bottom of the Layers palette. Press the letter "d" to set your Foreground color to black, and drag out the Copyright symbol over your photo (use your own judgement as to size and placement).

NOTE: If you end up with a Shape Layer or a path, go to the Options Bar and make sure that you have Fill Pixels selected (third icon from the left in the first group of icons on the left) before you draw the Copyright symbol.

Step Five:

Go under the Filter menu, under Stylize, and choose Emboss. Apply the Emboss filter with the default settings of Angle 135°, Height 3 pixels, and Amount 100% (you can increase the Height setting to 5 if you want the effect to be more pronounced); then click OK.

Step Six:

To smooth the edges of the Copyright symbol, go to the Layers palette, turn on Lock Transparent Pixels (the first icon from the left in the Lock section at the top of the palette), and add a 2- or 3-pixel Gaussian Blur (Filter>Blur> Gaussian Blur).

Step Seven:

Go to the Layers palette and change the Blend Mode of this Copyright symbol layer from Normal to Hard Light, to make the watermark transparent (as shown).

Step Eight:

Switch to the Type tool, enter the name of your studio, and position it where you think it looks best.

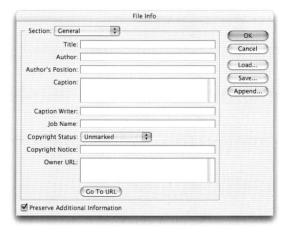

Step Nine:

You're going to apply the same filter to your type that you applied to the Copyright logo. But to apply a filter to type, you first have to convert your Type layer into a regular Photoshop image layer by Control-clicking (PC: Right-clicking) on the Type layer (in the Layers palette) and choosing Rasterize Layer from the resulting pop-up menu (as shown).

Step Ten:

Apply the Emboss filter to your rasterized type layer, and then change the Blend Mode from Normal to Hard Light to make the type see-through. That completes the first part of this two-part technique. The next part is embedding the copyright info into the file.

Step Eleven:

Go under the File menu and choose File Info to bring up the File Info dialog (shown here). This is where you enter information that you want embedded into the file itself. This embedding of info is supported by all Macintosh file formats, but on Windows only the major file formats are supported, such as TIFF, JPEG, EPS, PDF, and Photoshop's native file format.

Step Twelve:

In the File Info dialog, change the Copyright Status pop-up menu from Unmarked to Copyrighted Work (as shown). In the Copyright Notice field enter your personal copyright info. Then, under Owner URL, enter your full Web address. That way, when someone opens your file in Photoshop, they can go to File Info, click the Go To URL button, and it will launch their browser and take them directly to your site.

Step Thirteen:

Click OK and the info is embedded into the file. After copyright info has been added to a file, Photoshop automatically adds a Copyright symbol before the file's name that appears in the photo's Titlebar (as shown here). It also adds the symbol before the Document Size in the Info Bar at the bottom left of the document window. Last, flatten the image by choosing Flatten Image from the Layers palette's pop-down menu.

Step Fourteen:

Now you can automate the entire process with the click of one button. Start by opening a new photo, then go to the Actions palette and click on the Create New Action icon at the bottom of the palette. When the New Action dialog appears (shown here), name the Action, and choose the Function Key (F-key) that you want to use to apply the Action.

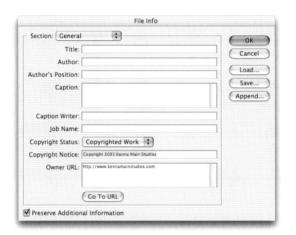

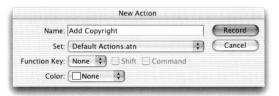

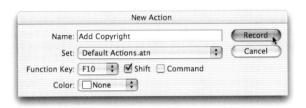

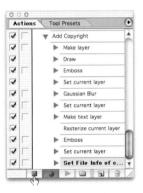

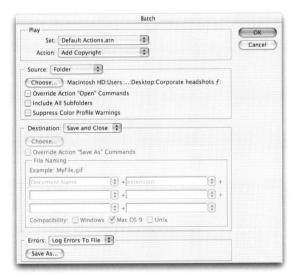

Step Fifteen:

Click the Record button (as shown) and repeat the whole process of adding the Copyright symbol and File Info, starting at Step One, and Photoshop will record all your steps. (I know, you're thinking, "Shouldn't you have told me this in Step One?" Probably, but it wouldn't be as much fun as telling you now.)

Step Sixteen:

When you're done, click the Stop button at the bottom of the Actions palette (as shown). You can close the Actions palette now, because you can apply the watermark, studio name, and copyright info just by pressing the F-key you chose in the New Action dialog.

Step Seventeen:

If you want to apply this Action to a whole folder full of photos, just go under the File menu, under Automate, and choose Batch to bring up the Batch dialog (which lets you pick one Action and automatically apply it to a whole folder of photos). In the Play section (at the top), for Action choose "Add Copyright" (as shown). Under Source, click the Choose button and navigate to your folder full of photos; then, under Destination, choose Save and Close. This will apply the watermark, studio name, and copyright info to your images, and then save and close the documents. If you want to save them to a different folder, or rename them, under Destination choose "Folder."

Digimarc is a digital copyright watermarking system that is applied to your photos from right within Photoshop using the Digimarc filter, which appears at the bottom of the Filter menu (you always wondered what that filter was for, didn't you?). The system is pretty ingenious, and although it requires an annual subscription to Digimarc service, you can do that online right from within the filter dialog. Here's how the process is done (and how to prepare your files for digital watermarking).

Step One:

Open a photo for digital watermarking. This watermark is applied directly to your photo, and as long as the photo isn't one big solid color (there are some variations in color and detail in the image), the digital watermark is imperceptible to the human eye (however, dogs can see it, no sweat, but they see it in black and white).

Step Two:

The embedding should take place right before you save the file, so do all your color correction, retouching, sharpening, and special effects before you get ready to embed the watermark. Also, this Digimarc embedding only works on a flattened photo, so if you have a layered document, duplicate it (by going under the Image menu and choosing Duplicate) and then flatten the duplicate layered document by choosing Flatten Image from the Layers palette's pop-up menu (as shown).

Embed Watermark Digimarc ID: ImageBridge Demo Personalize Image Information: Copyright Year Image Attributes: Do Not Copy Adult Content Target Output: Monitor Watermark Durability: Liss Wable Liss Durable Werify Cancel OK

Step Three:

Go under the Filter menu, under Digimarc, and choose Embed Watermark.

Step Four:

This brings up the Embed Watermark dialog. I'm assuming at this point you don't have a Digimarc account set up, so click the Personalize button (as shown). If you do have a Digimarc account, click the same button, and it will ask for your Digimarc ID and PIN. If not, you'll have a chance to get yours in the next dialog.

Step Five:

The Personalize Digimarc ID dialog is where you enter your Digimarc ID and PIN. If you don't have one, then click on the Info button (as shown); as long as you have an Internet connection, it will launch your browser and take you to Digimarc's Web site, where you can choose which subscription plan best suits your needs. At the time of this writing, the service started at \$49 for a one-year basic subscription and went up from there, based on how many photos you want to protect and other options you might want to purchase. See their site for details.

Step Six:

At the Digimarc site, the registration process is very simple (pretty much like any other e-commerce site these days). Immediately after you hit the Submit button (with your payment info), you're presented with your Digimarc ID and PIN. Enter these in the Personalize Digimarc ID dialog (as shown). Needless to say, that's not my real Digimarc ID number and PIN. Or is it? Hmmmm.

Step Seven:

Click OK to return to the Embed Watermark dialog. In the Image Information: Copyright Year field, enter the year the photo is copyrighted. For Image Attributes, enter the information you'd like to appear on the file. You also need to choose a Target Output. This helps determine how strongly the watermark should be applied to your photo (for example, Web images that will go through compression will need more durability than photos saved in lossless formats like TIFF or PSD). Look under the Watermark Durability slider in the dialog box to see the relationship between visibility and durability (kind of like the compression relationship in JPEG images, where higher quality means larger file sizes and lower quality means smaller file sizes).

Step Eight:

Click the Verify checkbox at the bottom left of the dialog if you want to check the strength of the watermark immediately after you apply it.

Step Nine:

When you click OK (with Verify turned on), it immediately verifies the strength of the watermark, and whether it was successful. Click OK in this dialog, and the process is complete—a copyright symbol appears next to your file's name when viewed in Photoshop. Also, your Web site URL, your contact info, and your copyright info is embedded into the file. Now it's okay to save the file. (Note: If you're saving as a JPEG, to preserve the watermark, it's recommended that you don't use a compression quality lower than 4.)

Step Ten:

Now that the info is embedded, if somebody opens your copyrighted photo in Photoshop, the watermark will be detected. You can check the watermark manually by going under the Filter menu, under Digimarc, and choosing Read Watermark (as shown).

Step Eleven:

This brings up the Watermark Information dialog that shows that the photo is copyrighted and whether the image is restricted. At the bottom-left corner of the dialog is a button called "Web Lookup;" if someone who downloaded your photo clicks on this button, it will launch their Web browser and take them directly to your copyright info and your contact info. Pretty slick stuff!

Showing a Client Your Work on Your Computer

Anytime I'm showing a client my work onscreen, I use this technique because it quickly tucks Photoshop out of the way so the client isn't distracted by the palettes, menus, and so on. They can focus on just the image, and not on the software I'm using. Also, it does a nice job of presenting each photo in almost a museum setting—perfectly centered on a black background with no distractions.

Step One:

Open the photo you want to show to your client in Photoshop.

Step Two:

Press f-f-Tab (that's the letter "f" twice; then the Tab key). The first "f" centers your photo onscreen, surrounded by gray canvas area. The second time you press "f", the background changes to black, and Photoshop's Menu Bar is hidden. Then, when you press Tab, it hides the Toolbox, Options Bar, and any open palettes, presenting your photo onscreen as shown here.

Step Three:

To return quickly to your normal display layout, just press f-Tab. Now that you know these two shortcuts, you can use a variation of them to create a slideshow from right within Photoshop.

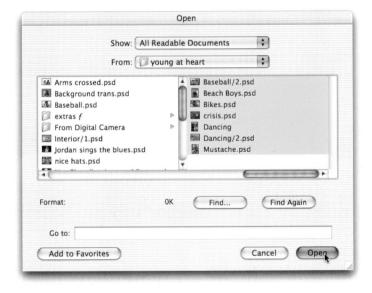

Step Four:

Go under the File menu and choose Open. In the Open dialog, click on the first photo you want to open, hold the Option key (PC: Alt key), and then click on all the other photos you want to open.

Step Five:

Click the Open button, and Photoshop will open all the photos, one right after the other (as shown here).

Step Six:

Now that all the photos you want in your slideshow are open, hold the Shift key and click on the Full Screen Mode button at the bottom of the Toolbox (as shown here).

Step Seven:

This centers the first photo in your stack of photos on a black background, but your palettes will still be visible, so press the Tab key to hide them.

Step Eight:

After your palettes are hidden, your slideshow is ready. To view the next "slide," just press Control-Tab and the next photo in the stack will open.

Because you held the Shift key when you switched to Full Screen Mode, the previous picture will automatically be hidden when the next photo appears. Continue through the stack by pressing Control-Tab. The slideshow will automatically loop, so scroll through as many times as you'd like.

Step Nine:

When you're done with your slideshow and want to return to Standard Screen Mode, press the Tab key to make the Toolbox visible again, hold the Shift key, and then click on the Standard Screen Mode button at the bottom of the Toolbox (as shown here).

Giving your clients the ability to proof online has many advantages, and that's probably why it's become so popular with professionals. Luckily, Photoshop has a built-in feature that not only automatically optimizes your photos for the Web, it actually builds a real HTML document for you, with small thumbnail images, links to large full-size proofs, email contact back to you, and more. All you have to do is upload it to the Web, and give your client the Web address for your new site. Here's how to make your own.

Step One:

Put all the proofs you want your client to view on the Web into one folder.

Step Two:

Go under the File menu, under Automate, and choose Web Photo Gallery (as shown).

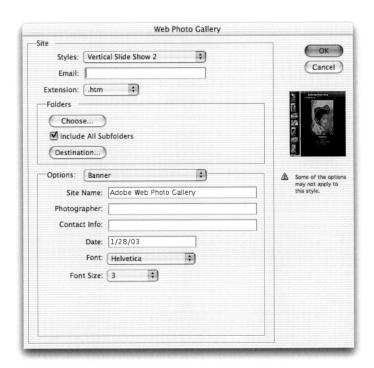

Step Three:

This brings up the Web Photo Gallery dialog. At the top is a pop-up list of styles (presets) where you can choose from different Web page layouts. A thumbnail preview of each template appears in the fa-right column of the dialog (below the Cancel button) as you choose the different styles. In this example, I chose Vertical Slide Show 2, which creates a Web site that automatically presents a slideshow displaying a fullsized photo every 10 seconds. In a separate frame down the left side of the page, there are small thumbnails that can be clicked on to display a particular photo full-sized. Just below the Styles pop-up menu is a field for entering your email address (which will appear prominently on your Web page) so your client can easily contact you with their choice made from the online proofs.

Step Four:

In the Folders section of the Web Gallery dialog, you specify the location of the folder of photos you want to put on the Web, and you determine which folder these Web-optimized images will reside in for uploading. When you click the Choose button, a dialog appears prompting you to Select Image Directory (the folder full of photos). Locate them and click the Choose button (as shown).

Step Five:

In the Options section of the dialog, choose Banner from the pop-up menu to enter the headlines and subheads for the site (as shown here). Next, from the Options pop-up menu, choose Large Images (shown in the capture in Step Six).

Step Six:

The Large Images Options area is where you choose the final size and quality of the full-size photos displayed on your Web page. You can also choose titles to appear under each photo in the Titles Use section. I recommend checking the Copyright checkbox, which will display your copyright info under each photo. Note: For this to work, you have to embed your copyright info in the photo first, by going under the File menu, choosing File Info, and entering your copyright text in the Copyright field.

Step Seven:

Change the Options pop-up menu to Security; then, in the Content pop-up menu, choose Custom Text. This makes available the Custom Text field where you can enter text that will appear right across your large-size photo. This is where you might add things like "Proof Copy," "Not for Printing," or "Not for Duplication." You can also specify the Font Size, Font Color, Opacity, and Position in this section.

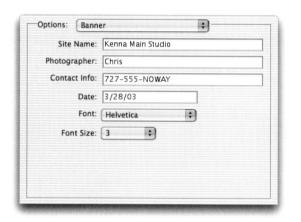

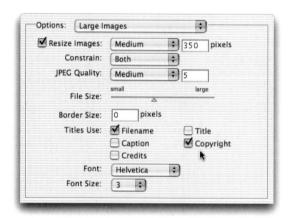

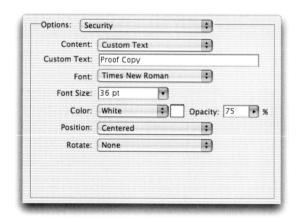

Back Forward Stop Refresh Name Autofil Print Mail Autofil Print M

Step Eight:

When you add custom text, here's how that text will appear over your photo.

Step Nine:

Click OK and Photoshop will do its thing—resizing the photos, adding custom text, making thumbnails, and so on. Then it will automatically launch your Web browser and display the HTML Web page it created for you. Here you can see the studio name in the top-left corner (which you entered in the Banner Options). Your email address appears with a live link (if your client clicks it, it will open their email client with your email address already entered in the "To:" field). It displays the full-size proof (with your custom text appearing over it), and the file's title right below it (which is important so the client can tell you which photos they want). Below that is the Copyright info (taken from the embedded File Info for that photo), and below that is your phone number (so you can get dates).

Step Ten:

Photoshop automatically creates all the files and folders you'll need (shown here) to put your Web Gallery up live on the Web, including your home page (index.htm), and puts them neatly in your destination folder ready for uploading.

Presets

1 of 20 items selected, 10.69 GB available

Once you're used to using Web Gallery, chances are you'll start wanting to do things that Web Gallery just can't do—like customizing the background with your logo, or having your logo link to your home page, or...(well, you get the idea). Luckily, Kevin Ames wrote a great article in the January/February 2003 issue of *Photoshop User* magazine, in his "Digital Photographer's Notebook" column, that showed step by step how to hack the code for the Web Gallery templates to create your own custom page. Kevin was kind enough to let me include his steps here in the book. Kevin rocks!

Optimized Colors

Step One:

Look inside your Adobe Photoshop application folder for a folder named Presets. Inside that you'll find a folder named WebContactSheet (as shown here). In this folder are folders with templates that Photoshop references to manufacture each style of Web site. (A word of caution: It's a good idea to make a copy of the folder that contains the style you want to modify—in case the code writing gets out of hand. If you forget to make a copy and want to go back, the original templates can be copied from the Photoshop 7 installer CD.)

000

Gradients

Step Two:

Open the folder named Simple, where you'll find the templates to modify: IndexPage.htm and Subpage.htm. Leave Thumbnail.htm alone. The other files, ani_ames_logoweb.gif and background2.gif, are the custom graphics that we want Photoshop to use when building the custom pages in this tutorial. They must be in the destination folder of the site that Photoshop makes.

<BODY bgcolor=%BGCOLOR% text=%TEXT% link=%LINK% vlink=%VLINK% alink=%ALINK%>

Change it to read:

<BODY bgcolor=%BGCOLOR% background="background2.gif" text=%TEXT% link=%LINK% vlink=%VLINK% alink=%ALINK%>

Step Three:

Open IndexPage.htm in a text editor. In Mac OS X, TextEdit won't always allow editing of an HTML file, so instead, open it in Word (or Simple Text in OS 9) by dragging the file onto the Word icon. With the "HTML Source" checked in the View menu, start by setting a pattern for the background. Look for the line of text shown here (top left) and change it as shown in the line of text below it.

Step Four:

Scroll down the document IndexPage.html to the two lines that read:

</TD>

and insert the following line of code between them:

<TD ALIGN="LEFT"></TD>.

In the IndexPage.htm (shown here), the first highlighted block shows some additional changes that we made that help keep the page private. In the second highlight (which is in the middle of the line of text that we changed in Step Three), we also changed "bgcolor=%BGCOLOR%" to "bgcolor=white" to set the background color to white, overriding Photoshop's background color options.

(On www.amesphoto.com, the standard background is white with a pattern of gray vertical lines, generated from background2.gif.) This disables the ability to change the background color in the Web Photo Gallery dialog, so change this only if you want every page to have the same background color. The third block shows the copy we added at the beginning of this step, which positions the logo at the upper-right of the page, establishes a link to the home page, and sets the image size and file name with no border. Here are some variables that will probably be different for your Web site:

First, in the line of code we added at the beginning of this step, look for the code:. When the logo is clicked, it tells the browser to look up two levels for the home page of the site (index.html). Look at the hierarchy of your Web site before adding this line. ".../" instructs to go up one level. On this site, the home page lives two levels above the Web Photo Gallery.

Second, the size of your logo will probably be different. Check the size in either Photoshop or ImageReady (Image>Image Size) and enter those values in pixels instead of Height="76" Width="225". Substitute the file name of your logo to be placed for the name ani_ames_logoweb.gif.

Step Five:

Open SubPage.htm in Word. Find the line that reads:

<BODY bgcolor=%BGCOLOR% text=%TEXT% link=%LINK% vlink=%VLINK% alink=%ALINK%>

After bgcolor=%BGCOLOR%, add the following text: background= "../background2.gif". Photoshop will put the sub-pages in a folder called Pages. The file background2.gif is located in the destination folder, so the sub-pages have to look up one folder for the graphic. Be sure that the code "../" precedes background2.gif, which tells the browser to look for it in the destination folder.

Step Six:

Scroll down to the lines:

</TD>

</TR>

Between them, insert the line:

<TD ALIGN="LEFT"><img height="76" width="225"

src="../ani_ames_logoweb.gif"

border="0"></TD>

This line contains two very important differences from that of the one used on IndexPage.htm in Step Four. There's an additional "../" in the link code () and the location of the logo (src=".../ani_ames_logoweb.gif"). The variables that you use on SubPage.htm will probably be the same as the modifications on your version of the IndexPage.htm. Save the page to the Simple folder.

Step Seven:

Add your graphic files to the destination folder. These are the only files that should be in the destination folder. Photoshop will add all the other files to this folder as it builds the Web site.

Step Eight:

Construct the Web site in Photoshop. Go under the File menu, under Automate, and choose Web Photo Gallery. In the Styles dialog, choose Simple. Under Options, choose Banner and fill in the site name, the photographer, contact info, font, and font size for the banner.

In the Folders section, choose the folder that holds the images for the new site. Select the destination folder.

Further customization happens with the Options pop-up menu with choices including Thumbnails, Large Images, Colors, and Security. Photoshop offers several size alternatives, as well as custom sizes for both Large Images and Thumbnails. In Custom Colors, preferences are made for the background, banner, text, links visited, and active links. Click OK and watch Photoshop go to work building your very own custom Web Photo Gallery.

Troubleshooting:

Where are the graphics? If the back-ground is missing and there's a box where the logo should be, check in the destination folder to make sure the graphics files are there. If a Web site looks like the example shown here, add the files to the destination folder. Then click Refresh on the browser, and all will be as intended.

Getting One 5"x7", Two 2.5" x 3.5", and Four Wallet Size on One Print

When it's time to deliver final prints to your client, you can save a lot of time and money by creating a "Picture Package," which lets you gang-print common final sizes together on one sheet. Luckily, Photoshop does all the work for you. All you have to do is open the photo you want ganged and then Photoshop will take it from there. Except the manual cutting of the final print, which is actually beyond Photoshop's capabilities. So far.

Step One:

Open the photo you want to appear in a variety of sizes on one page, then go under the File menu, under Automate, and choose Picture Package (the Picture Package dialog is shown here). At the top of the dialog, the Source block asks which photo you want to use as your Source photo. By default, if you have a photo open, it assumes that's the one you want to use (your Frontmost Document), but you can choose from the Use pop-up menu to use photos in a folder or an individual file on your drive. By default, Picture Package chooses an 8x10 page size for you, but you can also choose either a 10x16 or 11x17 page size.

Step Two:

You choose the sizes and layout for your Picture Package from the Layout pop-up menu (shown here). In this example, I chose (1) 5x7 (2) 2.5 x 3.5 and (4) 2x2.5, but you can choose any combination you like.

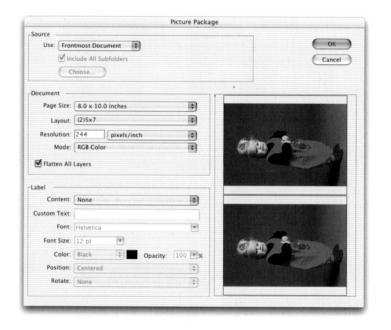

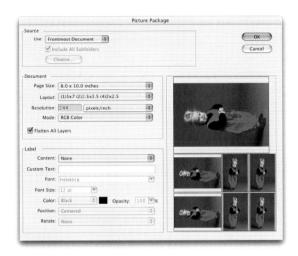

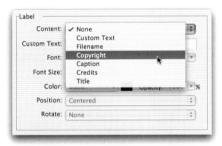

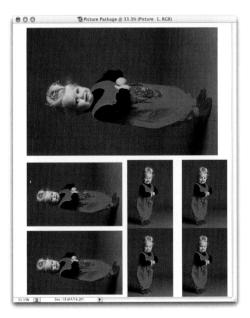

Step Three:

When you choose a layout, a large preview of the layout you've selected appears in the right column of the dialog. You can also choose the final output resolution you'd like in the Resolution field, and the Color Mode you'd like for your final output. (In this case, I chose RGB because I'll be printing them to a color inkjet printer.)

Step Four:

The bottom-left section of the dialog is for labeling your photos, but be forewarned—these labels appear printed right across your photos, so use these only if you're creating client proof sheets, not the final prints. Like the Web Photo Gallery, with the exception of adding your own custom text, this information is pulled from embedded info you enter in the File Info dialog, found under the File menu.

Step Five:

Click OK and Photoshop automatically resizes, rotates, and compiles your photos into one document (as shown). The one thing many photographers have complained about is that Picture Package doesn't offer you a way to add a white border around each photo in the package, but we've got a workaround for that in Step Six.

Step Six:

To have a white border appear around your photo in Picture Package, you have to first add it manually. So, start by pressing the letter "d" to set your Background color to white, then open your photo. Go under the Image menu and choose Canvas Size. Make sure the Relative Box is checked, and then enter the amount of white border you'd like in the Width and Height fields (I used 1/4 inch).

Step Seven:

When you click OK in the Canvas Size dialog, it adds a white border around your photo. Now you're ready to go under the File menu, under Automate, and choose Picture Package.

Step Eight:

Here's how your final Picture Package output will look, with a border added around each photo (compare it with the Picture Package output on the previous page with no border). Remember, although the final print sizes will be correct (a 5x7 will still measure 5x7 including the border), adding this white border does make the photo itself a little bit smaller in order to compensate.

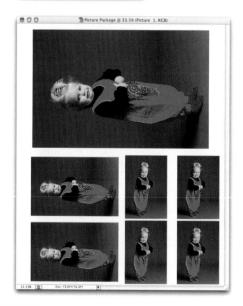

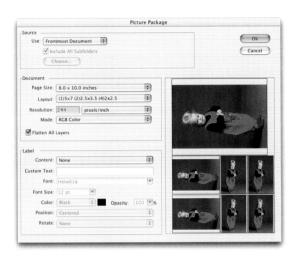

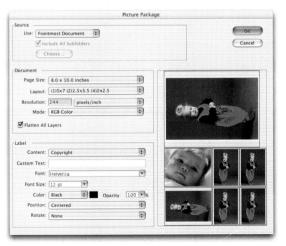

Step Nine:

Another feature of Picture Package is that you can have picture packages that use more than one photo. For example, to change one of the 2.5x3.5 prints to a different photo (while keeping the rest intact), just click on the preview of the image that you want to change to a different photo.

Step Ten:

When you click on this photo, a dialog will appear, prompting you to Select an Image File. Navigate to the photo you want to appear here.

Step Eleven:

Click the Open button, and that photo will now appear within your Picture Package (as shown here in the dialog's Preview column). You can replace any other photo (or all the photos) using the same method.

How to **Email Photos**

Believe it or not, this is one of those "most asked" questions, and I guess it's because there are no official guidelines for emailing photos. Perhaps there should be, because there are photographers who routinely send me high-res photos that either (a) get bounced back to them because of size restrictions, (b) take all day to download, or (c) never get here at all because "there are no official guidelines on how to email photos." In the absence of such rules, consider these the "official unofficial rules."

Step One:

Open the photo in Photoshop that you want to email. Before you go any further, you have some decisions to make based on whom you're sending the photo to. If you're sending it to "friends and family," you want to make sure the file downloads fast, and (this is important) can be viewed within their email window. I run into people daily (clients), who have no idea how to download an attachment from an email. If it doesn't show up in the window of their email client, they're stuck, and even if they could download it, they don't have a program that will open the file, so basically, they're stuck. So in short, make it fit in their email browser.

Step Two:

Go under the Image menu and choose Image Size. To play it safe, for "friends and family," use a resolution of 72 ppi and a physical dimension no wider than 8 inches and no higher than 5 inches (but the height isn't the big concern, it's the width, so make sure you stay within the 8" width). By limiting your emailed photo to this size, you ensure that friends and family will be able to download it quickly, and it will fit comfortably within their email window.

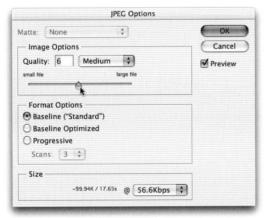

5x7 photo @ 300 Resolution Saved as a JPEG with 12 Quality = 2.2MB (download time: nearly 7 minutes)

5x7 photo @ 150 Resolution Saved as a JPEG with 12 Quality

= 656K (download time: Less than 2 minutes)

5x7 photo @ 300 Resolution Saved as a JPEG with 6 Quality

= 253K (download time: Less than 1 minute)

5x7 photo @ 150 Resolution Saved as a JPEG with 6 Quality = 100K (download time: 18 seconds)

Step Three:

If you're sending this to a client who does know how to download the file and print it, you'll need a bit more resolution (at least 150 and as much as 300, depending on how picky you are). However, the photo's physical dimensions are no longer a concern because again, the client will be downloading and printing out the file, rather than just viewing it onscreen in their email program (where 72 ppi is enough resolution).

Step Four:

As a general rule, the file format for sending photos by email is JPEG. To save the file as a JPEG, go under the Edit menu and choose Save As. In the Save As dialog box, choose JPEG, and then click OK. This brings up the JPEG Options dialog (shown here). This format compresses the file size, while maintaining a reasonable amount of quality. How much quality? That's up to you, because you choose the Quality setting in the JPEG Options dialog. Just remember the golden rule: the higher the quality, the larger the file size, and the longer it will take your client to download it.

Step Five:

Your goal is to email your client a photo that is small in file size (so it downloads quickly), yet still looks as good as possible. (Remember, the faster the download, the lower the quality, so you have to be a little realistic and flexible with this.) The chart shown here gives you a breakdown of how large the file size and download time would be for a 5x7 saved with different resolutions and different amounts of IPEG compression. It's hard to beat that last one-with an 18-second download on a standard dial-up modem.

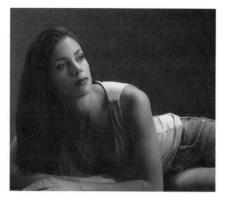

KEVIN AMES

Kevin Ames is a commercial photographer who holds the PPA Craftsman degree and is an Approved Photographic Instructor. He has served as Co-Chairman of the Digital Imaging and Advanced Imaging Technology Committee of PPA and Chairman of the Commercial Advertising Group. He's a digital photography instructor on the PhotoshopWorld "Dream Team," and writes the "Digital Photographer's Notebook" for *Photoshop User* magazine. Kevin specializes in creating evocative images that promote his customers' products, services, and ideals. www.amesphoto.com (email: kevin@amesphoto.com).

IACK DAVIS

Jack is co-author of the award-winning guide to Photoshop, *The Photoshop Wow! Book*, as well as an award-winning designer/ photographer and contributing editor to numerous books on digital imagery. For almost 20 years, he has been an internationally recognized creative spokesperson on the role of the computer in the visual communication process. Davis teaches as part of the "Dream Team" for the National Association of Photoshop Professionals, has his own national Wow! Seminar Tour, and leads digital photography workshops at the Lepp Institute of Digital Imaging. When he's not in his studio, he's usually on the beach somewhere in Polynesia with a digital camera and analog paints soaking up the local color. Visit www.software-cinema.com/wow or www.peachpit.com/wow.

IIM DIVITALE

Jim has been an Atlanta photographer and instructor for over 25 years. During the last ten years, Jim has specialized in digital photography and computer photo illustration for ad agencies, design firms, and corporations nationwide. His digital photography has been featured in, among others, *Graphis Photo, Print, Archive Magazine, Creativity, Professional Photographer, PEI, Digital Output Magazine,* and *Photo District News.* Jim has lectured at Seybold, Photo Plus, PhotoshopWorld, Imaging USA, ASMP, HOW Design, and the World Council of Professional Photographers, and writes a column on digital capture for *Photoshop User* magazine. See more of Jim's work at www.DiVitalePhoto.com.

CAROL FREEMAN

Carol Freeman is a gifted photographer who combines her graphic design and photographic skills with her love and appreciation for the natural world. She has been published in many publications including *The 2002 Audubon Wildflower Calendar, Kew Magazine, Nikon World Magazine,* and others. She is a Nikon-sponsored photographer and a guest speaker for Fuji Photo Film USA, conducting seminars on the many intriguing and mystifying aspects of nature photography. Carol's work has won numerous awards, most recently the *Graphic Design USA* award and the Bronze Summit award for her *In Beauty, I Walk* 2002 calendar. Carol is happiest when she is out in nature looking for her next photograph. She can be reached at 847-404-8508.

VINCENT VERSACE

Photographer Vincent Versace is a recipient of the 1998 Computerworld Smithsonian Award in Media Arts & Entertainment and the 2001 Shellenberg fine art award. His work is part of the permanent collection of the Smithsonian Institution's Museum of American History. Articles about Vincent's work have appeared in Shutterbug, Studio Design and Photography, Professional Photographer, Petersen's Photographic, Popular Photography, and PC Photo. His work is recommended by United Talent Agency, the William Morris Agency, International Creative Management, Creative Artists Agency, Gold/Miller, and Bluetrain Entertainment. Vincent is able to leap tall buildings in a single bound, and on the weekends he is a part-time superhero and short-order cook.

RICHARD LOPINTO

With close to thirty years experience at Nikon, Inc. (Vice President of SLR Camera Systems, 35mm, APS, and Pro Digital products for Nikon), Richard's experience in the world of photography began at age 10, and he has grown up within the industry, gaining experience at virtually every level as he honed his picture-taking skills, mastered technology, developed a keen understanding of marketing, and excelled in sales. He has led the introductions for all of Nikon's SLR models since the Nikon F3, and most recently is personally managing Nikon's trendsetting D1X, D1H, and D100 digital SLR cameras and Capture software. In addition to his marketing responsibility, Richard frequently speaks at industry events, and directs the company's professional support programs such as Nikon Professional Services and Nikon School.

IIM PATTERSON

A writer/photographer for more than 50 years (yep, a half century), Jim now devotes most of his time to a pretty successful freelance travel writing and photography avocation. He writes the column for Mac Design Magazine, called "The Digital Camera," and also writes for Photoshop User magazine. Jim is part of the PhotoshopWorld "Instructor Dream Team," and he writes a weekly digital photography column for PlanetPhotoshop.com. He writes numerous reviews on digital cameras, including digital camera and inkjet "shootouts" for both Photoshop User and Mac Design magazines. Jim is author of the novel The Thirteen and lives with his wife Betty in Largo, Florida.

DAVID MOSER

Dave got his start in professional photography doing equestrian photography, and had his work published in numerous equestrian magazines. He then studied biomedical photography at RIT, before becoming a pioneer in Internet news delivery as one of the founders of Web portal MacCentral.com. Today Dave acts as Chief Operating Officer of KW Media Group and Publisher of Nikon's Capture User magazine. Photography still remains an important part of his life where he now primarily shoots nature and concert shots, and his work appears in numerous Photoshop books.

INDEX

Symbols

16-bit mode, 133-145

dodging and burning, 137–139 selections, 164–165 shades of gray, 134

8-bit mode, 133 shades of gray, 134

A

Actions, 69, 300-304

Add Noise, 239

Adjustment Layers, 115-116

Channel Mixer. See Grayscale
Color Balance, 127–128, 130,
190–191
Curves, 116, 194–195
dragging—and—dropping, 117

Ames, Kevin, 4, 76, 148, 169, 184, 190, 198, 208, 217, 230, 317, 340

Arrow keys, 21, 48, 61, 262, 264 Auto Color, 123–124, 125–126

Hue/Saturation, 246-247

В

Banding, 239

Batch processing, 302-304, 327

Batch renaming, 304

See also File Browser

Blend Modes, 73, 80

Color, 87, 100, 191, 240, 251, 313

Darken, 171, 204, 209

Hard Light, 308, 324

Lighten, 171, 175, 180, 209

Luminosity, 312

Multiply, 73, 199, 200, 274

Overlay, 137, 187

Screen, 80, 163, 194

Soft Light, 189

Blue channel noise. See Digital Noise

Body sculpting, 222-235

arms, 230-231

cloning body parts, 232-235

love handles, 224-225

slimming, 222-223, 226-229

Brush Picker, 170-171, 174

Brush tool. See Tools

Burn tool. See Tools

C

Camera Raw plug-in, 140-145

Canvas Size, 260

CD jewel case, 13

Channels palette, 161, 273, 298, 309

color correcting with, 266-269

Client presentation, 332-335

on the Web, 336-339

Clipping Path

exporting, 159-160

Clone Stamp tool, 170-171, 174-175,

204-205, 227, 229, 231-235

Cloning, 215, 229, 234-235

Collaging, 252-255

Color. See also Blend Modes

changing object's, 246-247

for emphasis, 240-241

Color aliasing. See Digital Noise

Color Balance. See Adjustment Layers

Color Correcting, 104-139

flesh tone (RGB), 121-122

flesh tones (CMYK), 118-120

one area, 127-130,

with Auto Color, 123-126

with black/gray/white card, 131-132

Color Sampler tool. See Tools

Color Settings, 104-105

Color space. See Color Settings

Colorize, 92

Contact Sheet II, 8-12

thumbnails, 9-12

Copyright. See File Info

Crop tool. See Tools

Cropping, 44-57

cancel cropping, 46

canvas area, 56

crop border, 45

Rectangular Marquee tool, 52

to a specific size, 47-48

Trim. 54-55

Cuerdon, David, 98, 206, 312

Curves, 106-107, 109-114, 116,

118-120, 132. See also Image menu

and Adjustment Layers

setting Eyedropper values, 107–109,

114

Custom Shape tool. See also Tools

D

Darken. See Blend Modes

DeLillo, Helene, 226

Depth of field, 256-259

Desaturate, 89

Digimarc, 328-331

Digimare, 320 331

Digital negatives, 6

Digital Noise, 74-76

DiVitale, Jim, 68, 76, 102, 169, 189,

278, 290, 312

Dodge tool. See Tools

Duotone, 282-288

Halftone Screens, 287 presets, 285–286 saving, 288

E

Email photos, 348–349
Eraser tool. See Tools
Extract filter, 150–153.
See also Masking
Eyedropper tool. See Tools

F

Fade, 76, 124, 219, 306 Feathering, 78, 99, 121, 129, 172, 192, 202, 215 high resolution, 245 File Browser, 14-37 accessing, 14-15 Batch Renaming, 29-32 deleting images, 25, 34 Dock to Palette, 15 exporting cache, 35-36 panel displays, 17-18 EXIF data, 18-19 navigation, 17 preview, 17, 20 ranking, 25-26 Batch Ranking, 27-28 clear, 26

rotating images, 33-34

View options, 21-23

sorting, 24

thumbnails, 16

File Info, 325-327

Filter menu

Emboss, 308
Find Edges, 310
Gaussian Blur, 99, 178, 206, 209, 239, 244, 257, 310, 313, 324
Liquify, 213–214, 224–225
Motion Blur, 242–243
Pinch, 96

Flash

fill flash, 82–85 overexposed, 72–73 removing, 77–79 Flesh tones. See Color Correcting Free Transform, 94–96, 216, 67 perspective, 216 Full-Screen Mode, 334

G

Gaussian Blur. See Filter menu

Gradient tool. See Tools
Grayscale
Ansel Adams Effect, 278–279
converting RGB using Calculations, 280–281
Channel Mixer, 276–279
Lightness channel, 272–275
GretagMacbeth, 132
Grid, 60–63

Н

Hard Light. See Blend Modes

Healing Brush, 173, 181–182, 184–185,
217–219. See also Patch tool

High ISO noise. See Digital Noise

Highlights, 162–163

History Brush, 85, 139, 152, 179, 241.

See also History palette

History palette, 83–85, 138–139, 179, 197 Hue/Saturation. See also Adjustment

.....

1

Layers and Image menu

Image menu, 52
Adjustments
Auto Color, 123–126
Curves. See Curves
Hue/Saturation, 92, 122, 193, 203.
See also Colorize
Levels. See Levels
Calculations. See Grayscale
Crop, 52, 53
Image Size, 64–66, 68–69
Rotate Canvas, 59
Trim, 54–55, 264
Image Size. See Image menu

J JPEG 2000 Plug-In, 146-147

Info palette, 113, 119, 120

Keystoning, 94–97

L

K

Lab Color, 74–75, 272, 299
Layer Mask, 129–130, 199–200, 212, 238–239, 243, 245, 318
for collaging, 253
Levels, 78–80, 82–85, 106, 115, 123–125, 129, 133–135, 137–138, 144, 163, 267–268, 306, 310–311, 342

Lighten. See Blend Modes
Liquify. See Filter menu
Love handles. See Body sculpting
Luminosity, 74, 162, 272–273, 299,
305–306, 314. See also Blend Modes

M

Magic Wand tool. See Tools
Masking, 150–167
Measure tool. See Tools
Moiré, 98–100
Motion
adding, 242–243
Motion Blur. See Filter menu
Multiply. See Blend Modes

N

New documents, 40 custom sizes, 40–43 preset sizes, 40

New Layer

Fill with Overlay–neutral color (50% gray), 187–188 **Noise.** *See* Digital Noise

O

Opacity, 73, 81, 85, 90, 93, 124, 130, 139, 163, 175, 180, 185, 187, 188–189, 191, 195, 199, 201, 204, 207, 210–211, 219, 229, 235, 238, 249, 251, 253, 254, 262, 263–266, 274, 281, 308, 313, 338

Open dialog, 115

Overexposed. See Flash
Overlay. See Blend Modes

P

Panoramas

color-matching segments, 265–269 stitching, 260–265

Paste Into, 249

Patch tool, 176-177, 183

Path. See also Pen tool

turn into a selection, 155

Pen tool, 154–159, 230–231

drawing curves, 156-159

Perspective. See Keystoning

Photography filters

replicating, 250-251

Picture Package, 344-347

Portrait retouching, 170-219

acne/freckles, 178-179

blemishes, 170-173

dodging and burning, 186-189

eyes

dark circles, 174-177

enhancing, 196-197

eyebrows and eyelashes, 198-201

whitening, 192-195

hair, 190-191

hot spots, 204-205

nose, 215-216

nostrils, 217-219

skin softening, 206-212

smiles, 213-214

teeth, 202-203

wrinkles, 181-185

Q

Quick Mask mode, 256-257

R

RAW photos. See 16-bit mode

Rectangular Marquee tool. See Tools

Red eye, 86-93

Removing the signs of aging. See

Portrait retouching

Replacing the sky, 248-249

Resizing images, 64-69

increasing size, 68-69

Resolution, 9, 17, 43, 48, 64-66, 78,

141, 160, 239, 245, 287, 295, 345,

348-349

Retouching. See also Portrait

retouching

Roxio Toast Titanium, 7

S

Screen. See Blend Modes

Select menu, 78

Feather, 78. See also Feathering

Selections

16-bit mode, 164-165

dragging, 165

hiding, 122

loading, 161

loading highlights, 162-163

saving, 161

Sharpening, 292-319

close-ups, 314-318

edge sharpening, 307, 309-311

Lab sharpening, 298-304

luminosity sharpening, 305-306

Unsharp Mask, 196–197, 258,

292-297, 305, 311-312, 318

with layers, 312-313

Slimming. See Body sculpting

Soft Light. See Blend Modes
Standard Screen Mode, 335
Straighten crooked photos, 58-63

T

Threshold, 110–111
Tool Presets, 49–51

Crop tool, 49

Tools

Add Anchor Point tool. *See* Pen tool Brush tool, 86 Burn tool, 137 Color Sampler tool, 110–114 Crop tool, 48, 57. *See also* Cropping

Custom Shape tool, 322-323

Direct Selection Arrow. See Pen tool

Dodge tool, 137

custom, 49-51

Eraser tool, 92, 153, 207, 235, 263

Eyedropper tool Sample Size, 105

Gradient tool, 253-256

Magic Wand tool, 89

Measure tool, 58–59

Rectangular Marquee tool, 52

crop with, 52

Zoom tool, 86, 88, 141, 213, 224, 227,

266, 292

U

Underexposed Photos, 80, 81 Unsharp Mask. See Sharpening V

Vignette

focus, 244-245 lighting, 238-239

W

Watermarking, 322–325
Web Photo Gallery, 336–339
customizing, 340–343
White Balance. See Camera Raw
plug-in

Z

Zoom tool. See Tools

Cover Credits

Photo by Kevin Ames, Ames Photographic Illustration (www.amesphoto.com)

Model—Elona/L'Agence

Paige Schneider—make up/represented by CREWS

L.J. Adams/art direction and styling/represented by CREWS

Stacey Jenkins and Nicole Jones/stylist assistants

Photographer's Assistants: Summer Sipos, Justin LaRose

Hand knit silk tank and matching skirt by BK/Bano Italian Design, Atlanta

Embroidered silk voile top/Almanac, Atlanta

Topcoat/The Propmistress, Atlanta

Jewelry-Elsa Peretti mesh collar and cuff/Tiffany & Co.

Chapter 1

P. 4: Chapter Lead-in Photo by Kevin Ames

Pp. 11–36: All photos by Dave Moser Nikon D100 and Sony Cybershot

Chapter 2

P. 38: Chapter Lead-in Photo by Jim Patterson Nikon D100

P. 44: Carol Freeman

P. 47: Felix Nelson Nikon D100

P. 52: Carol Freeman

P. 54: Jack Davis Nikon D100

P. 56: Carol Freeman

P. 58: Photo courtesy of Digital Vision

Pp. 60 and 64: Scott Kelby

P. 67: Carol Freeman

P. 68: Scott Kelby

Chapter 3

P. 70: Chapter Lead-in Photo by Carol Freeman Nikon F5, Fuji Provia

P. 72: Photo courtesy of Digital Vision

P. 74: Dave Moser

P. 76: Lesa Snyder Nikon Coolpix 885 P. 77: David Oliver

P. 80: Jack Davis Nikon D100

P. 82: Kevin Ames

Pp. 86 and 88: Frank Soler

P. 94: Scott Kelby

P. 98: Courtesy of Arabesque Photography

Chapter 4

P. 102: Chapter Lead-in Photo by Jim DiVitale Fuji GX690-II

Pp. 106-118: Jack Davis

P. 121: Courtesy of Digital Vision

Pp. 123 and 127: Scott Kelby

P. 131: Felix Nelson

P. 134: Dave Moser

Pp. 137-146: Richard LoPinto

Chapter 5

P. 148: Chapter Lead-in Photo by Kevin Ames Nikon DCS 76C

Pp. 150-153: Courtesy of Digital Vision

P. 154: Courtesy of PhotoDisc

P. 162: Jack Davis

P. 164: Scott Kelby

Chapter 6

P. 168: Chapter Lead-in Photo by Vincent Versace Nikon D1H

P. 170: Kevin Ames

Pp. 174-186: Courtesy of Digital Vision

P. 190: Kevin Ames

Pp. 192-202: Courtesy of Digital Vision

P. 204: Felix Nelson

P. 206: Courtesy of Digital Vision

P. 208: Courtesy of AbleStock by Hemera

P. 213: Courtesy of Digital Vision

P. 215: Courtesy of Digital Vision

P. 217: Kevin Ames

Chapter 7

P. 220: Chapter Lead-in Photo by Richard LoPinto Nikon D100

Pp. 222-226: Courtesy of Digital Vision

P. 230: Kevin Ames

Pp. 232-234: Courtesy of Digital Vision

Chapter 8

P. 236: Chapter Lead-in Photo by Jack Davis Nikon D100

P. 238: Felix Nelson

Pp. 240-250: Courtesy of Digital Vision

P. 252: Photo courtesy of PhotoDisc

Pp. 256-265: Courtesy of Digital Vision

Chapter 9

P. 270: Chapter Lead-in Photo by Carol Freeman Nikon F5

P. 272: Carol Freeman

P. 276: Jim DiVitale

P. 279: Carol Freeman

P. 280: Jim DiVitale

Chapter 10

P. 290: Chapter Lead-in Photo by Jim DiVitale Fuji GX690-II

P. 292: Carol Freeman

Pp. 298-301: Jack Davis

Nikon D100

Pp. 305-312: Courtesy of Digital Vision

Pp. 314-317: Kevin Ames

Chapter 11

P. 320: Chapter Lead-in Photo by Jack Davis Olympus E-10

Pp. 322-328: Jim DiVitale

Pp. 332-339: Courtesy of Digital Vision

P. 343: Kevin Ames

Pp. 344-348: Jim DiVitale

digitalvision

Special thanks to Royalty-free stock provider Digital Vision (www.digitalvisiononline), for allowing us to use their fantastic stock photos, and for making them available for download from the book's companion Web site:

www.scottkelbybooks.com/digibookphotos.html

The book was produced by the authors and their design team using all Macintosh computers, including a Power Mac G4 733-MHz, a Power Mac G4 Dual Processor 1.25-GHz, a Power Mac G4 Dual Processor 500-MHz, a Power Mac G4 400-MHz, and an iMac. We use LaCie, Sony, and Apple monitors.

Page layout was done using QuarkXPress 5.0. Our graphics server is a Power Mac G3, with a 60-GB LaCie external drive, and we burn our CDs to a TDK veloCD 32X CD-RW.

The headers for each technique are set in 20-point CronosMM700 Bold with the Horizontal Scaling set to 95%. Body copy is set using CronosMM408 Regular

at 10 point on 13 leading, with the Horizontal Scaling set to 95%.

Screen captures were made with Snapz Pro X and were placed and sized within QuarkXPress 5.0. The book was output at 150 line screen, and all in-house proofing was done using a Tektronix Phaser 7700 by Xerox.

ADDITIONAL RESOURCES

ScottKelbyBooks.com

For information on Scott's other Macintosh and graphics-related books, visit his book site. For background info on Scott, visit www.scottkelby.com.

http://www.scottkelbybooks.com

National Association of Photoshop Professionals (NAPP)

The industry trade association for Adobe® Photoshop® users and the world's leading resource for Photoshop training, education, and news.

http://www.photoshopuser.com

KW Computer Training Videos

Scott Kelby is featured in a series of more than 20 Photoshop training videos, each on a particular Photoshop topic, available from KW Computer Training. Visit the Web site or call 813-433-5000 for orders or more information.

http://www.photoshopvideos.com

Photoshop Down & Dirty Tricks

Scott is also author of the best-selling book *Photoshop 7 Down & Dirty Tricks*, and the book's companion Web site has all the info on the book, which is available at bookstores around the country.

http://www.downanddirtytricks.com

Adobe Photoshop Seminar Tour

See Scott live at the Adobe Photoshop Seminar Tour, the nation's most popular Photoshop seminars. For upcoming tour dates and class schedules, visit the tour Web site.

http://www.photoshopseminars.com

PhotoshopWorld

The convention for Adobe Photoshop users has now become the largest Photoshoponly event in the world. Scott Kelby is technical chair and education director for the event, as well as one of the instructors.

http://www.photoshopworld.com

PlanetPhotoshop.com

"The Ultimate Photoshop Site" features Photoshop news, tutorials, reviews, and articles posted daily. The site also contains the Web's most up-to-date resources on other Photoshop-related Web sites and information.

http://www.planetphotoshop.com

Photoshop Hall of Fame

Created to honor and recognize those individuals whose contributions to the art and business of Adobe Photoshop have had a major impact on the application or the Photoshop community itself.

http://www.photoshophalloffame.com

Kelby's Notes

Now you can get the answers to the top 100 most-asked Photoshop questions with Kelby's Notes, the plug-in from Scott Kelby. Simply go to the How Do I? menu while in Photoshop, find your question, and the answer appears in an easy-to-read dialog box. Finally, help is just one click away.

http://www.kelbysnotes.com

Mac Design Magazine

Scott is Editor-in-Chief of *Mac Design Magazine*, "The Graphics Magazine for Macintosh Users." It's a tutorial-based print magazine with how-to columns on Photoshop, Illustrator, QuarkXPress, Dreamweaver, GoLive, Flash, Final Cut Pro, and more. It's also packed with tips, tricks, and shortcuts for your favorite graphics applications.

http://www.macdesignonline.com

Photoshop 7 with a Wacom Tablet

Photoshop's behind-the-scenes photo editing power...

1. Dynamically change tool size

A Wacom pen tablet gives you the power to change the size of any of Photoshop's 20 pressure-sensitive tools with pen pressure. Press softly to get a thin stroke—press harder to get a thicker stroke. Here's the Clone Stamp set up to be pressure-sensitive for size—try out the other pressure-sensitive tools for fun! (Visit our web site for a list of all 20 pressure-sensitive Photoshop tools.)

2. Change tool opacity on the fly

Set the Paintbrush for Opacity, and you have Photoshop's most powerful tool for great layer masks! Paint lightly for a semi-transparent look, press harder for a clean knock-out. And when you're done with your Layer Mask, give the Art History brush a try—press lightly with your pen for transparent strokes, press harder for more opaque strokes.

3. Blend colors with your Paintbrush

Being able to change color during a brush stroke can give you some great effects. Set the Photoshop 7 Paintbrush to be color-sensitive in the Color Dynamics sub-palette and try it out. We've set the Paintbrush to be color-sensitive for an "organic" look as we colorize the black & white photo below with two different shades of peach.

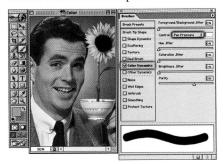

4. Try a little tilt

Select the Shape Dynamics sub-palette and you can set the Angle to be affected by Pen Tilt. Modify a round brush to be an angular calligraphy brush, tilt the pen to the left or right and you'll get beautiful calligraphic brushstrokes. (By the way, almost all of the pressure-sensitive tools are tilt-sensitive tool)

5. A finger on the Wacom Airbrush

Wacom's Airbrush Pen now offers you a new method of control in Photoshop 7—the Fingerwheel. Grab the Wacom Airbrush, select the Photoshop Paintbrush, and you can set size, opacity, scatter, color and more to respond to the roll of the fingerwheel.

6. The comfort you need

The Intuos2 Grip Pen is built for comfort. It has a cushioned, contoured grip area and features Wacom's patented cordless, battery-free technology for a natural feel and superior performance.

7. Put it all together

Now imagine editing photographs with some of your favorite Photoshop techniques and the Wacom tablet. Control size and opacity with pressure to create accurate layer masks, burn and dodge quickly, and make subtle color corrections exactly where you want them.

The only tool you need to master Adobe Photoshop

If you use Photoshop, you know that it's never been more important to stay up to date with your Photoshop skills as it is today. That's what the National Association of Photoshop Professionals (NAPP) is all about, as we're the world's leading resource for Photoshop training, education, and news. If you're into Photoshop, you're invited to join our worldwide community of Photoshop users from 106 different countries around the world who share their ideas, solutions, and cutting-edge techniques. Join NAPP today—it's the right tool for the job.

NAPP MEMBER BENEFITS INCLUDE:

- Free subscription to Photoshop User, the award-winning Adobe Photoshop "how-to" magazine
- Exclusive access to NAPP's private members-only Web site, loaded with tips, tutorials, downloads, and more
- Discounts on Photoshop training seminars, training videos, and books
- Free Photoshop tech support from our Help Desk and Advice Desk
- Get special member deals on everything from color printers to software upgrades to Zip disks, and everything in between
- Print and Web designers can earn professional certification and recognition through NAPP's new certification program
- Learn from the hottest Photoshop gurus in the industry at PhotoshopWorld, NAPP's annual convention

The National Association of Photoshop Professionals The Photoshop Authority

One-year membership is only \$99 (U.S. funds)
Call 800-738-8513 (or 727-738-2728)
or enroll online at www.photoshopuser.com

www.informit.com

YOUR GUIDE TO IT REFERENCE

New Riders has partnered with **InformIT.com** to bring technical information to your desktop. Drawing from New Riders authors and reviewers to provide additional information on topics of interest to you, **InformIT.com** provides free, in-depth information you won't find anywhere else.

Articles

Keep your edge with thousands of free articles, in-depth features, interviews, and IT reference recommendations—all written by experts you know and trust.

Online Books

Answers in an instant from **InformIT Online Books'** 600+ fully searchable online books.

Catalog

Review online sample chapters, author biographies, and customer rankings and choose exactly the right book from a selection of over 5,000 titles.

▶ Registration already a member? Log in. ▶ Book Registration

Publishing the Voices that Matter

OUR AUTHORS

PRESS ROOM

web development

we're all navigating.

design

photoshop

iii new media

3-D

server technologies

You already know that New Riders brings you the Voices that Matter.

But what does that mean? It means that New Riders brings you the

Voices that challenge your assumptions, take your talents to the next

level, or simply help you better understand the complex technical world

EDUCATORS

ABOUT US

CONTACT US

Visit www.newriders.com to find:

- ▶ Discounts on specific book purchases
- ▶ Never before published chapters
- ▶ Sample chapters and excerpts
- Author bios and interviews
- ► Contests and enter-to-wins
- Up-to-date industry event information
- ▶ Book reviews
- Special offers from our friends and partners
- Info on how to join our User Group program
- Ways to have your Voice heard

HOW TO CONTACT US

VISIT OUR WEB SITE

WWW.NEWRIDERS.COM

On our Web site you'll find information about our other books, authors, tables of contents, indexes, and book errata. You will also find information about book registration and how to purchase our books.

EMAIL US

Contact us at this address: nrfeedback@newriders.com

- · If you have comments or questions about this book
- · To report errors that you have found in this book
- · If you have a book proposal to submit or are interested in writing for New Riders
- If you would like to have an author kit sent to you
- If you are an expert in a computer topic or technology and are interested in being a technical editor who reviews manuscripts for technical accuracy
- To find a distributor in your area, please contact our international department at this address. nrmedia@newriders.com
- For instructors from educational institutions who want to preview New Riders books
 for classroom use. Email should include your name, title, school, department, address,
 phone number, office days/hours, text in use, and enrollment, along with your request
 for desk/examination copies and/or additional information.
- For members of the media who are interested in reviewing copies of New Riders books. Send your name, mailing address, and email address, along with the name of the publication or Web site you work for.

BULK PURCHASES/CORPORATE SALES

The publisher offers discounts on this book when ordered in quantity for bulk purchases and special sales. For sales within the U.S., please contact: Corporate and Government Sales (800) 382-3419 or **corpsales@pearsontechgroup.com**. Outside of the U.S., please contact: International Sales (317) 581-3793 or **international@pearsontechgroup.com**.

WRITE TO US

New Riders Publishing 201 W. 103rd St. Indianapolis, IN 46290-1097

CALL US

Toll-free (800) 571-5840 + 9 + 7477 If outside U.S. (317) 581-3500. Ask for New Riders.

FAX US

(317) 581-4663

WWW.NEWRIDERS.COM

PHOTOSHOP 7

Photoshop 7 Magic

Sherry London, Rhoda Grossman 0735712646 \$45.00

Photoshop 7 Artistry

Barry Haynes, Wendy Crumpler 0735712409 \$55.00

Photoshop 7 Killer Tips

Scott Kelby, Felix Nelson 0735713006 \$39.99

Inside Photoshop 7

Gary Bouton, Barbara Bouton, Robert Stanley, J. Scott Hamlin, Daniel Will-Harris. Mara Nathanson 0735712417 \$49.99

Photoshop Studio with Bert Monroy

Bert Monroy 0735712468 \$45.00

Photoshop Restoration and Retouching

Katrin Eisemann 0789723182 \$49.99

Photoshop Type Effects Visual Encyclopedia

Roger Pring 0735711909 \$45.00

Creative Thinking in **Photoshop**

Sharon Steuer 0735711224 \$45.00

Photoshop 7 Power Shortcuts

Michael Ninness 0735713316 \$19.99

VOICES
THAT MATTER